BODY KNOTS

HOWARD SCHATZ

FOREWORD BY OWEN EDWARDS

First published in the United States of America in 2000 by
RIZZOLI INTERNATIONAL PUBLICATIONS, INC.
300 Park Avenue South
New York, NY 10010

ISBN: 0-8478-2250-8
LC 99-76993

Designed by Karen Engelmann
Printed and bound in Italy

Howard Schatz and Beverly Ornstein are represented by

THE WONDERLAND
PRESS

BODY KNOTS

HOWARD SCHATZ

FOREWORD BY OWEN EDWARDS

RIZZOLI
NEW YORK

WARNING: DON'T TRY THIS AT HOME

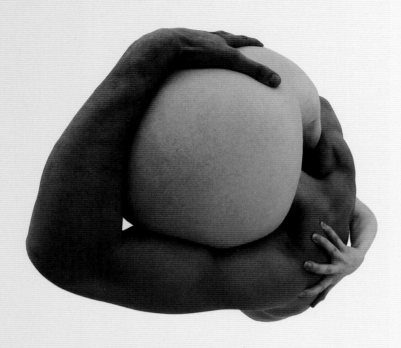

"Bryan, you sit down here and tuck your legs in...good. Lenna, hide your feet here, under the left side of his tush and his thigh—good—now bend yourself over him, over his head, and get the top of your head all the way down and into his lap. Bryan, pull your head way down, try to touch your chin to your chest and your nose to your belly button. OK, now, take your left arm and wrap it around her, from the back of her thighs, over her tush, and onto her back—I want your arm to cover the line of her tush and to support her so she won't fall over when you two squeeze the knot.

"Now, Lenna, take your right hand—place it backwards and put it up his back—higher, higher—get your fingertips to reach up toward his neck. With your left arm grab his right arm and Bryan, you grab her left arm, and pull the knot tight. Keep your heads tucked way in, hidden. Great. Now, I'm coming in with my camera to look for the image, to find the knot. When I count to three, squeeze really tight and hold it until I take the picture."

Holding the camera, I walk around them, visualizing an image. It's biological sculpture that I'm after, without identification (no head, except rarely, for effect). I bend down, lay on the ground to shoot up, or get on a ladder to shoot down. I look, I look, I look. Often I'll ask for an adjustment, to bring a hand or shoulder closer to the camera, or to hide a foot. And I look.... When I see it, I come in close—and then "one, two, three, SQUEEZE!!!!!!"

Snap (pop), the picture is taken and they loosen their grip—often with "aaaaagh." I look some more, find another perspective, or make another adjustment, then count again, "squeeze!", make a picture. This goes on for five or six shots and then we "untie" and start all over again.

HOWARD SCHATZ

The majority of the people who "tied" themselves into knots for this project are dancers, trained to follow exacting instructions and psychologically prepared for a very difficult physical challenge. Here's what it was like:

TYING KNOTS

The great magazine art director Alexey Brodovitch used to tell his photographers that if they looked through the lens and saw something they'd seen before, they shouldn't press the shutter. For any artist, this injunction against repetition or derivation would be daunting. The demand for novelty can lead to despair, desperate acts, and all sorts of nonsense slouching along under the banner of art. For a photographer, the search for something entirely new can be especially maddening, since there has never been a more voracious collector and creator of images than the camera. Just try imagining something that hasn't been tracked down on the planet or tricked up in a studio. The medium has already had its share of Mozarts and Beethovens (not to mention legions of Vivaldis and Ravels), so much of what is done today refers to a brief but glorious past. Every now and then a photographer who is very good or very lucky (or both) happens upon something original, but before you know it that startling vision has been converted into a trademark style.

Howard Schatz is very good and perhaps very lucky. In the space of a relatively short career in photography, he has created a collection of pictures that is rarely less than exceptional and remarkably often entirely new. Novelty, of course, is not by itself a virtue. What's best about Schatz's work is that he shows us things in a new way not to shock and infuriate but to delight and refresh. He opens our eyes wide, and makes us glad he did.

For the past ten years, Schatz has worked with dancers. His artistic collaboration with the members of troupes in New York and San Francisco, both classical and modern, began almost accidentally when he was exploring ways to photograph various sorts of people underwater in a swimming pool (including my son and me, fully dressed). In his typically methodical, indefatigable way, Schatz had tried many approaches without settling on an approach that worked. Then he discovered that one of his subjects, Katita Waldo, a ballerina with the San Francisco Ballet, could express physical energy in the zero gravity of immersion. With a discipline learned through years of training, Waldo was able to ignore the novel conditions of her environment and create intensity where others had given in to a kind of weightless lassitude. The ballerina became a kind of muse, launching Schatz on a long and continuing photographic partnership with all kinds of dancers. This involvement has resulted in three underwater books, a rapt study of dancers' bodies in the studio, and numerous covers and portraits for *Dance* magazine. It's never safe to predict an artist's trajectory, especially when that artist is as protean, determined, and inclined to obsession as Schatz. But for the moment, at least, with BODY KNOTS, his work with dancers seems to have reached a remarkable crescendo that will be difficult to surpass.

Though dancers are the subjects of BODY KNOTS, it's not insignificant that this work is a digression. Schatz, it so happens, became a full-time photographer only after rising to prominence in an entirely different field. It may be, then, that he's less worried than a younger artist about whether everything he does makes good linear sense—whether a given project adheres closely to the main stem of his previous successes. Rather, Schatz is willing to be lured down an unfamiliar path by any idea that intrigues him, and he'll test that idea exhaustively, like a mathematician with a promising theorem, until it proves out or not. If the promise becomes a project, all that matters to him is that by working and reworking an idea he can capture images that were worth the pursuit.

The idea that produced BODY KNOTS was uncomplicated: the photographer wanted to make "biologic sculpture" using two or more bodies intertwined, reducing anatomy to primal simplicity, braiding limbs and torsos into a kind of living netsuke. Like such predecessors as Bill Brandt, Andre Kertesz, and Irving Penn, Schatz wanted

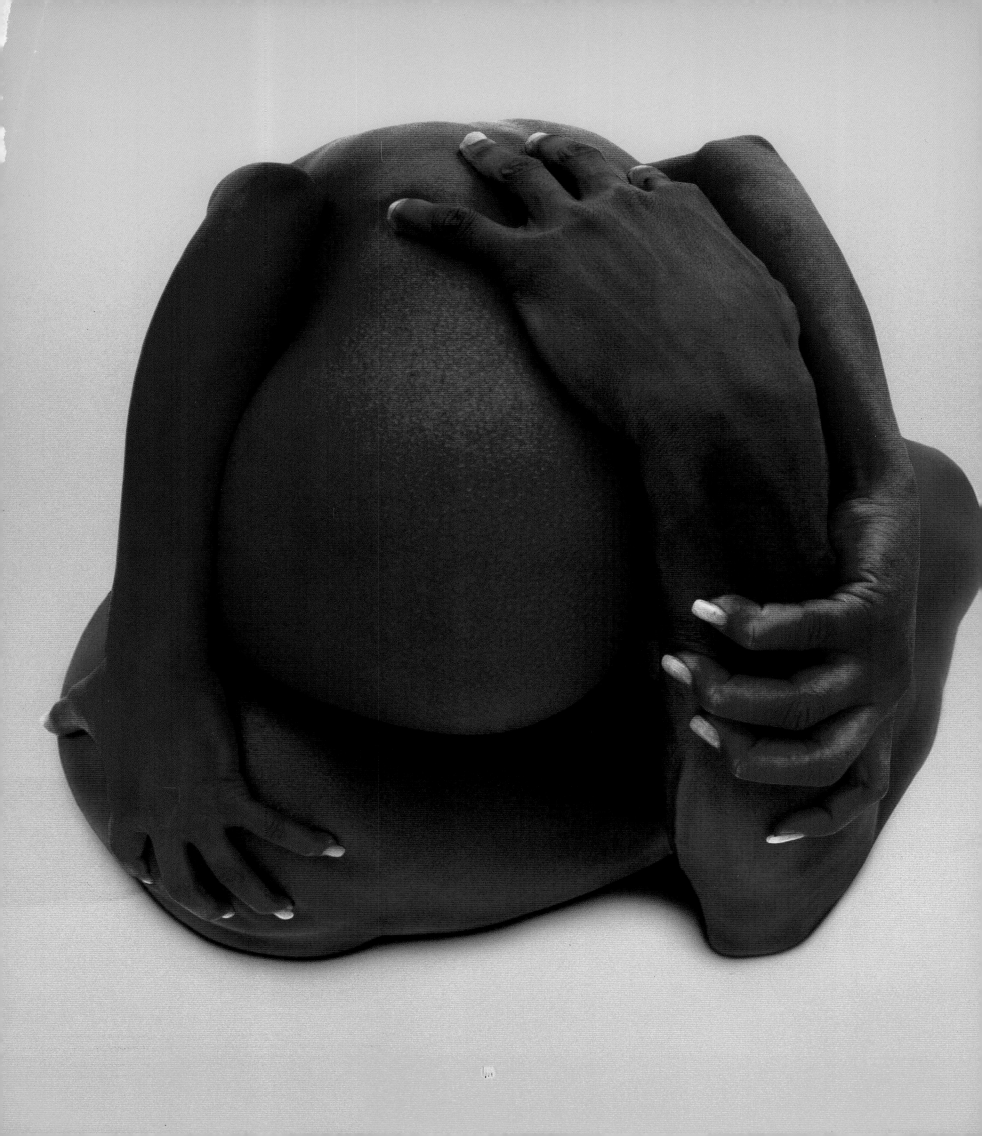

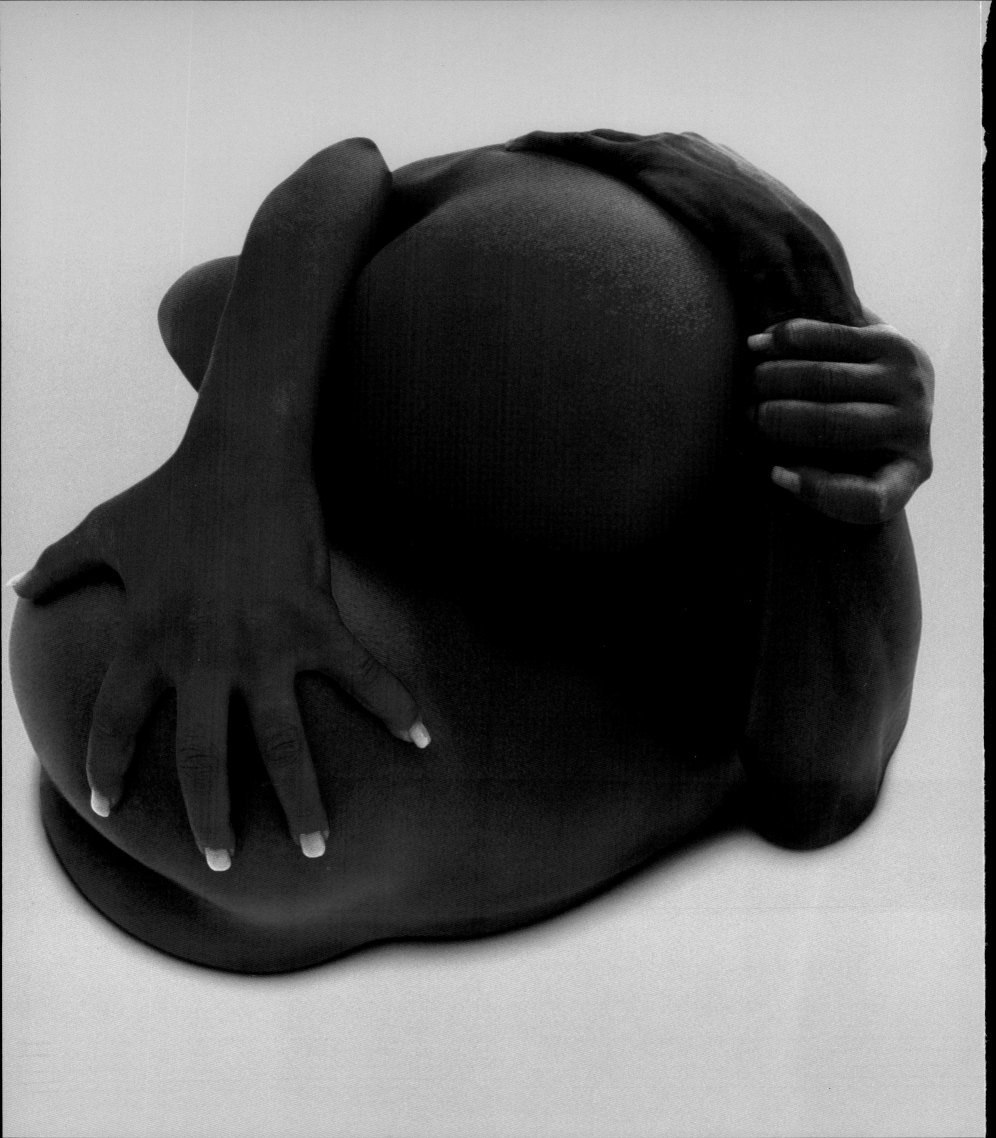

to re-see the body, but he wanted to go further: to make separate bodies into a single, mysterious structure. In one aspect of his earlier underwater work, Schatz produced an intriguing alphabet book in which each letter and number was formed by the carefully choreographed combination of a male and female dancer. These intricately worked out poses, though strictly programmatic (each had to produce a readable letter), must have suggested other, more abstract possibilities. The process of achieving these forms, arduous for dancers and photographer alike, gave Schatz the ability to coax unseen shapes out of the profoundly familiar material of the body, and the language to ask his dancers for what he needed.

The idea to make abstract human sculpture may have been simple, but the work was not. In his introduction to this book, the photographer describes how he proceeded and what the dancers went through (though looking at these pictures, it's not hard to imagine the grunts and groans). But it seems safe to say that not even the demands of underwater work were as rigorous as these sometimes perverse, pretzeled poses. Schatz talks about "getting past the thought that these knots were bodies," but his models weren't so lucky. Though he wasn't able to succeed at tying every knot he imagined—"My ideas were always modified by what human bodies could do"—Schatz was able to direct them into contortions almost impossible for a viewer to deconstruct. He used a computer to manipulate colors and shadow and sometimes overlay patterns, but with only one exception—which the reader must ferret out on his or her own—the positions were as they appear. How fortunate for Schatz that dancers are so accustomed to suffering!

The best ideas are self-generating and self-evolving, and so are the best artists. As Schatz went from one knot to the next, the variations on a theme mutated. The simplest forms grew more complex: bodies metamorphosed into beetles; hands and feet swooped into the foreground and took on lives of their own (with mute eloquence expressing surprise, delight, shock); and the most basic pose of a single human being became more grotesque than the most tormented gargoyle agonizing above Paris. Given the new and

increasingly potent artistic ordnance of the computer, Schatz was able to take already fantastical pictures and, sitting late into the night in front of a glowing screen, add layer after layer of imagination and variations. In the process, he accomplished one of the hardest things in photography: he makes us smile, shake our heads in wonder, and sometimes laugh. A wacky color palette, pages of multiple knots that look like something out of a madcap Boy Scouts manual, knots as pearls, as museum exhibitions, as chocolate candy, as weird wallpaper, all became possible in the digital darkroom. To those who still harbor doubts about the artistic legitimacy of such post-negative computer enhancement, Schatz says simply: "I could have actually painted the models, but that would have diminished the possibilities of what I and they could attempt in the studio. Looking at all the directions I could go on the screen taught me what I did and didn't have to worry about when I was actually shooting."

Howard Schatz did not set out to make metaphors, just to chip away at the marble of a visual idea. We're free to look at these pictures and take from them whatever we see, to build our own meanings beyond anything the photographer intended. After all, the intertwinings of humans, in body and mind, filled with the counter tension of clinging and resisting, lush with sexual promise and rife with discomfort and claustrophobia, are irresistibly present in these pictures. We can easily imagine the models laughing, squirming, feeling the stirrings of excitement, and finally groaning and dreaming of freedom. We are reminded of this irony: humans spend their days and hours seeking to become interlocked with others, then spend at least an equal amount of time and energy looking for the key.

But we need not dwell on that. These are wonderful pictures that need have no other meaning than the pleasure and surprise they bring. They show us what we haven't seen before, and we can be glad Howard Schatz pushed the shutter.

OWEN EDWARDS

Other side: Three different views of the same body knot

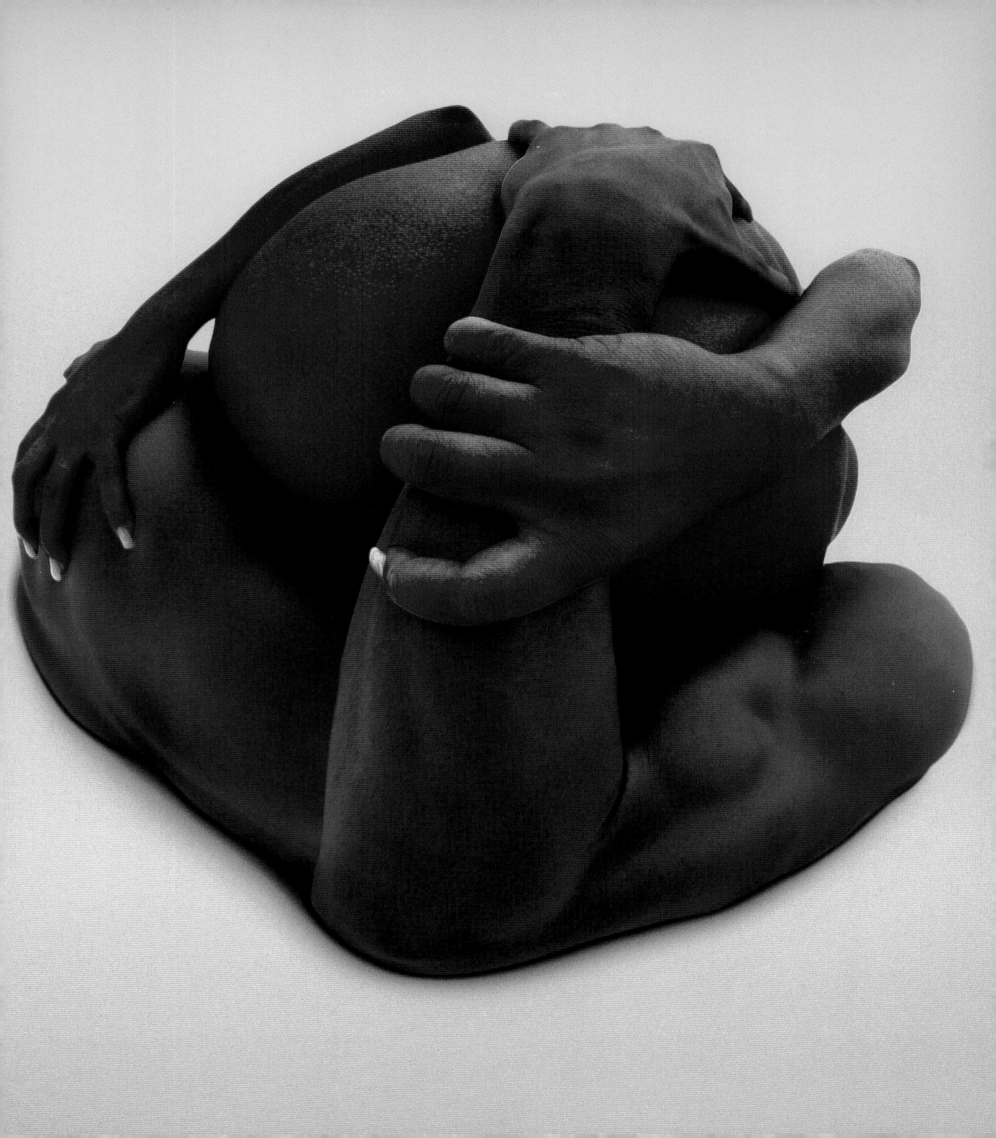

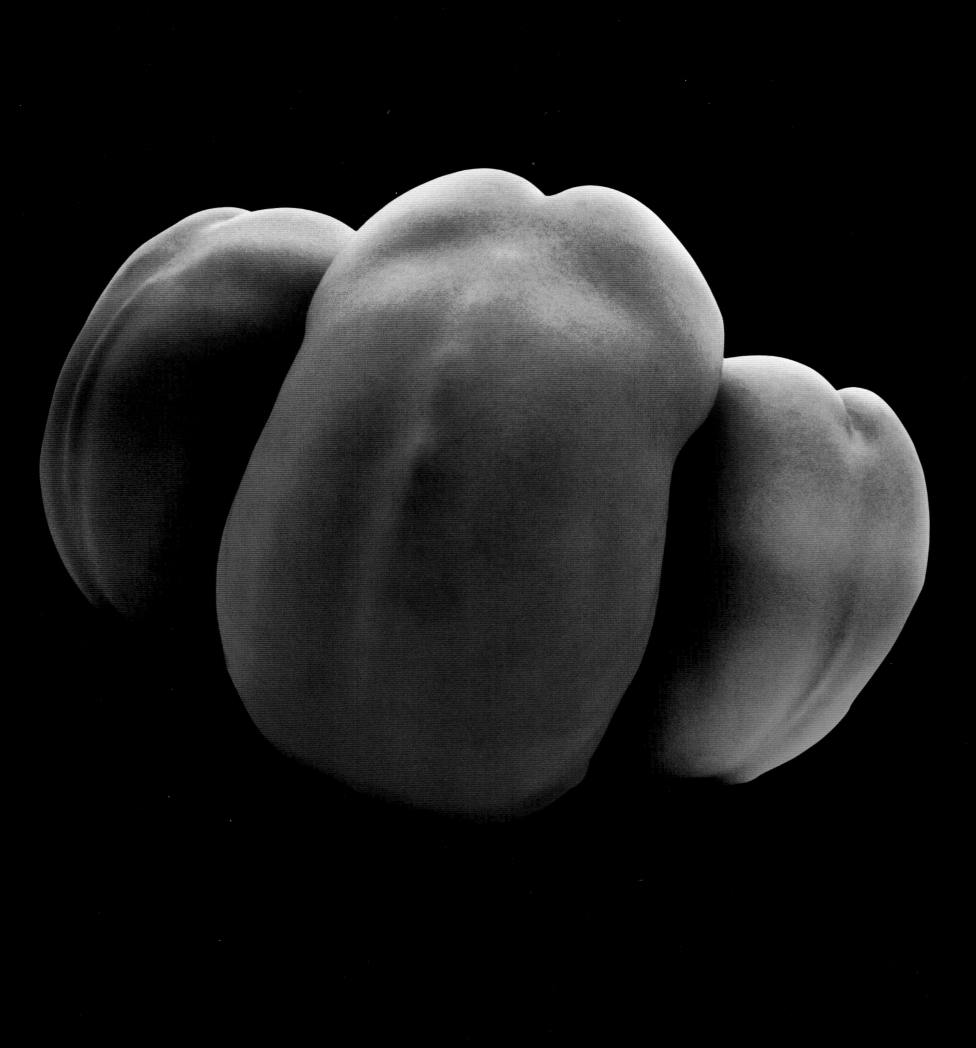

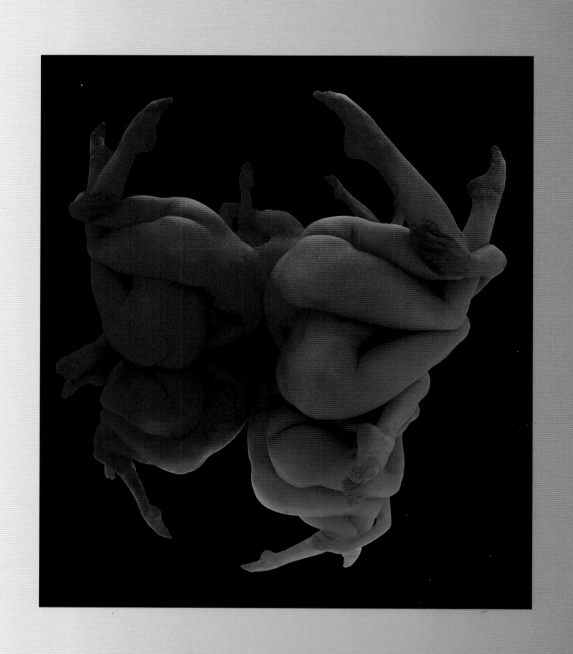

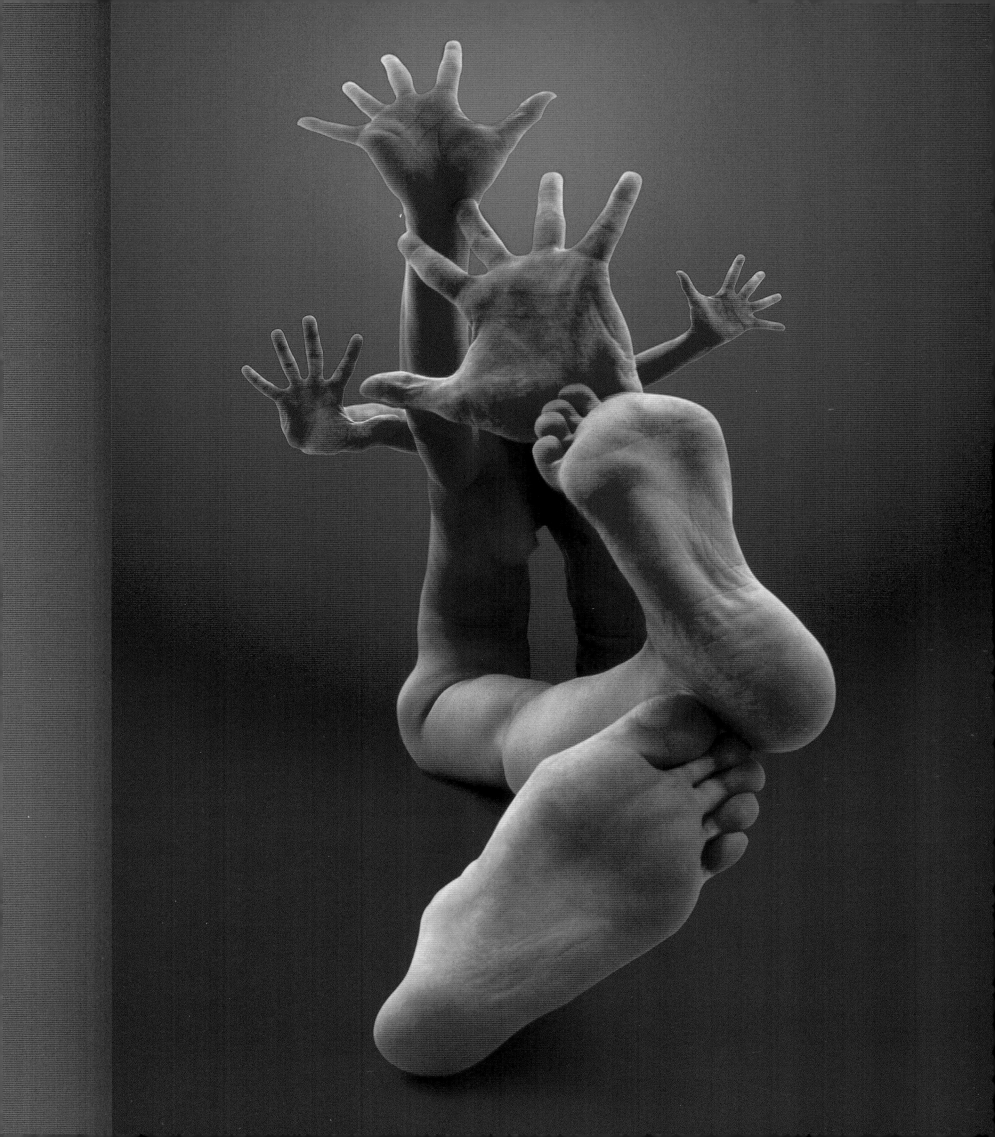

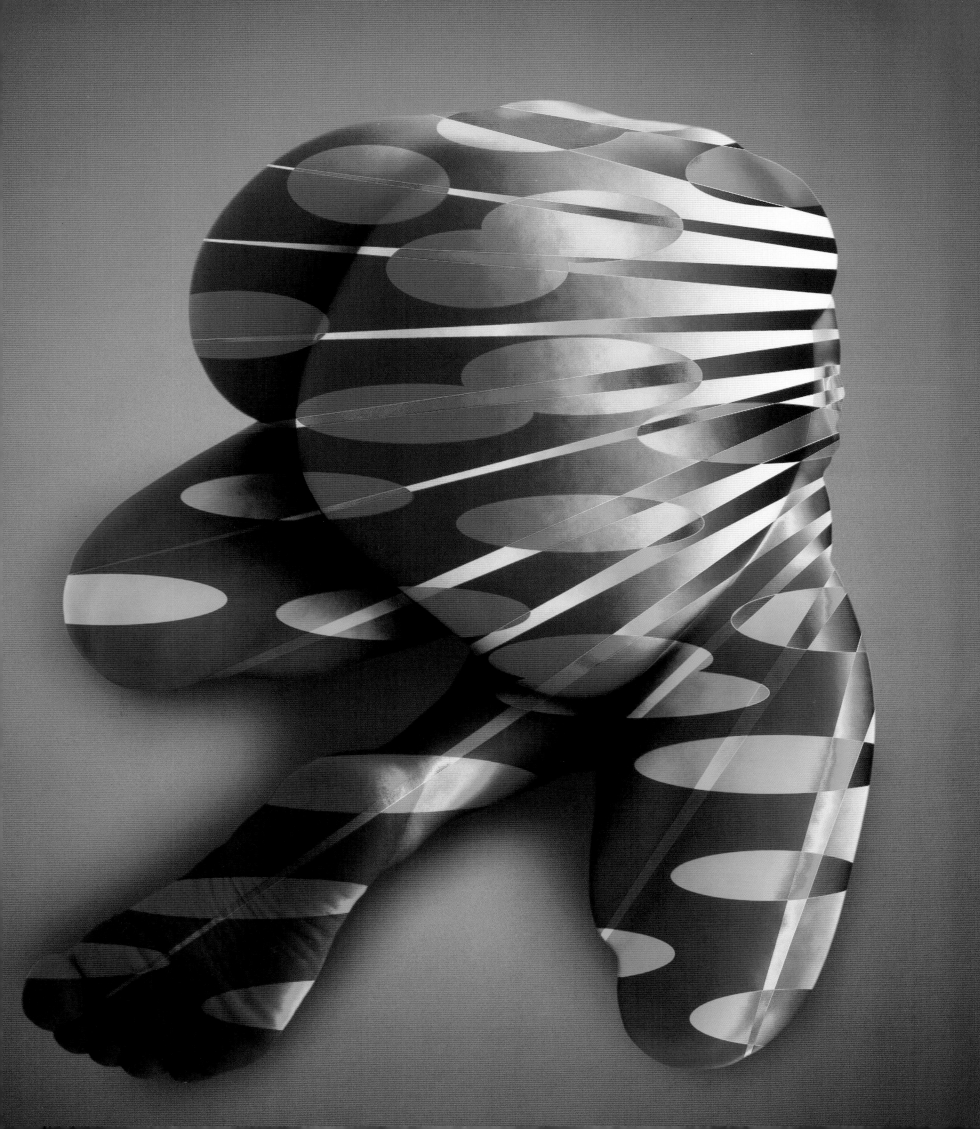

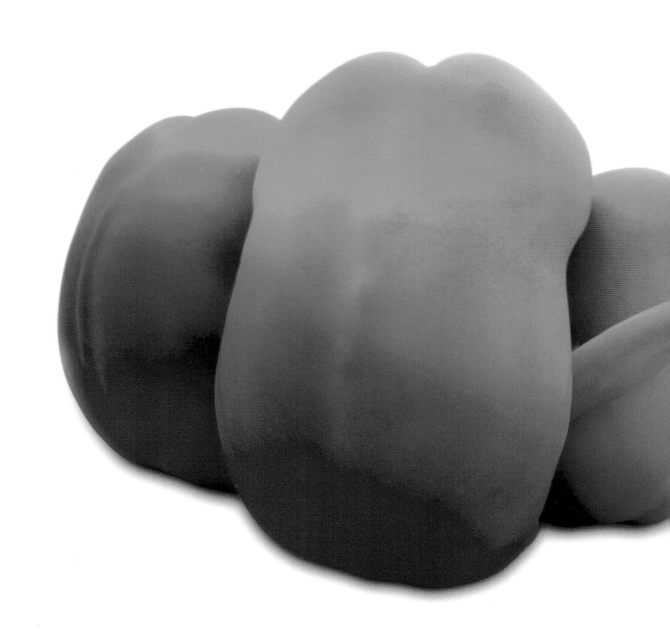

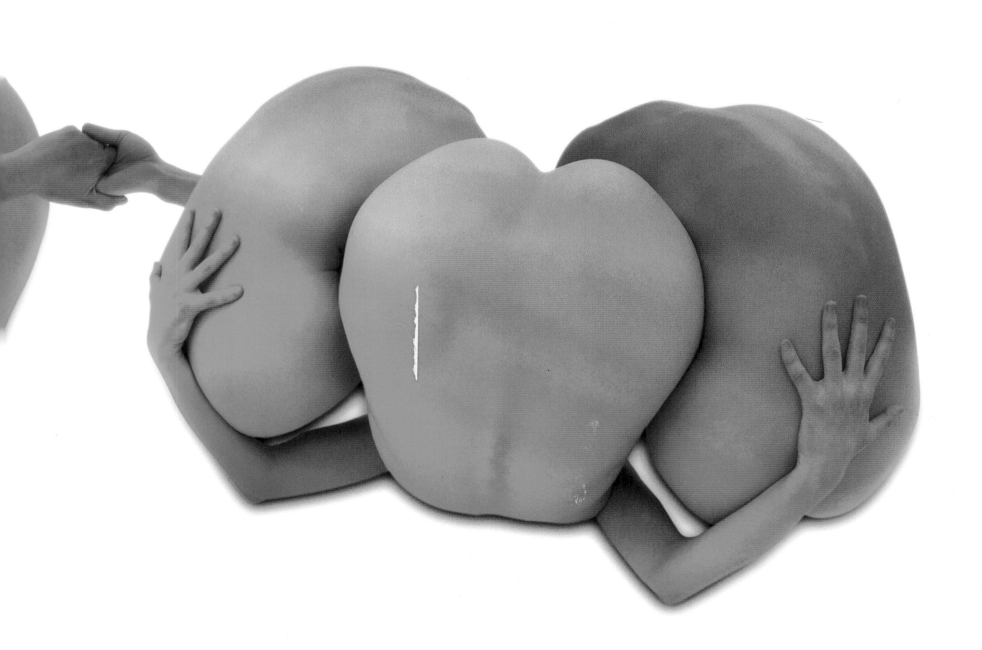

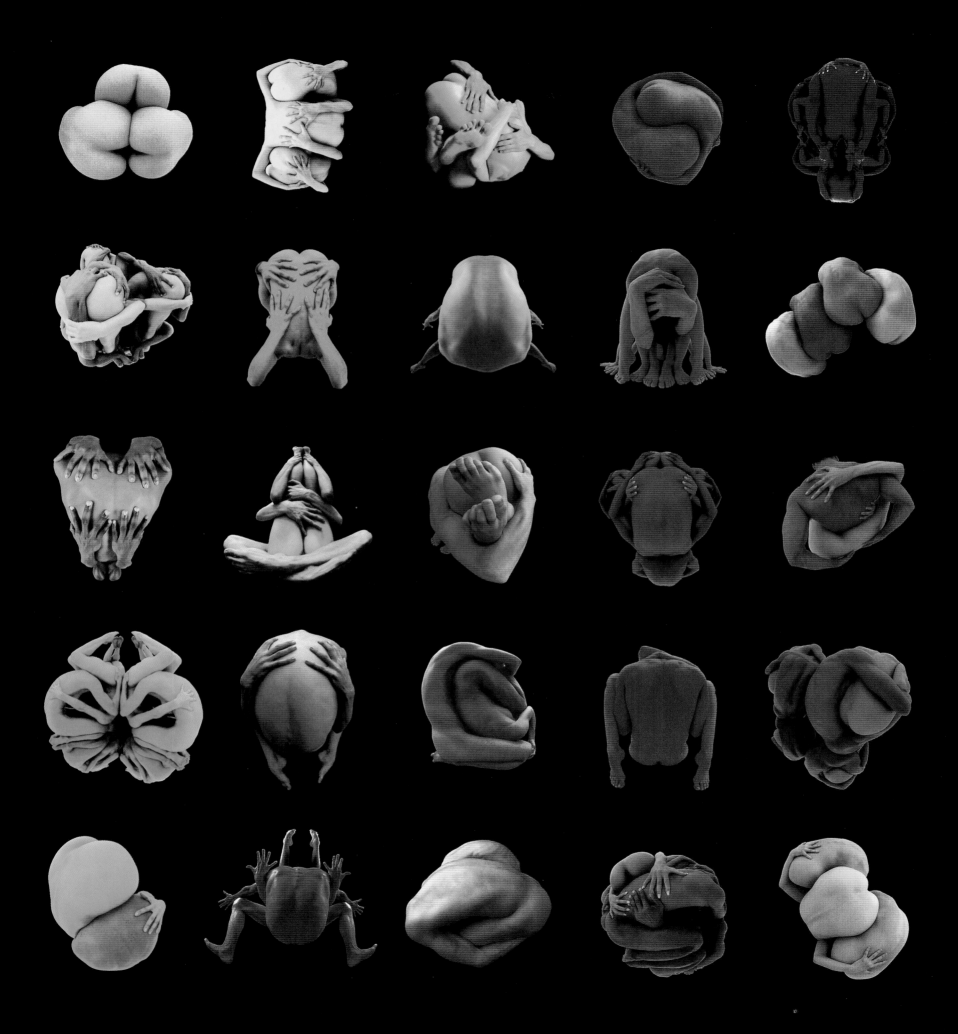

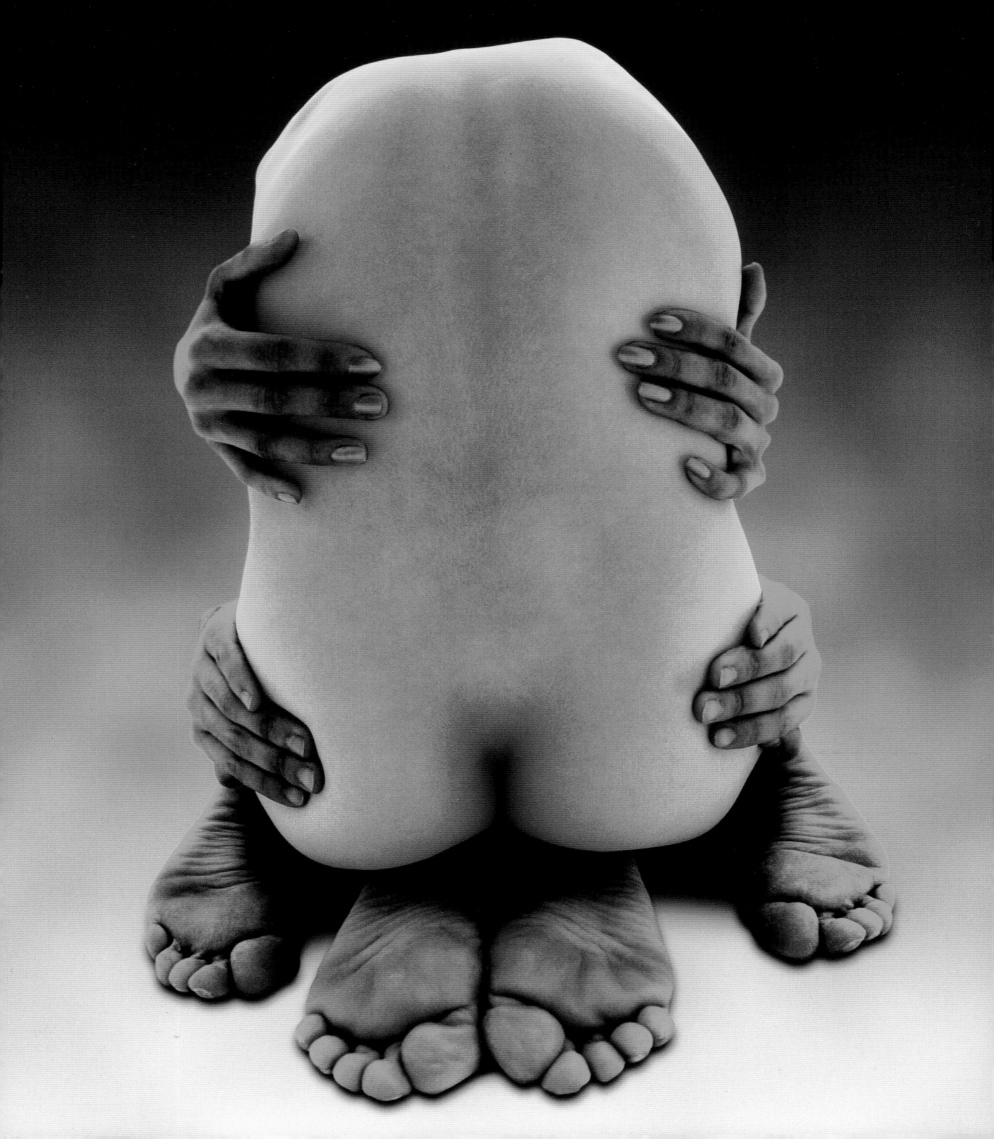

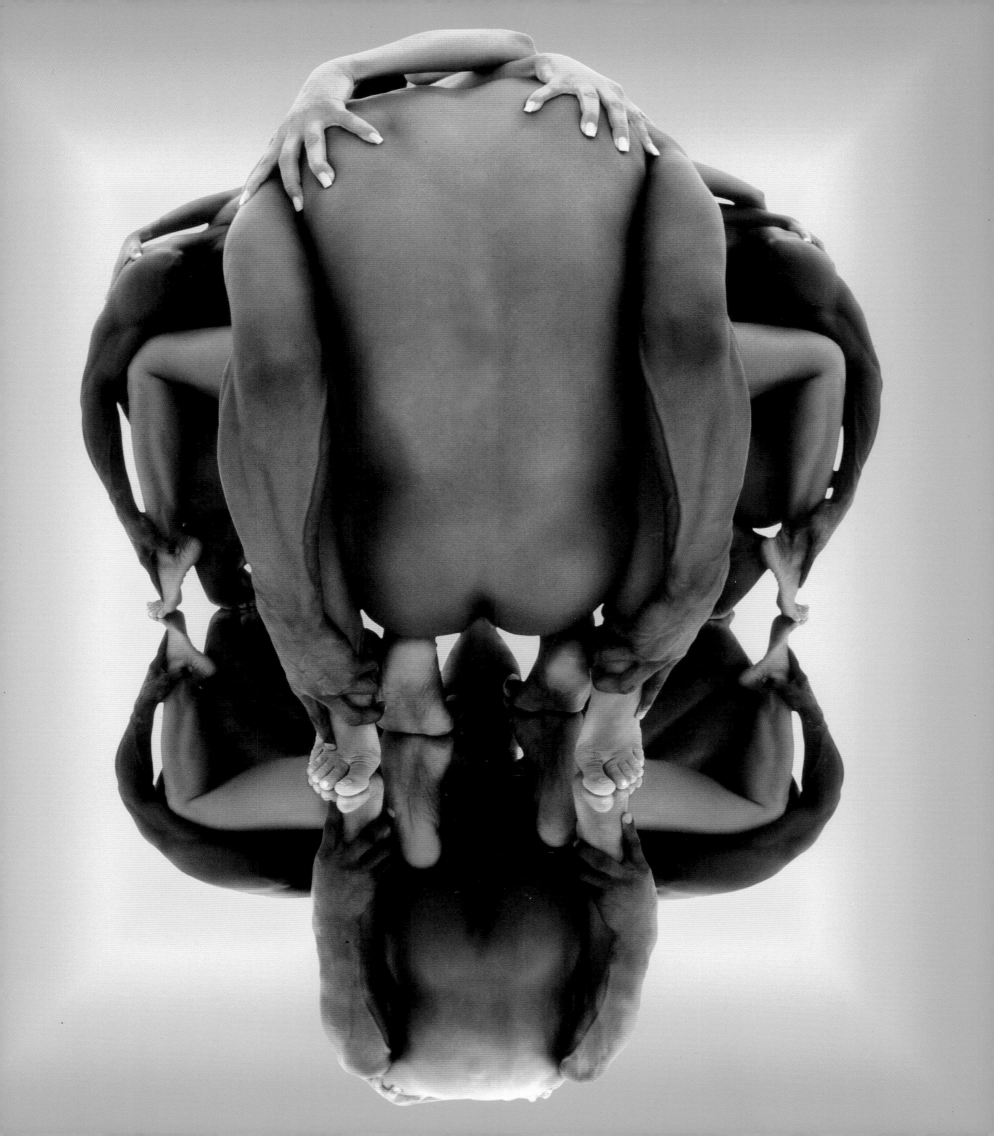

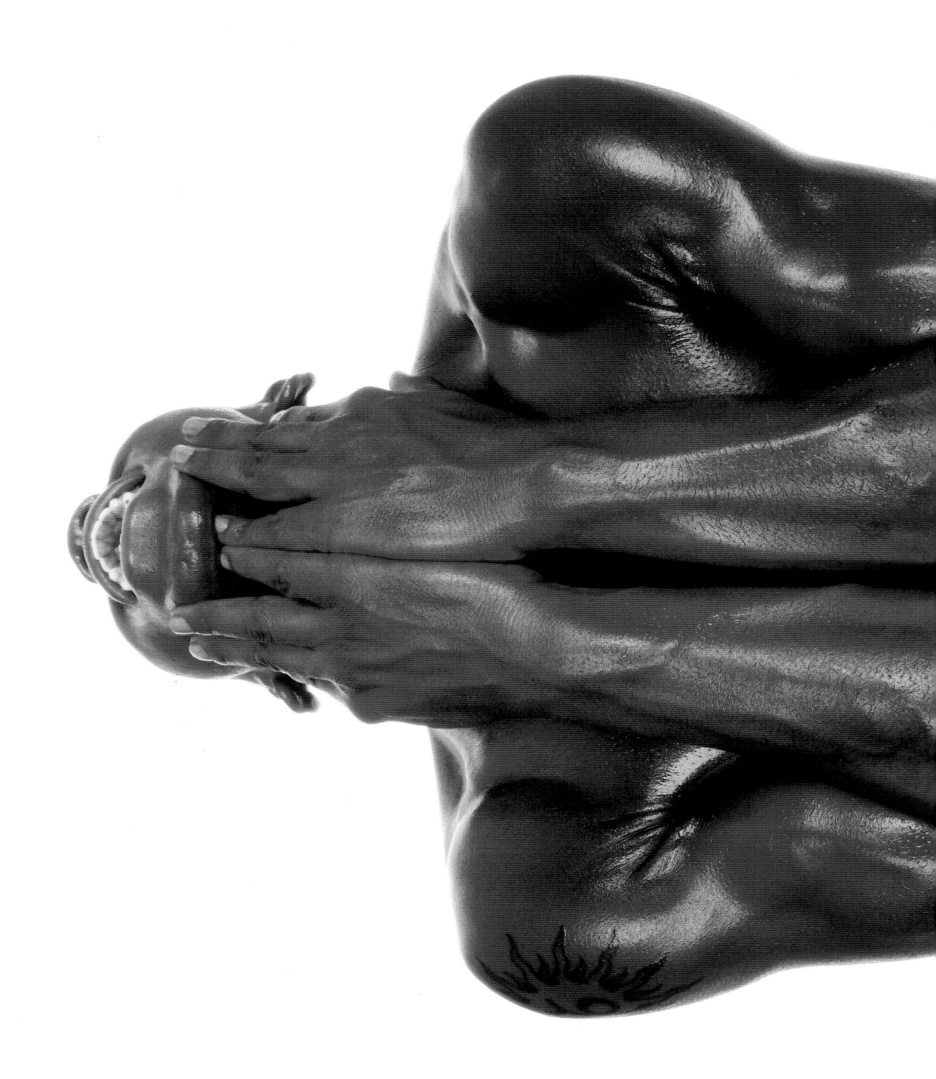

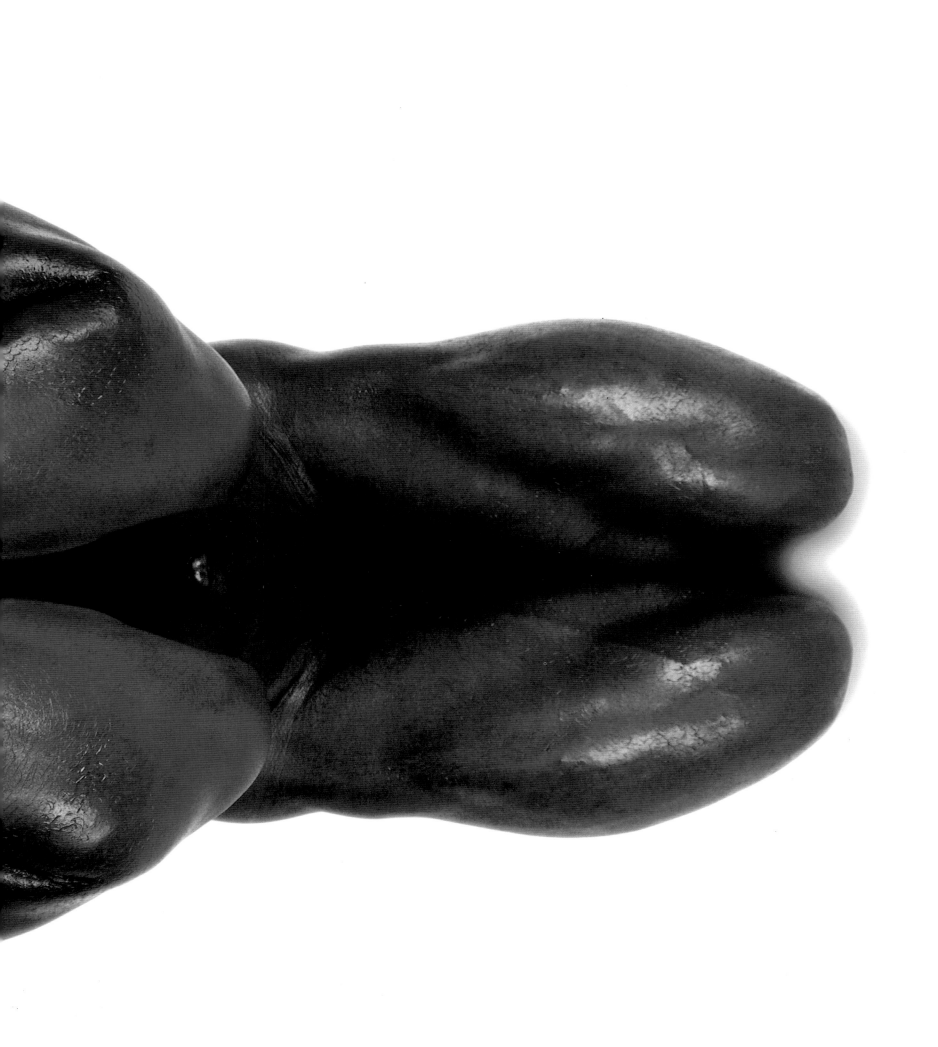

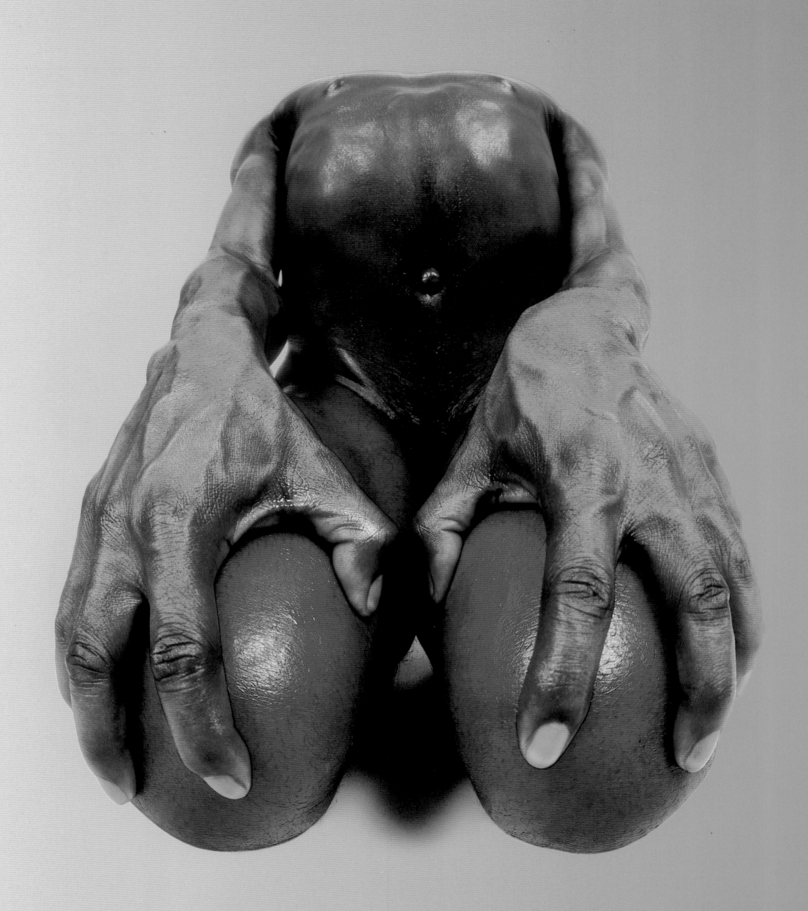

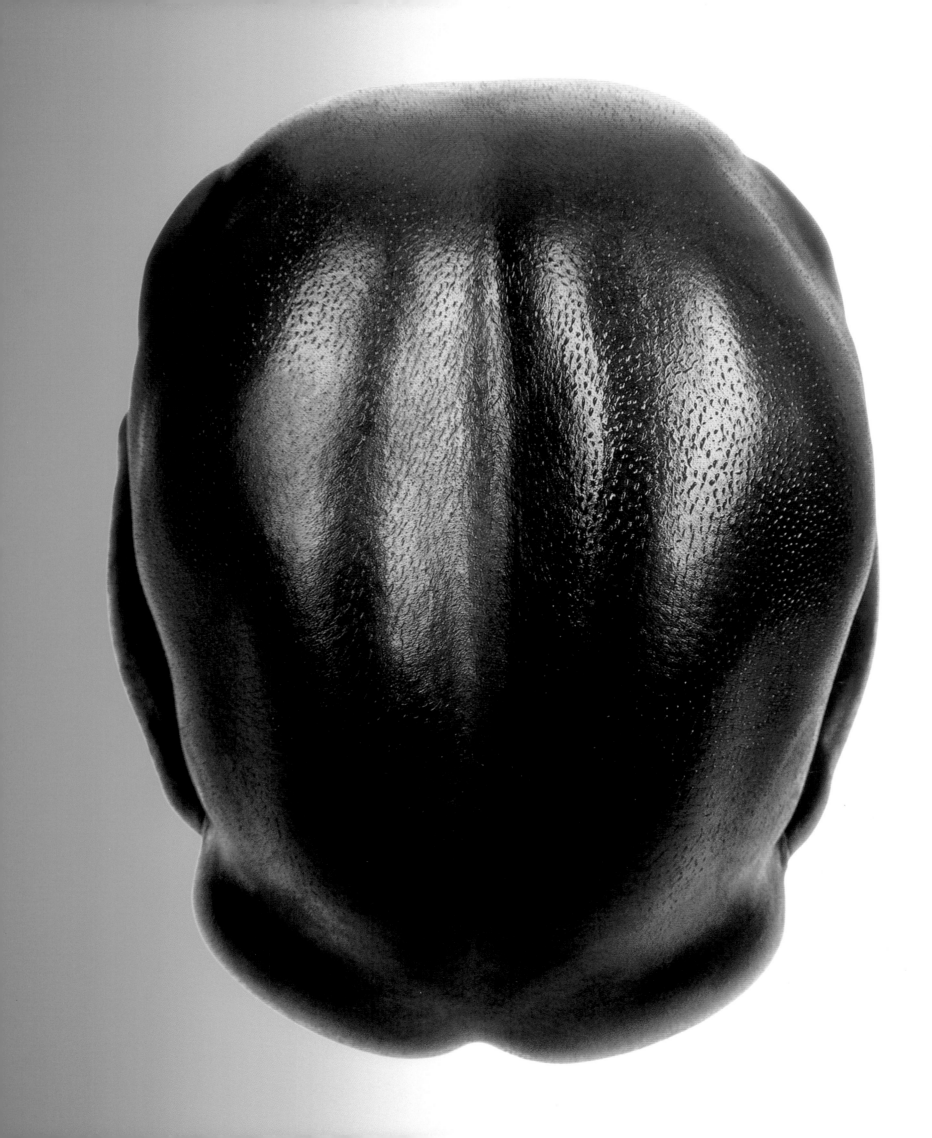

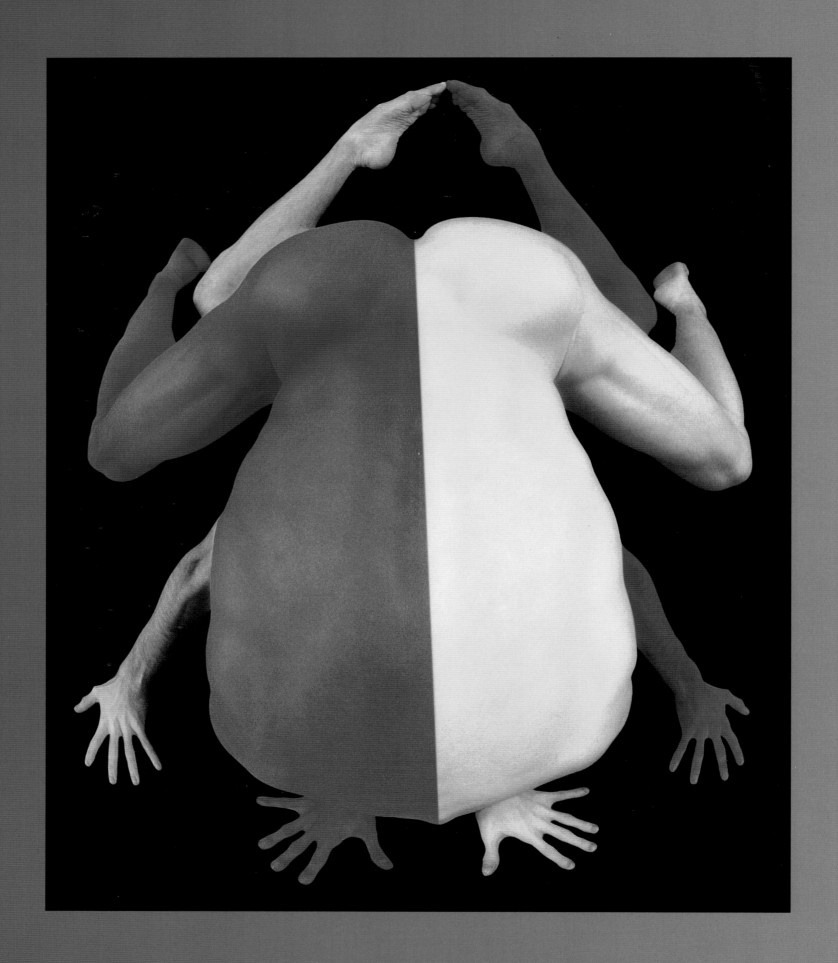

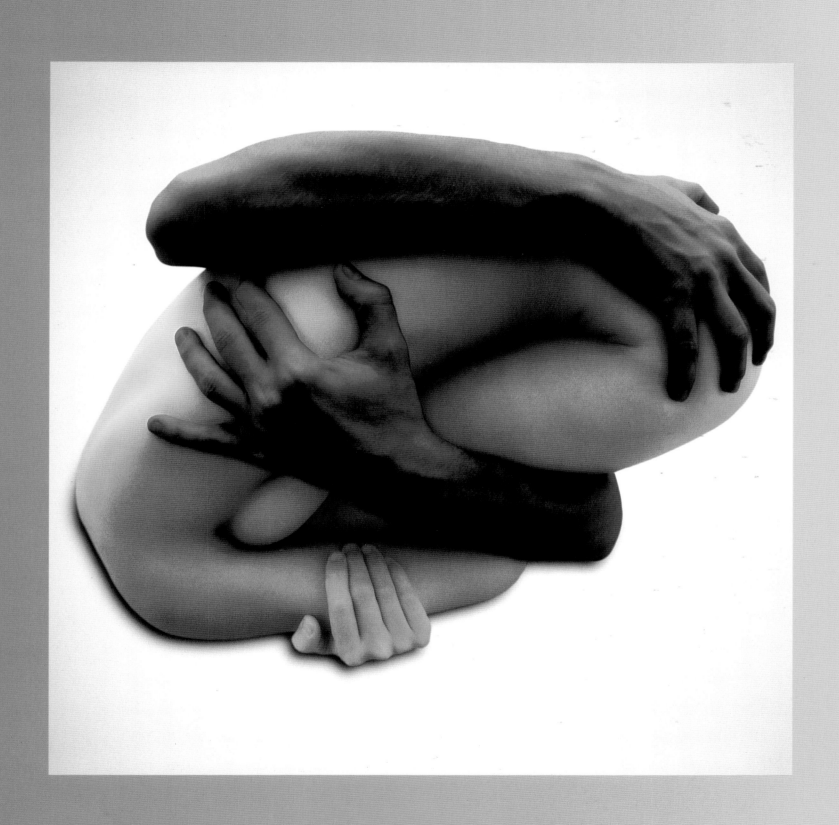

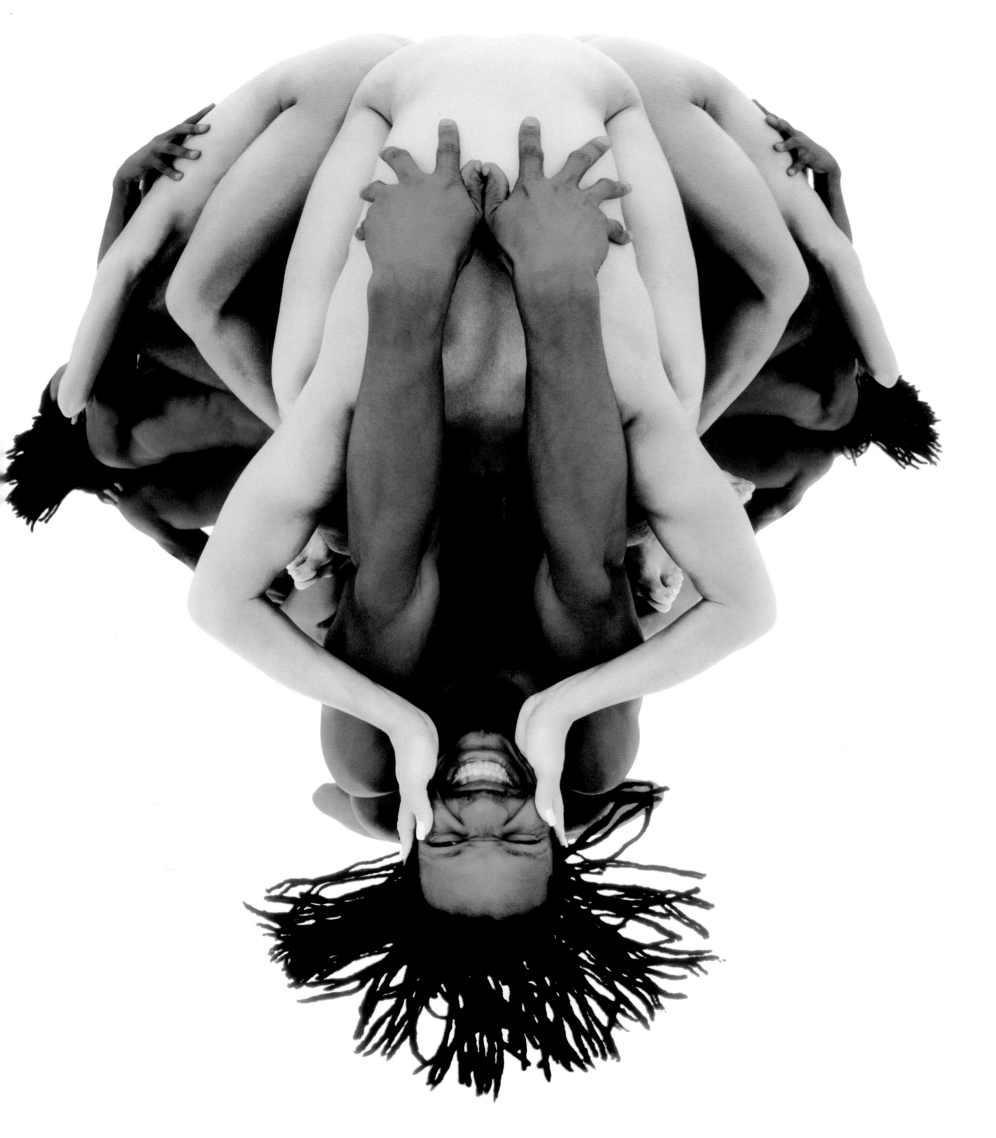

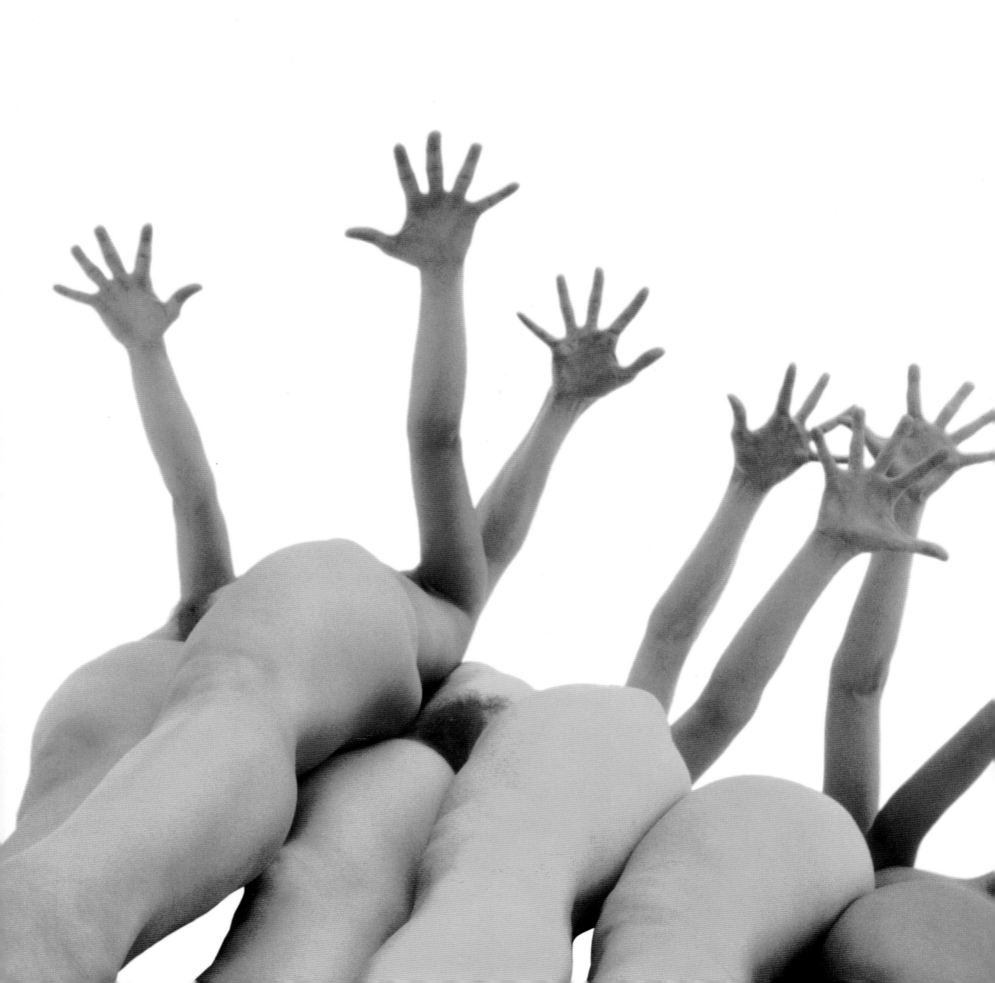

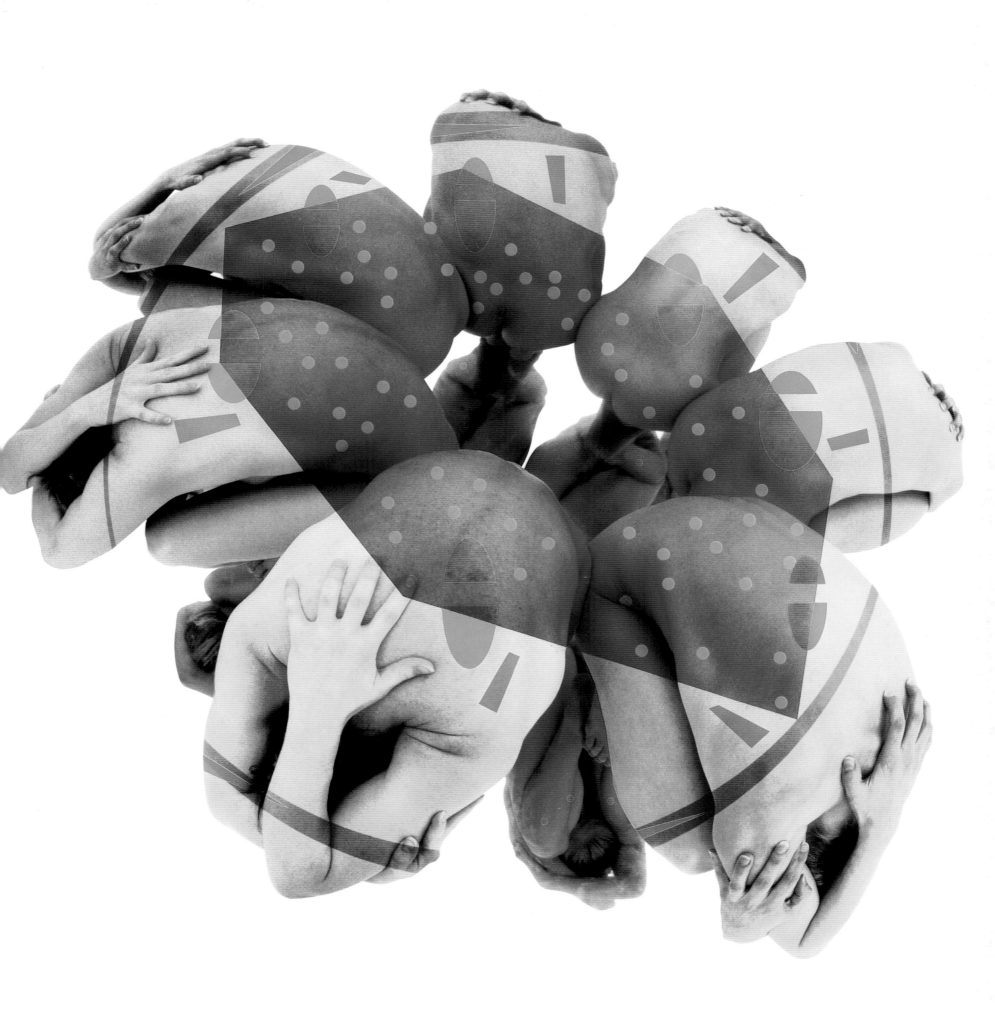

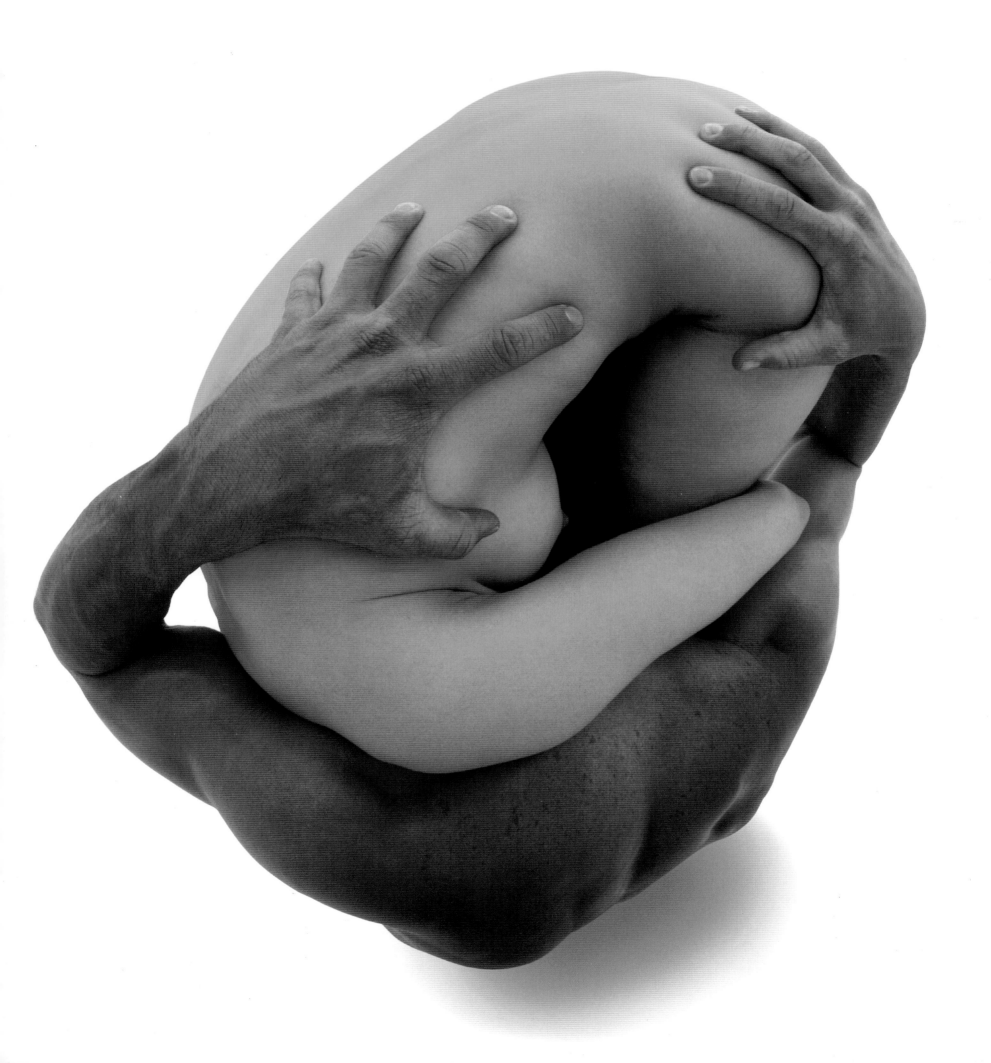

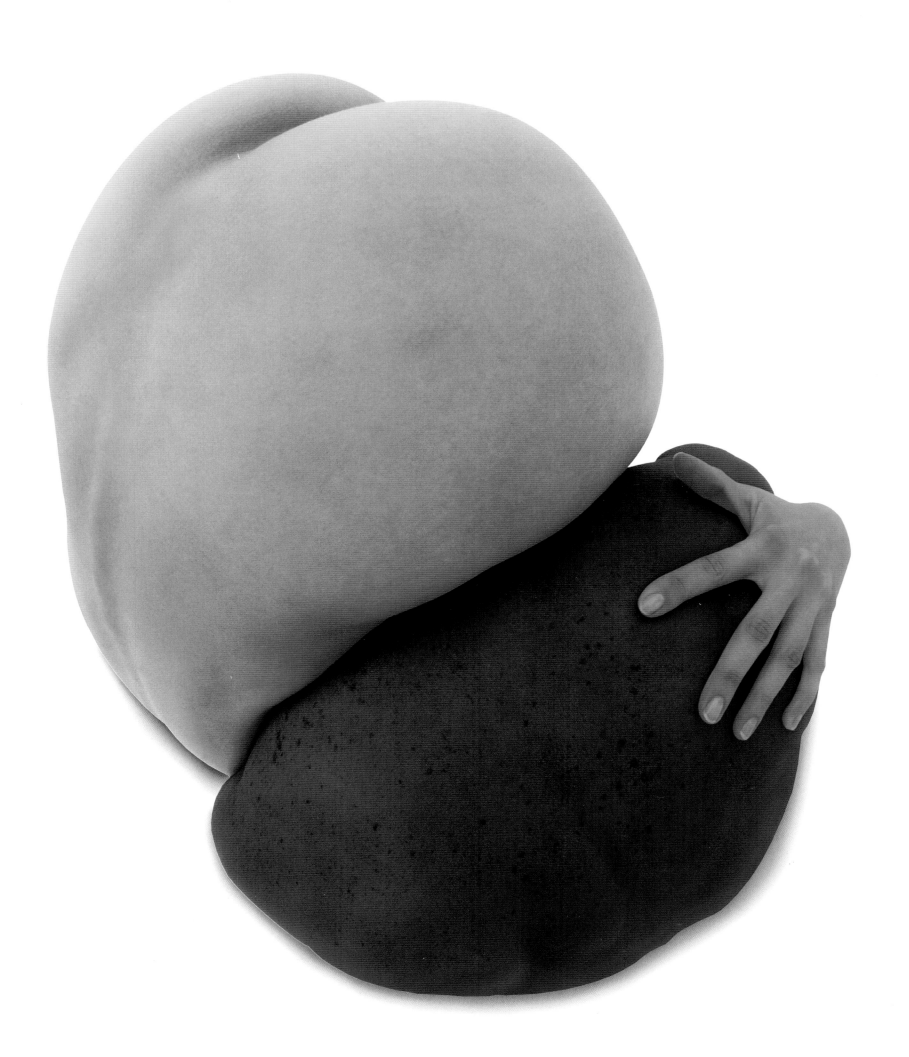

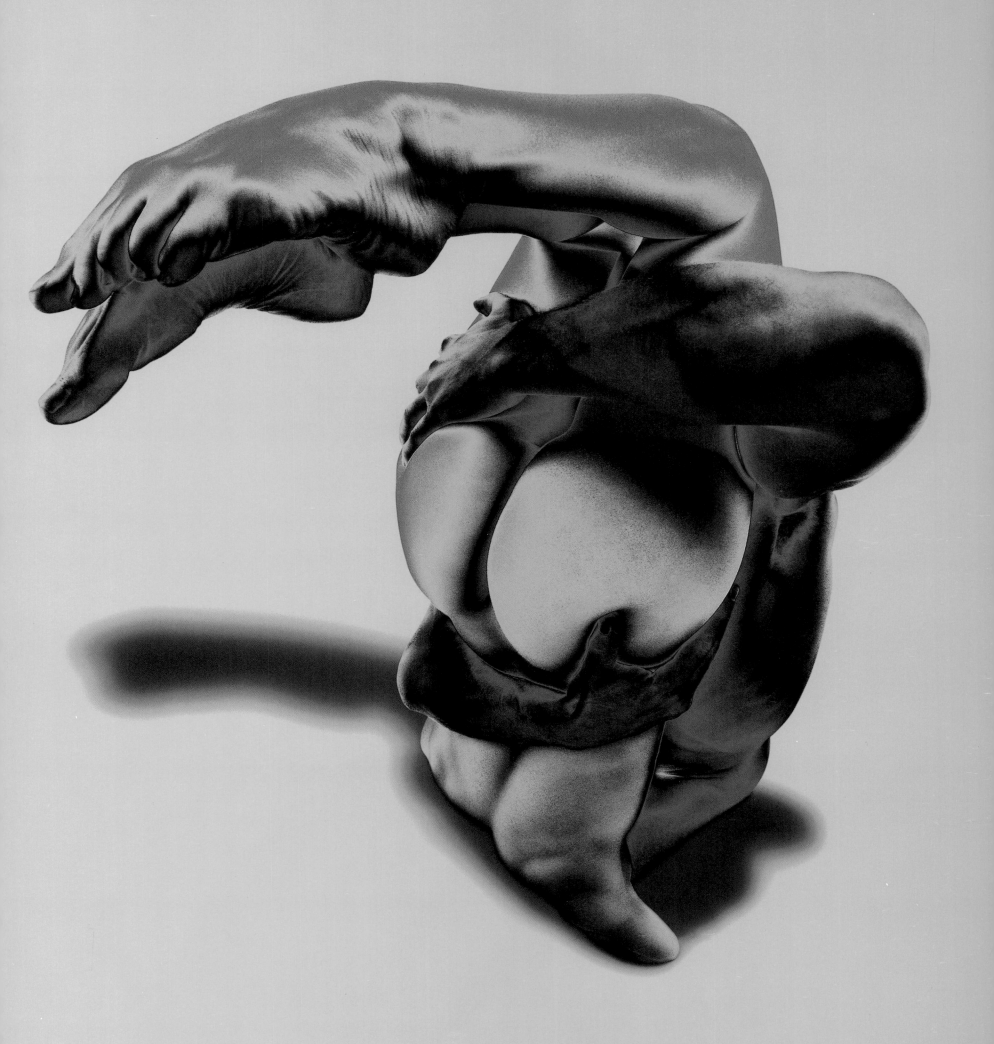

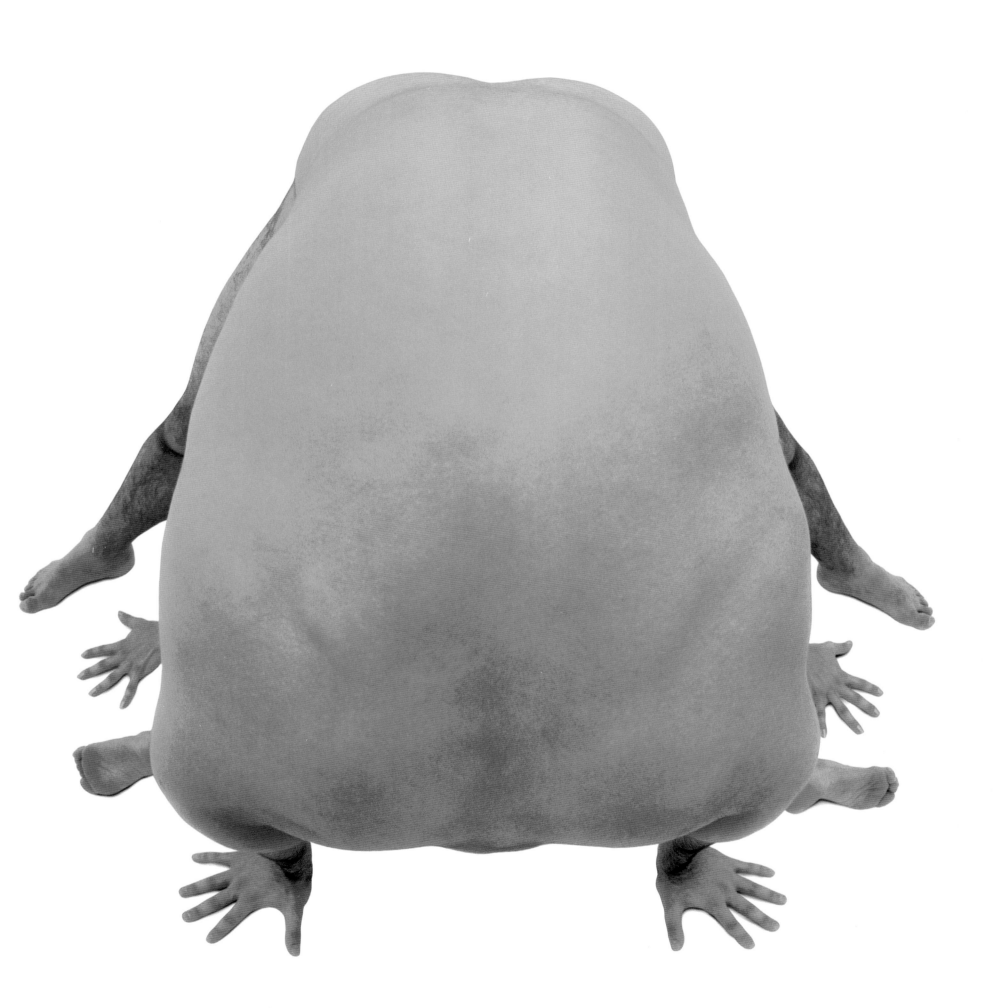

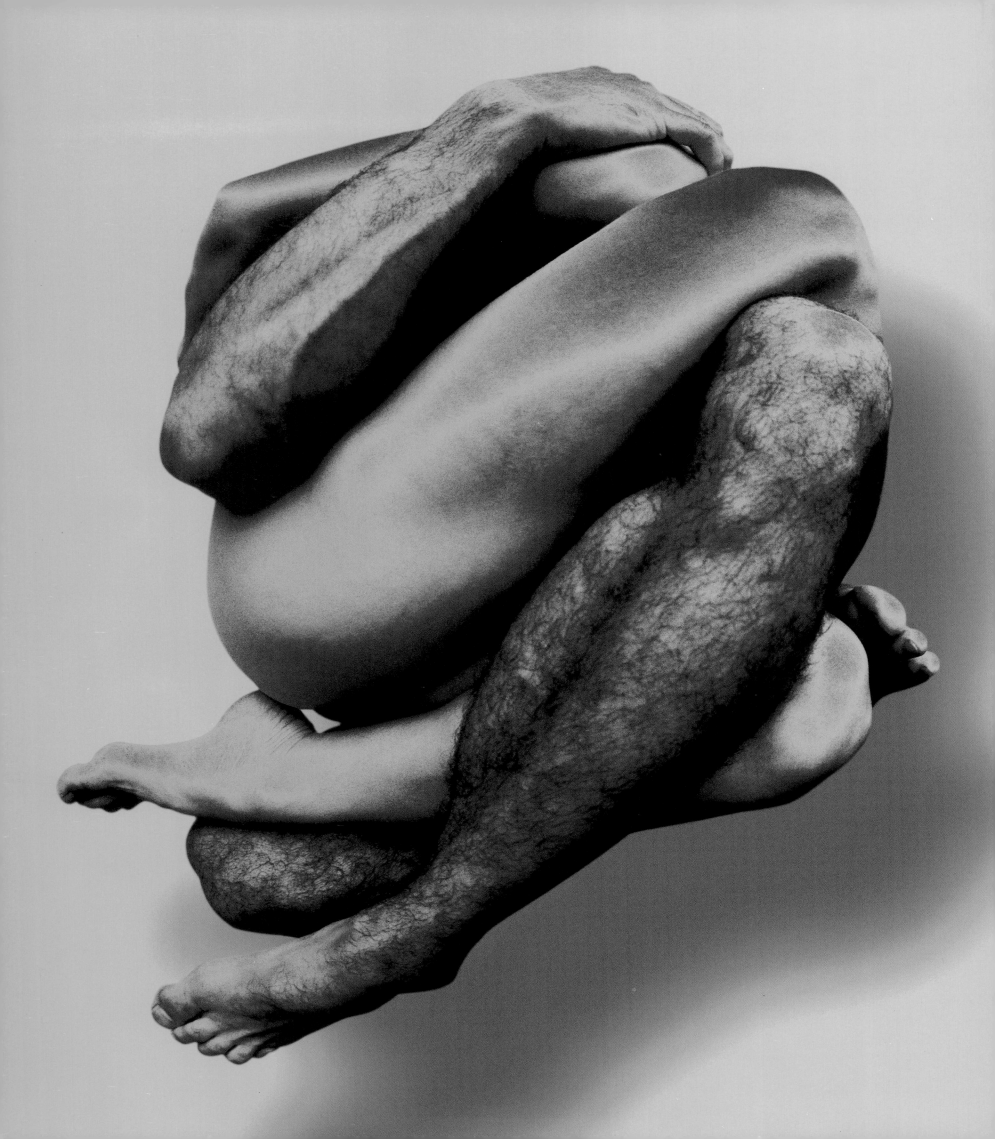

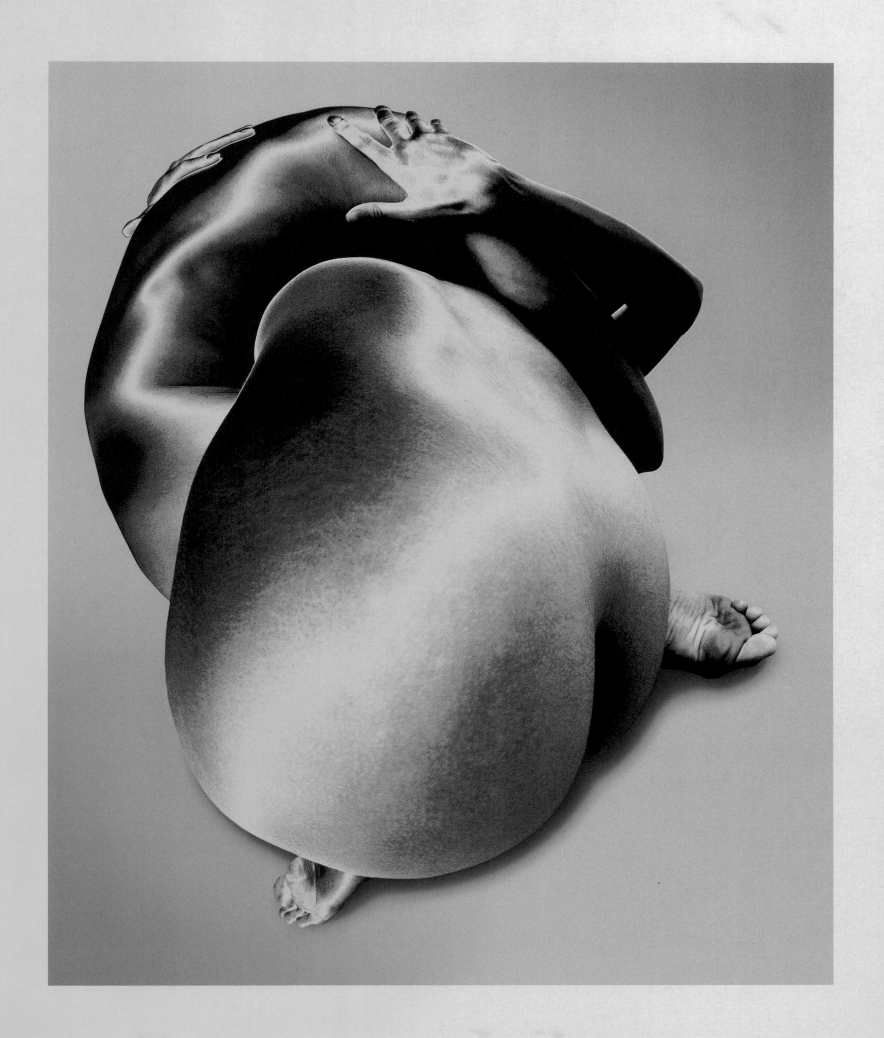

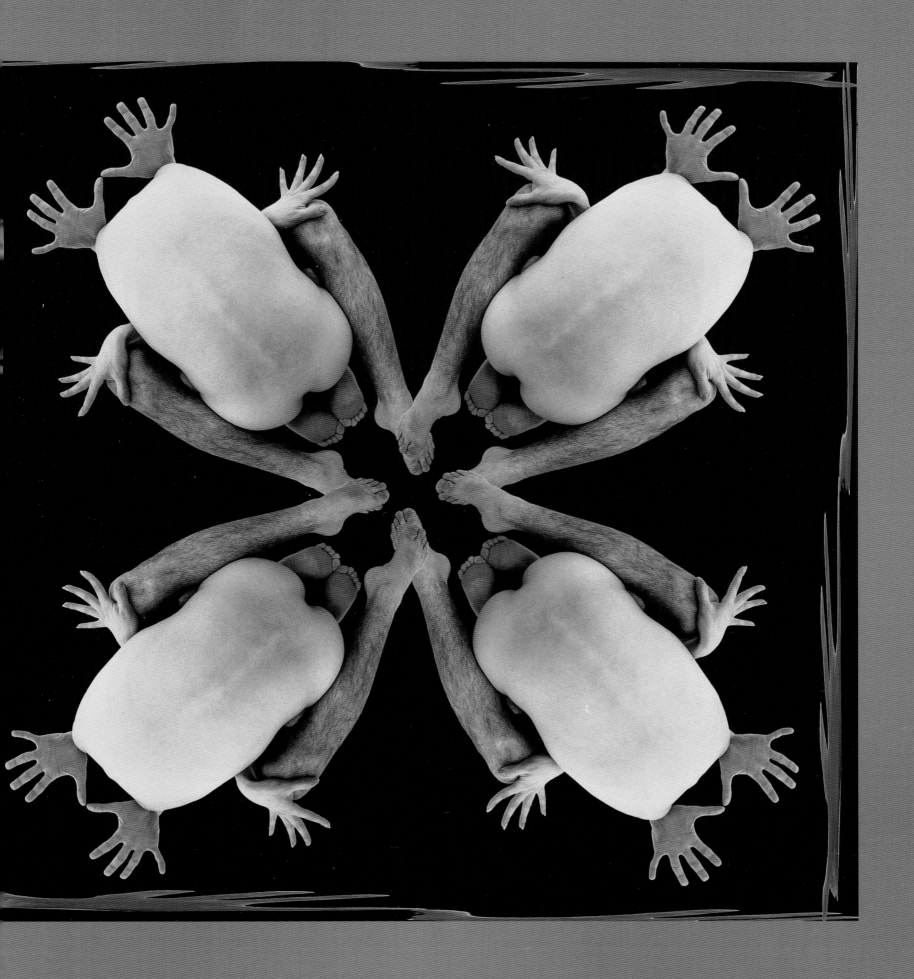

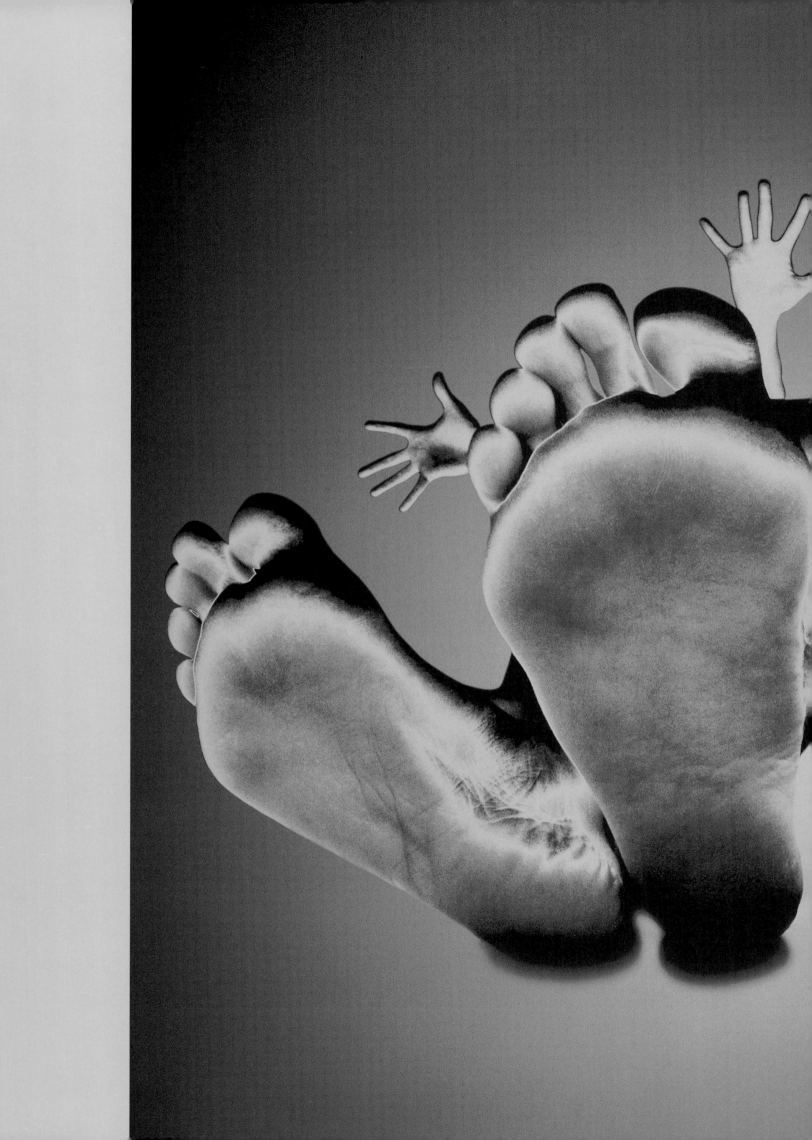

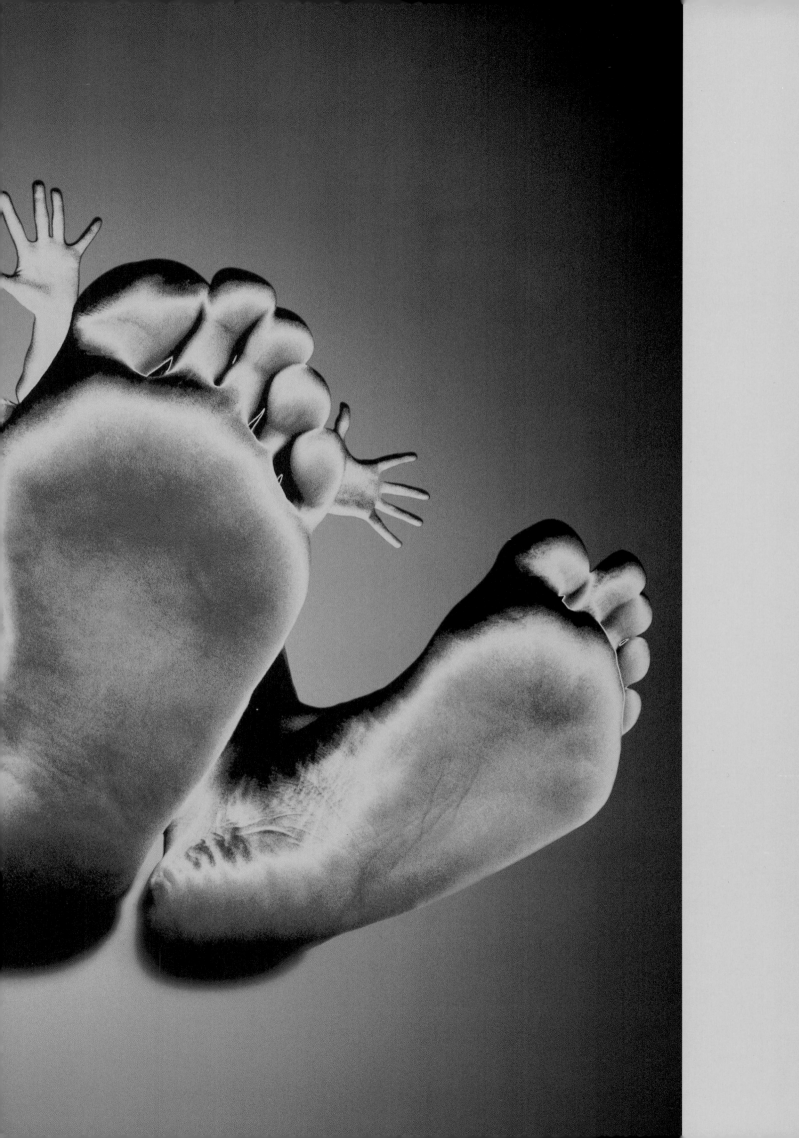

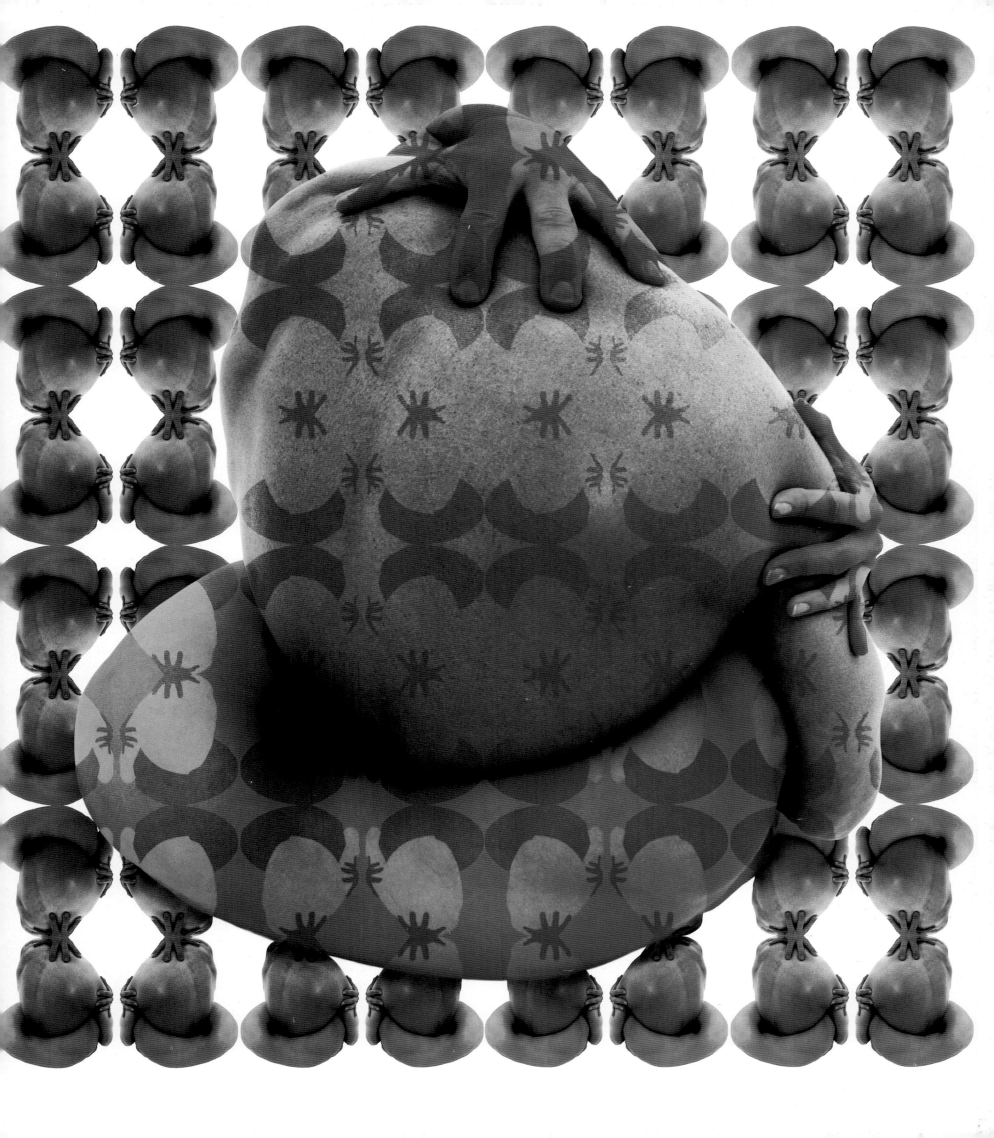

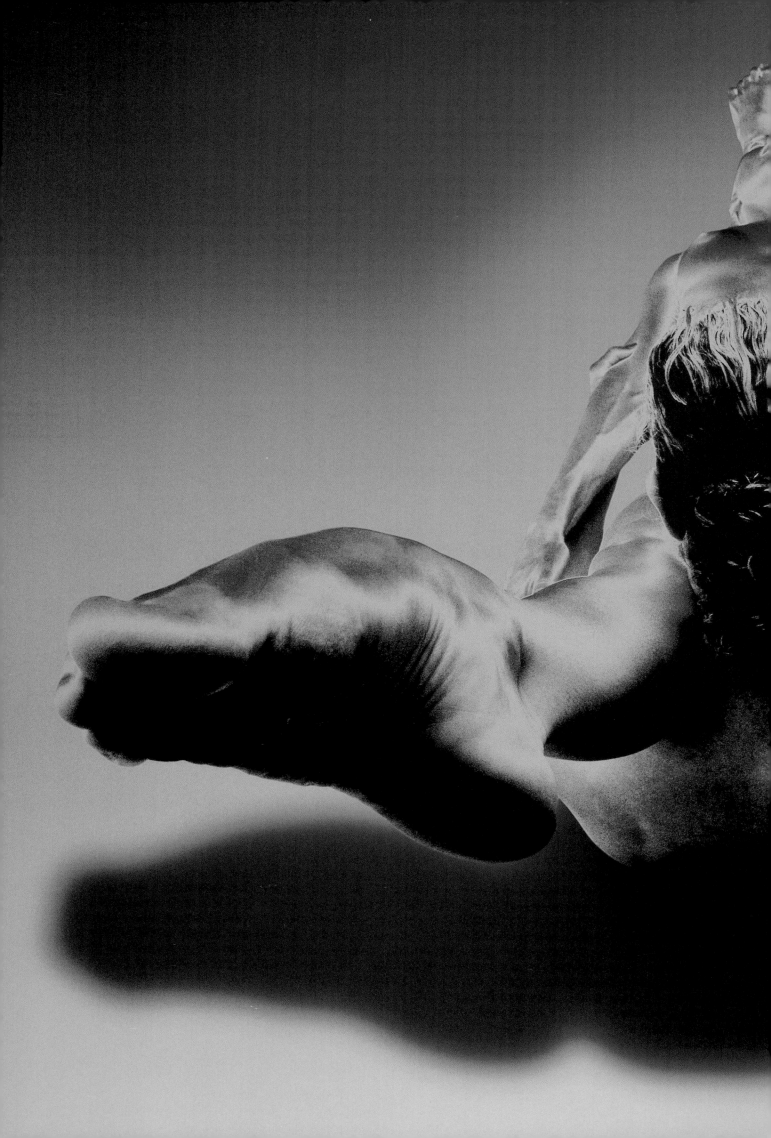

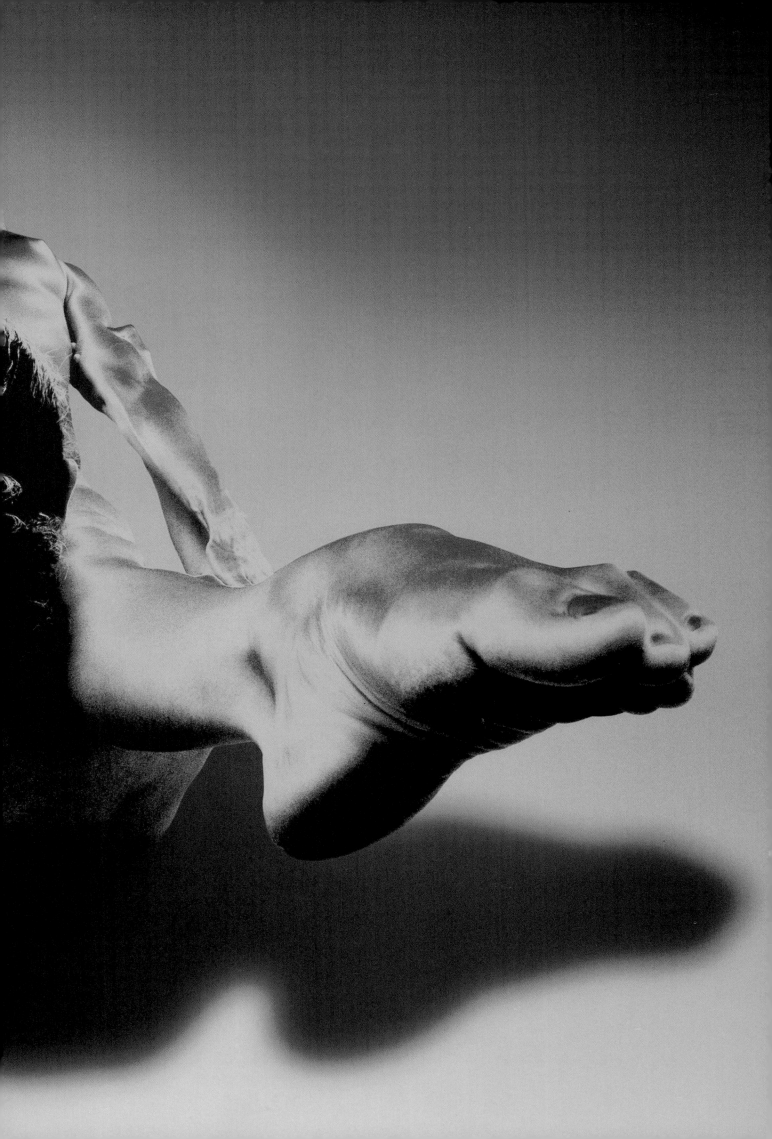

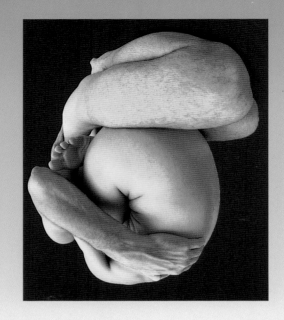
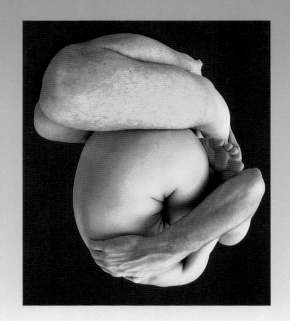
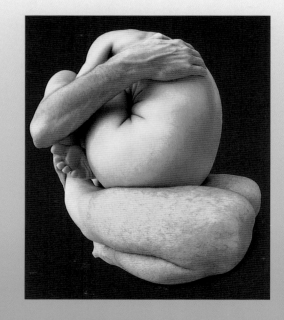
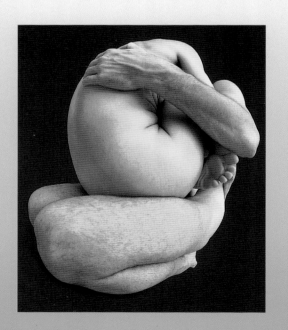

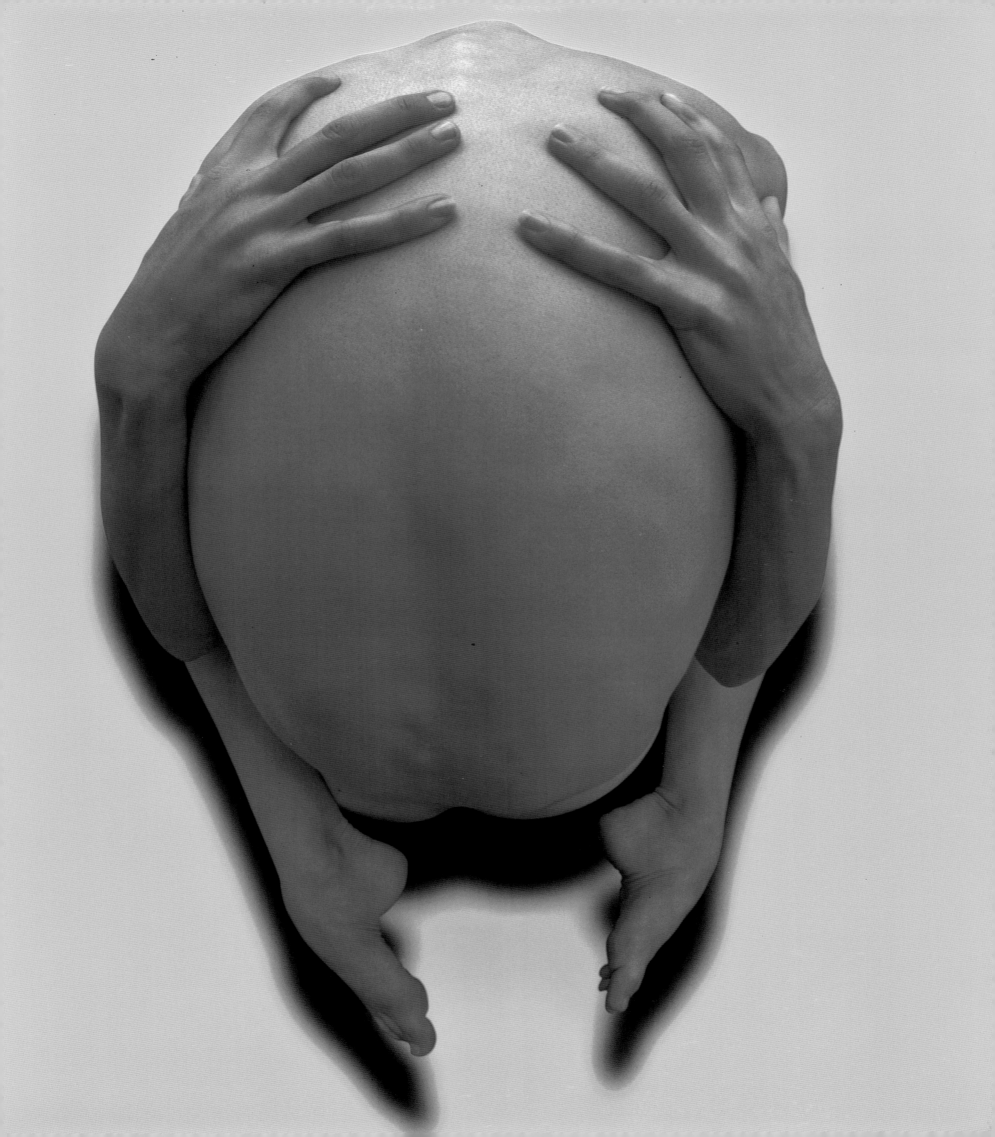

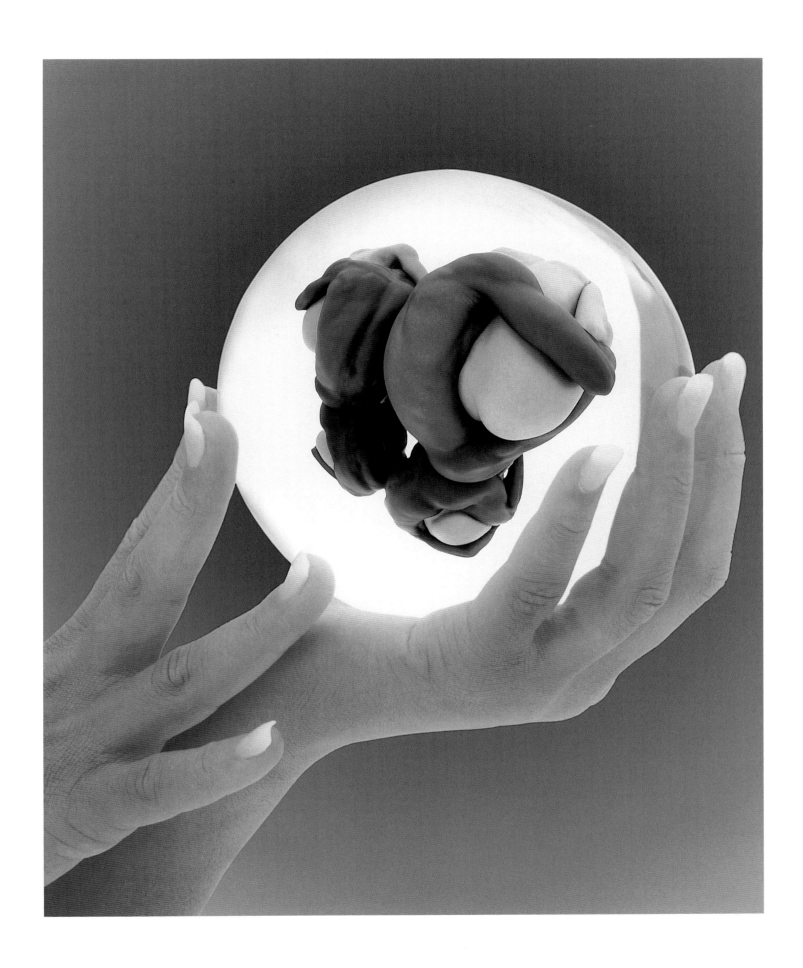

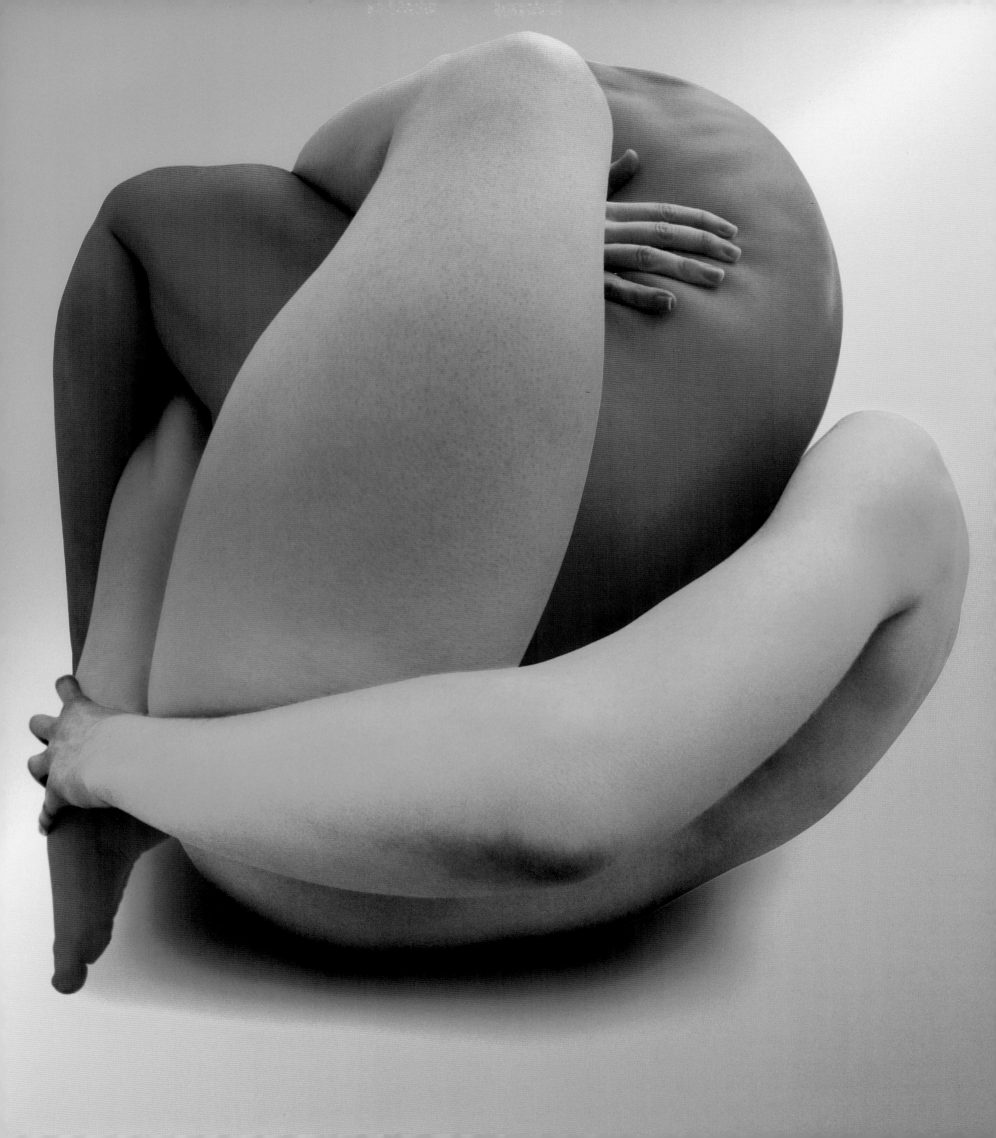

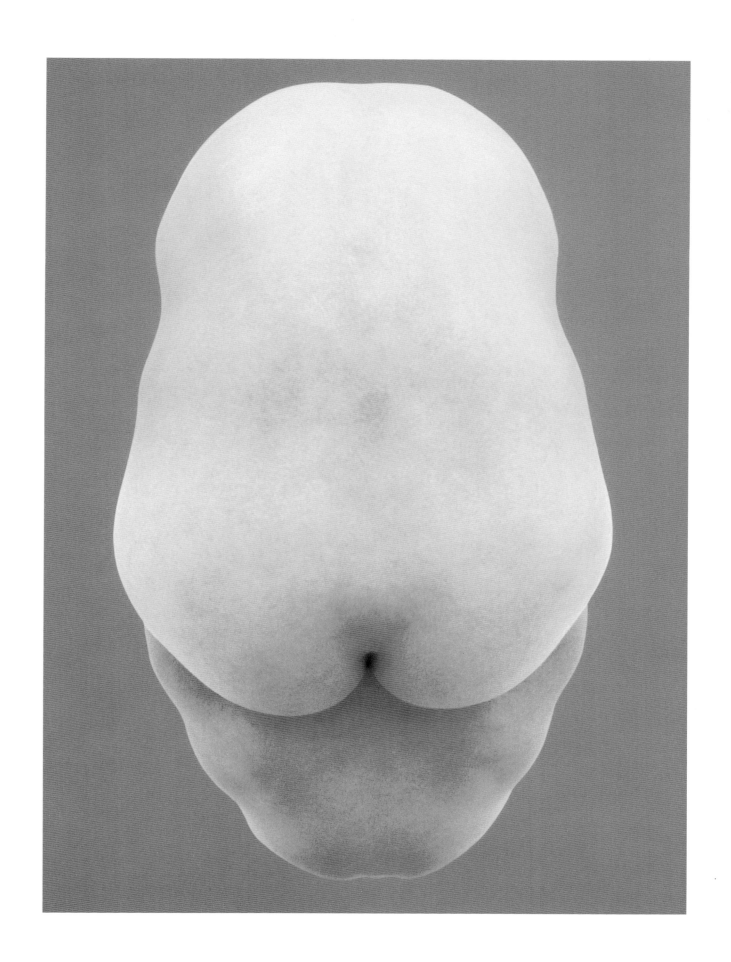

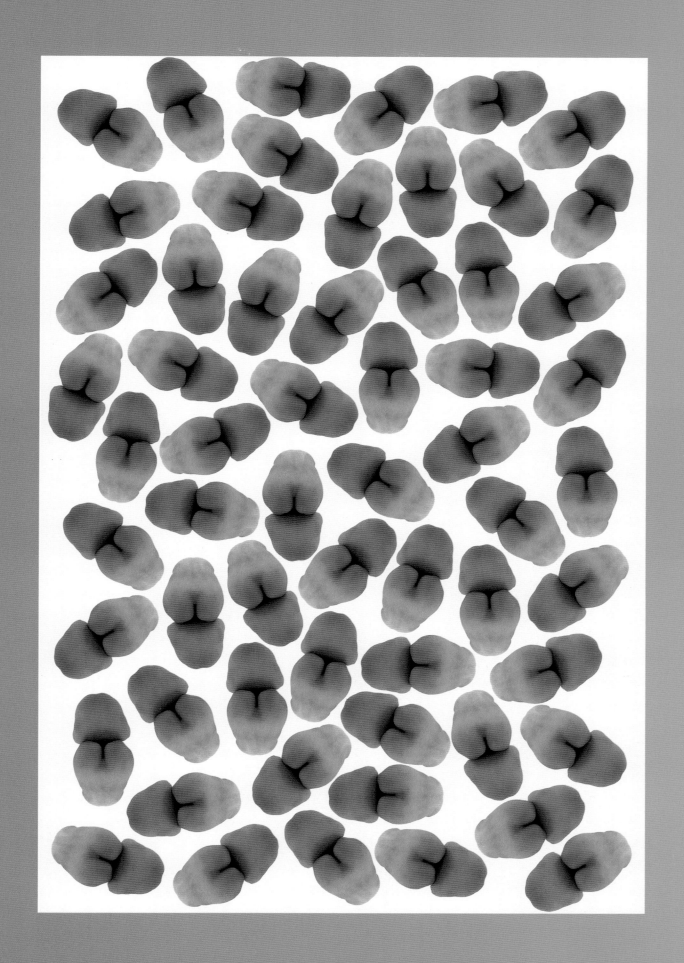

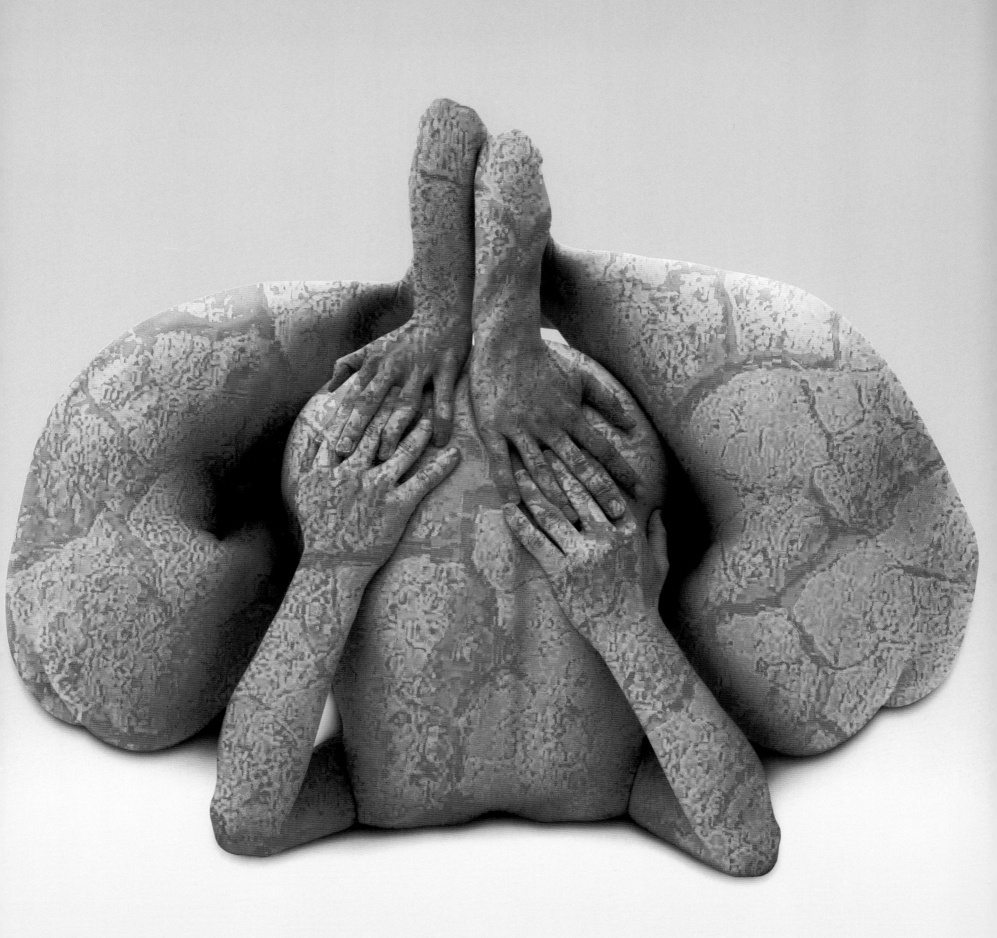

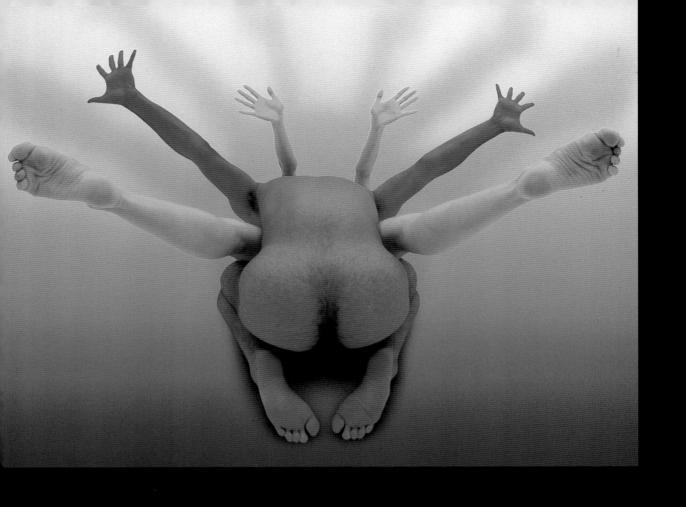
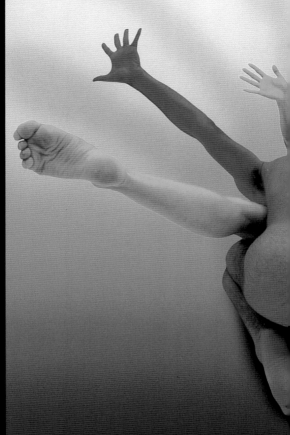
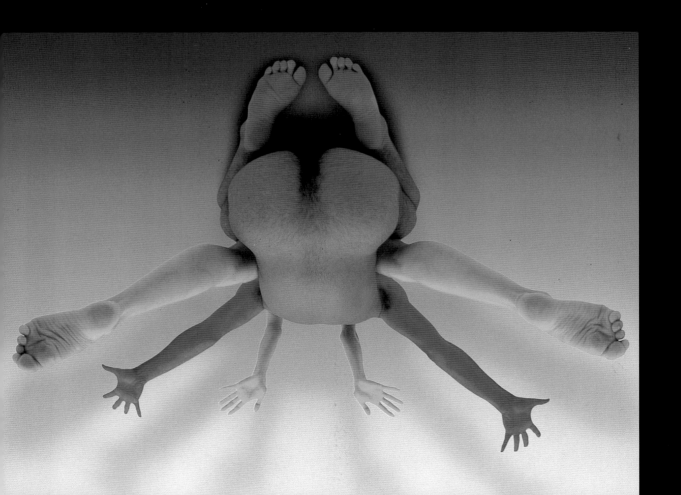
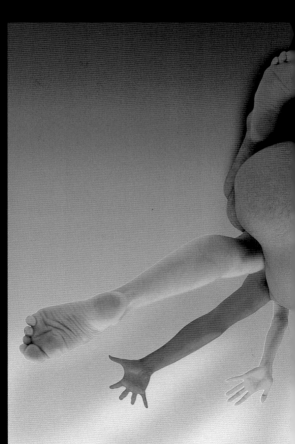

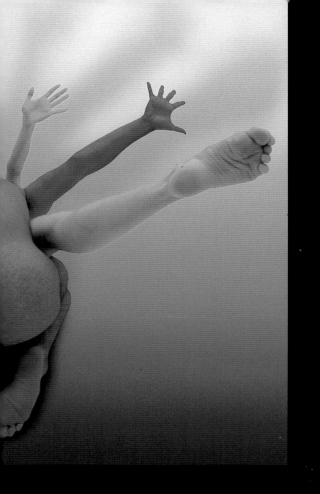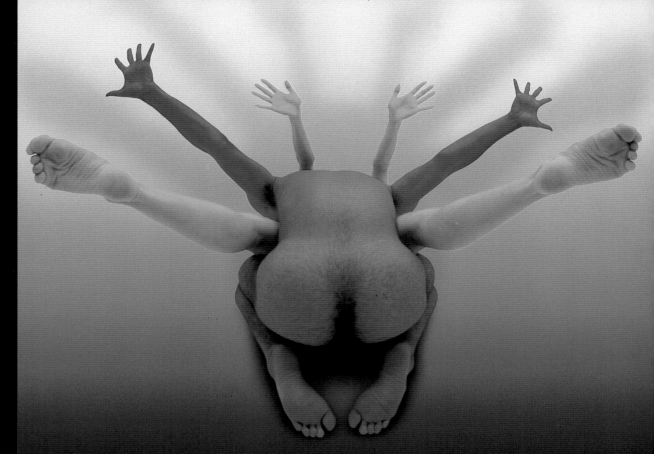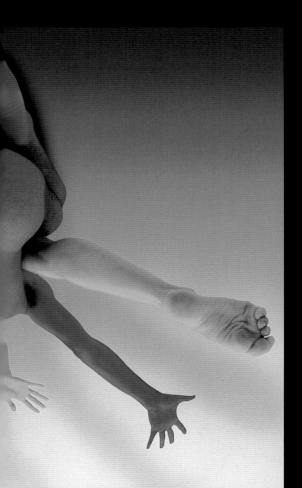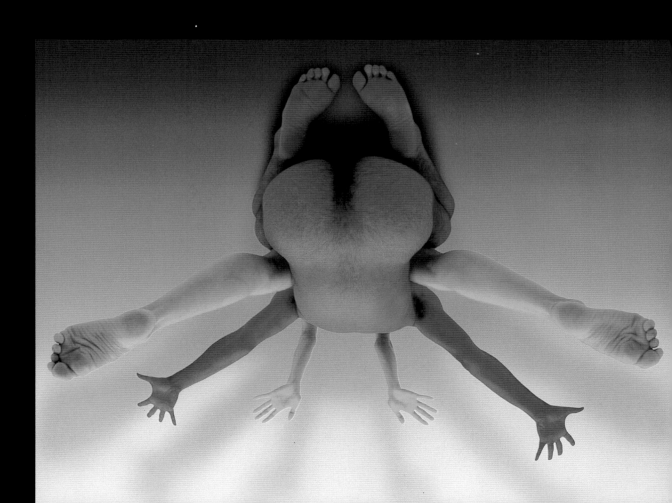

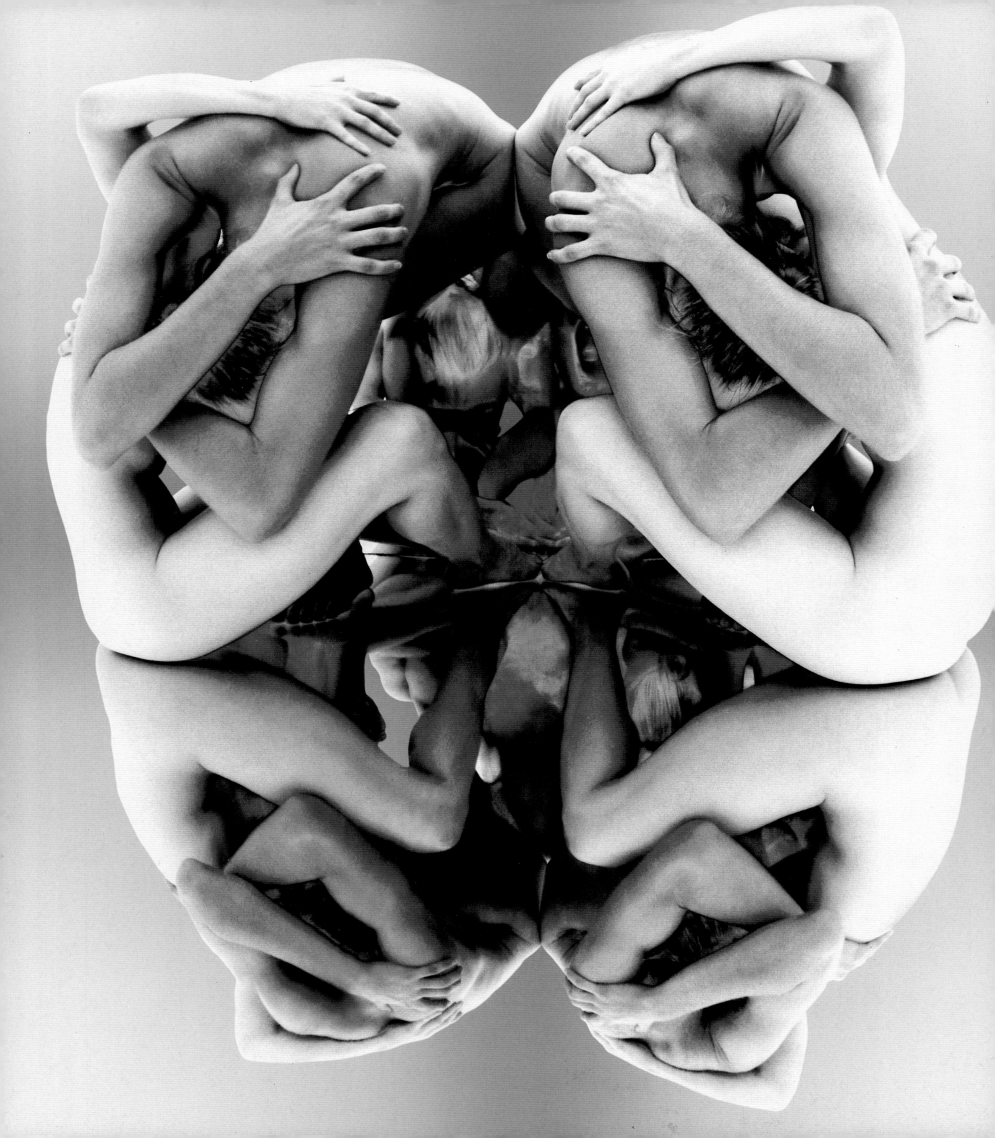

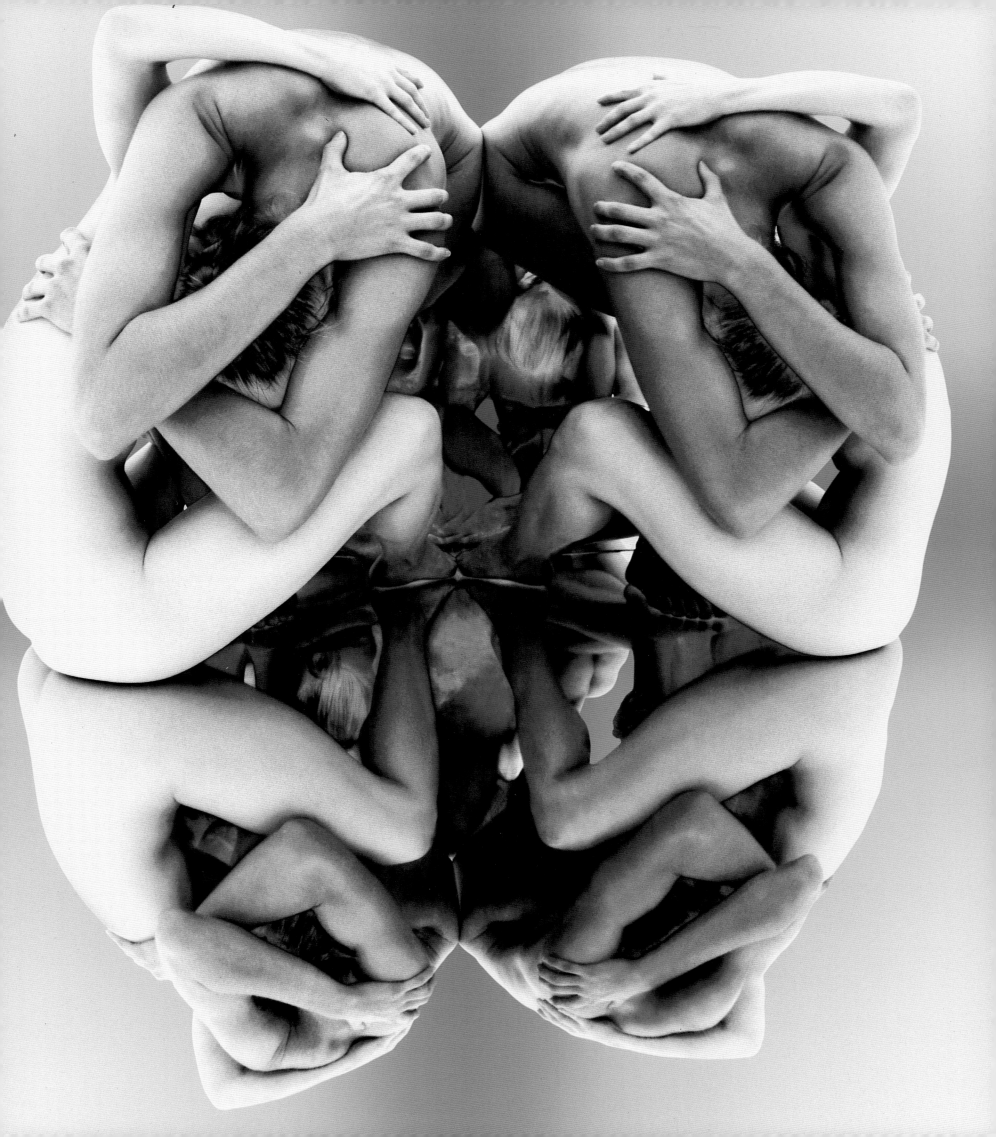

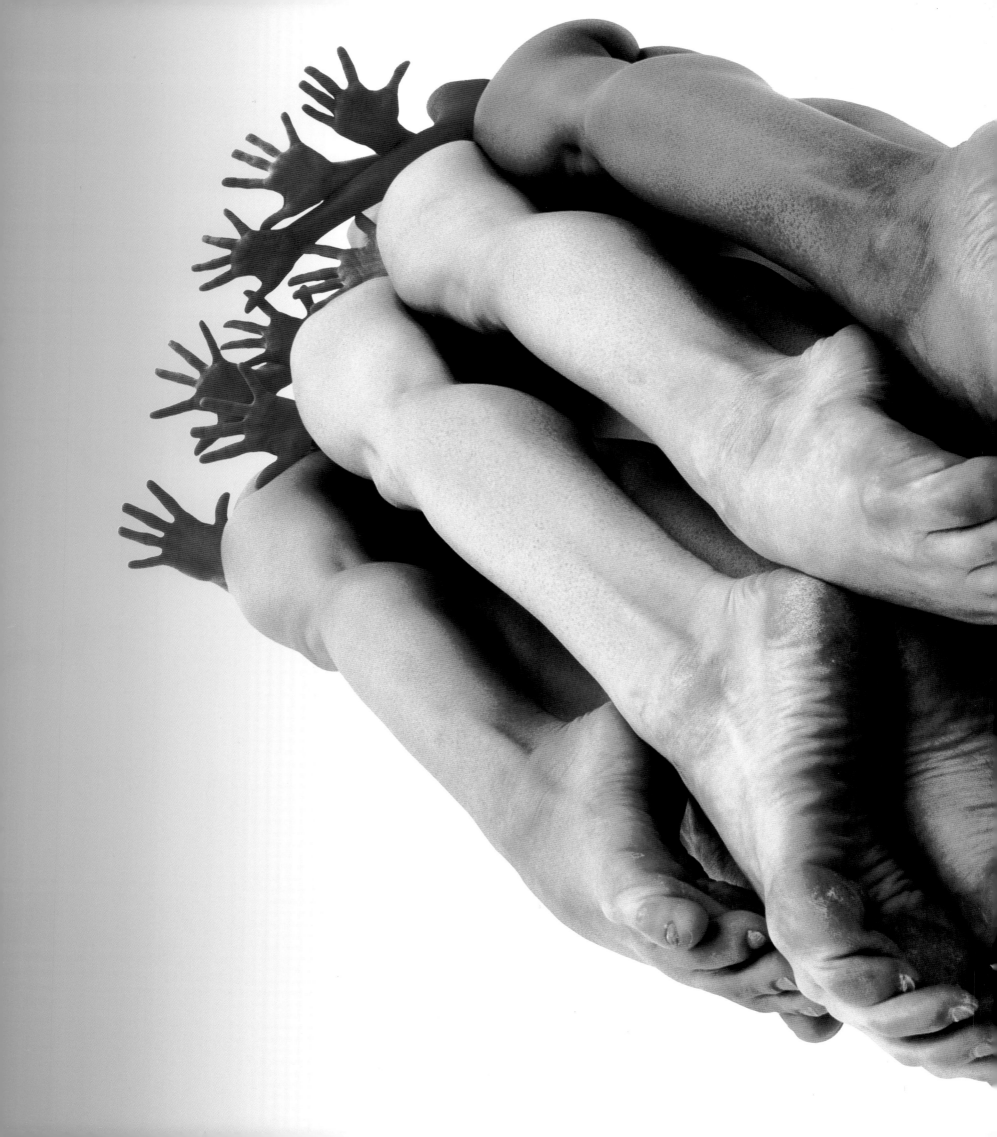

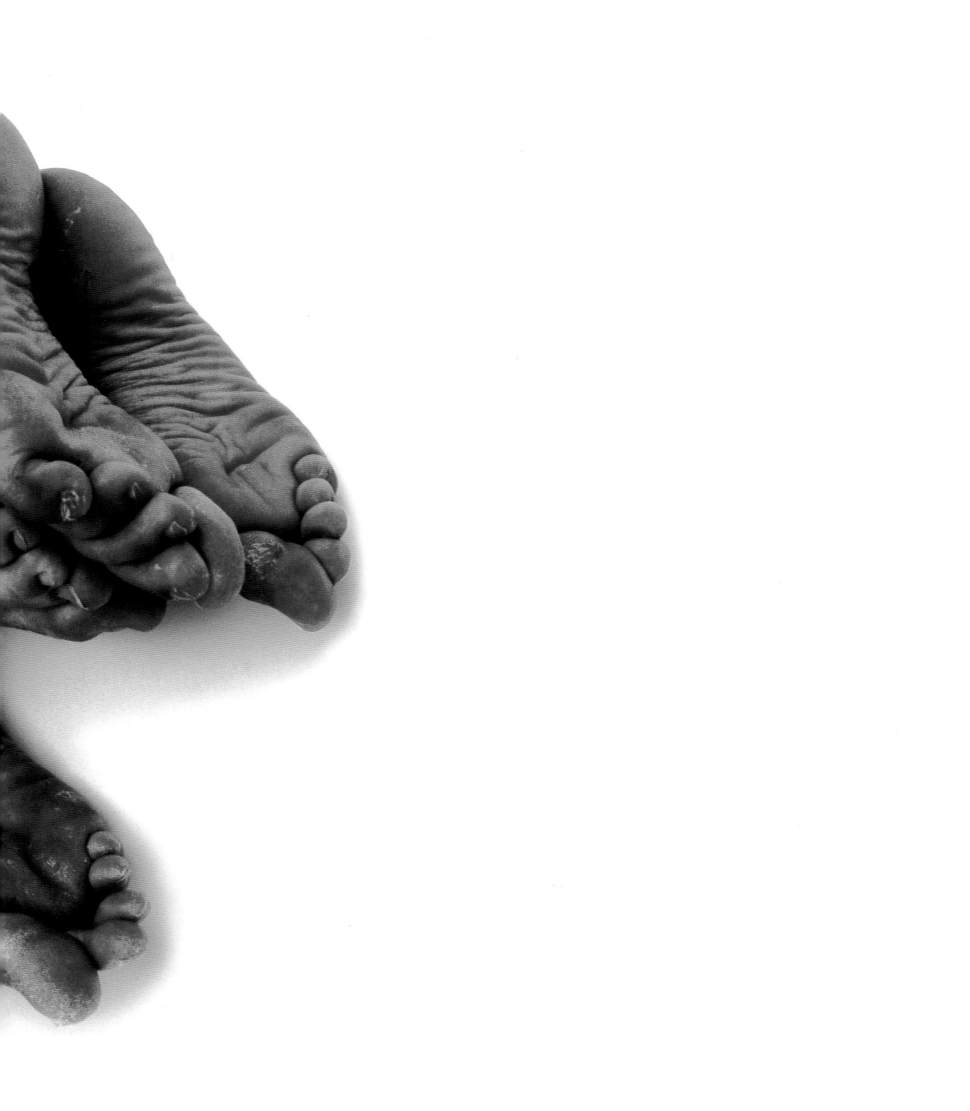

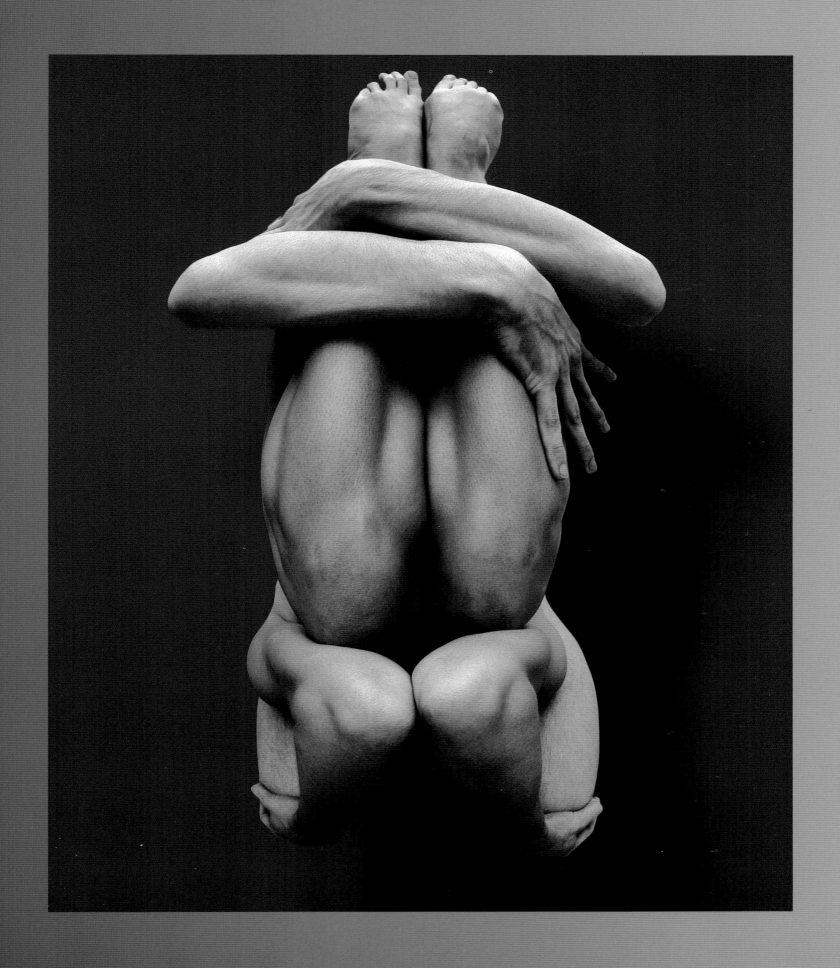

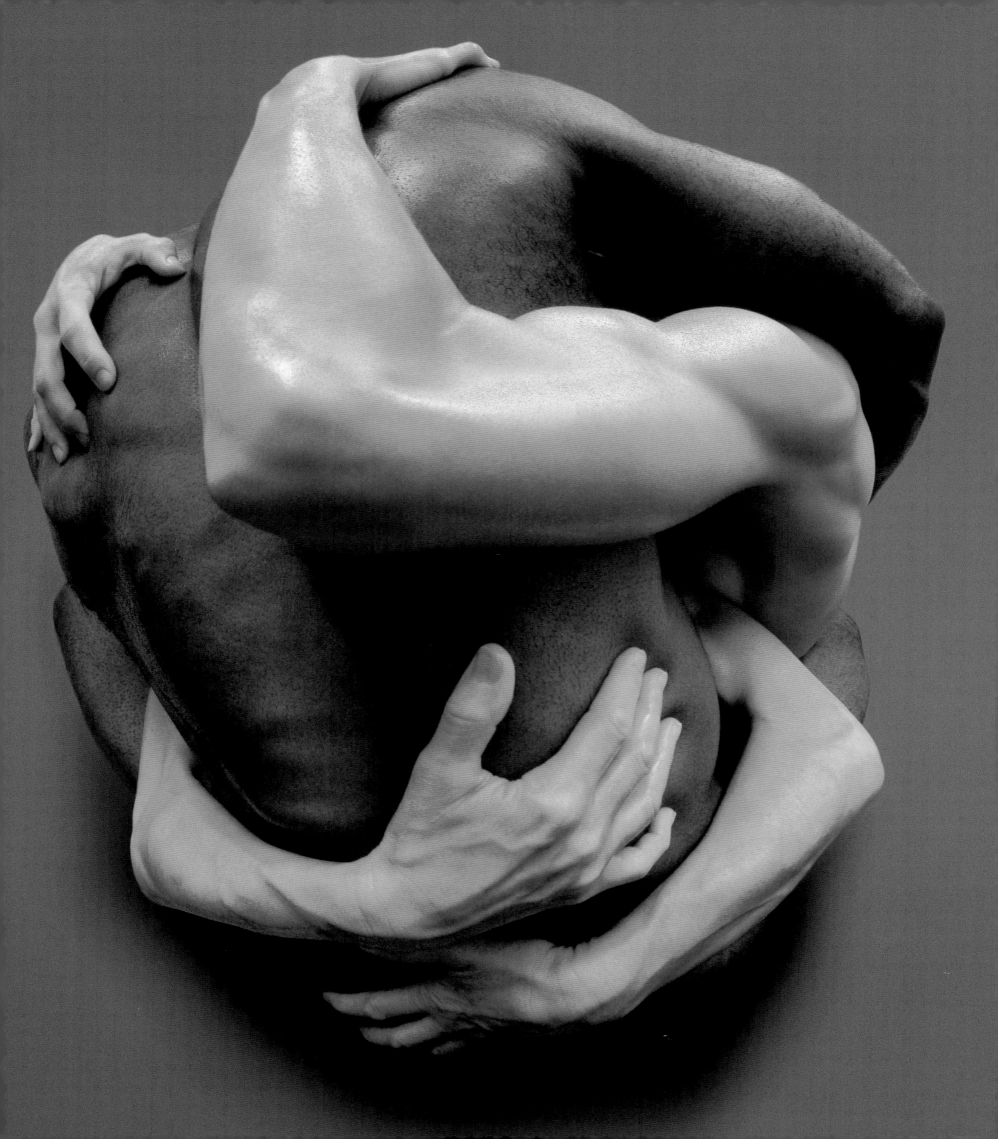

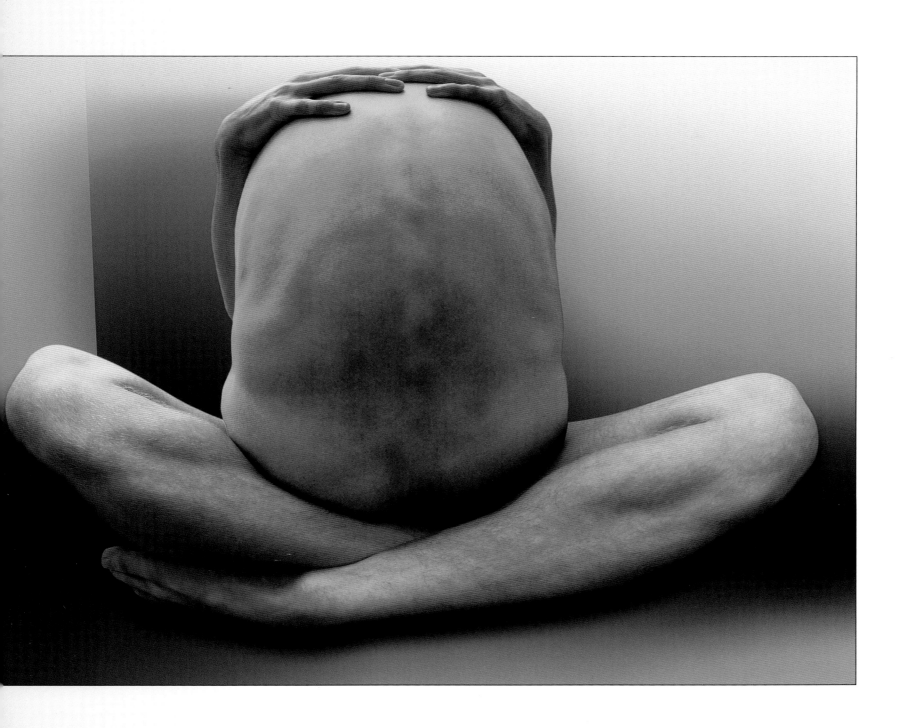

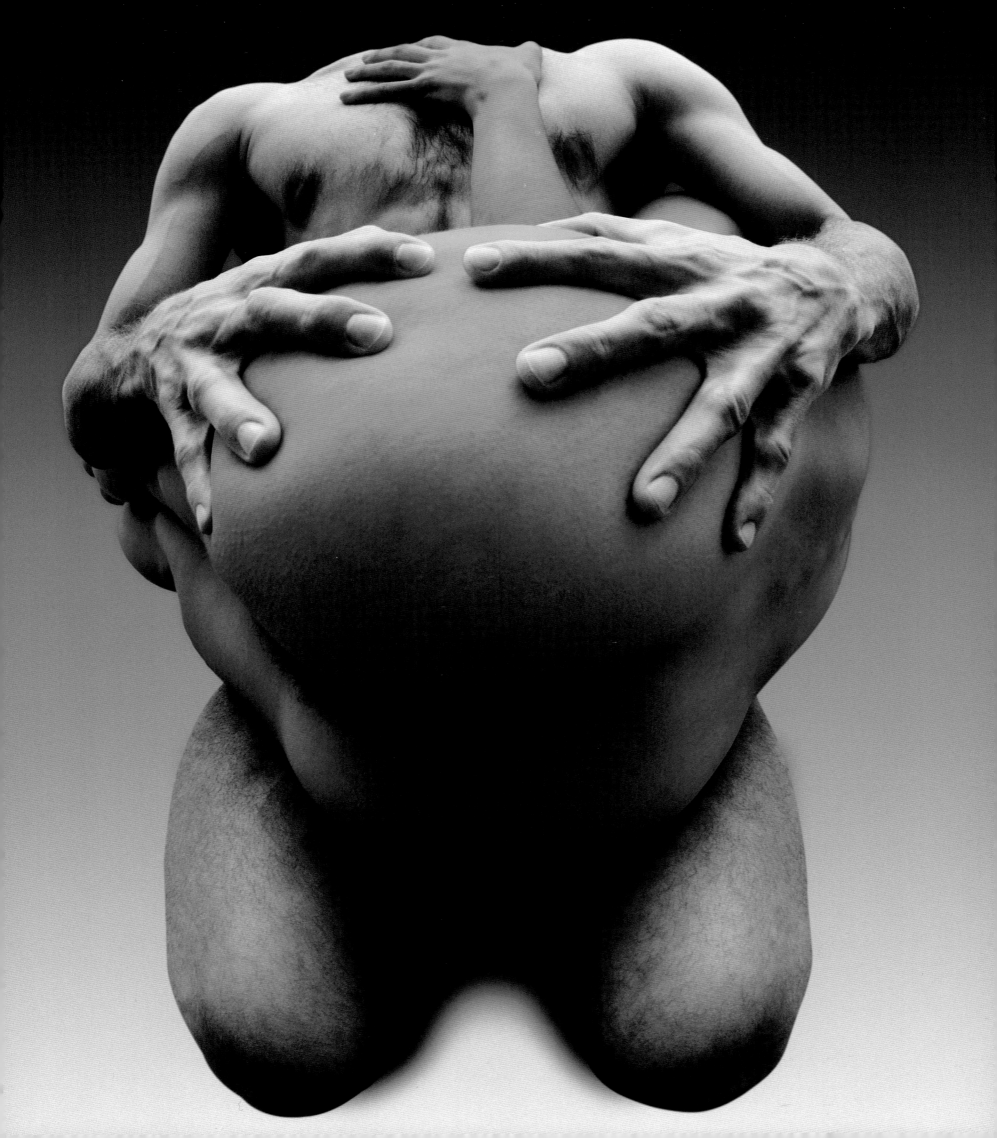

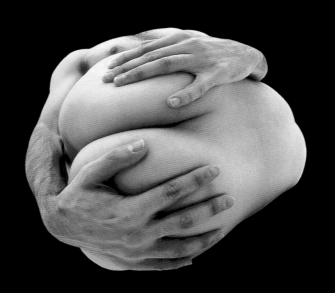

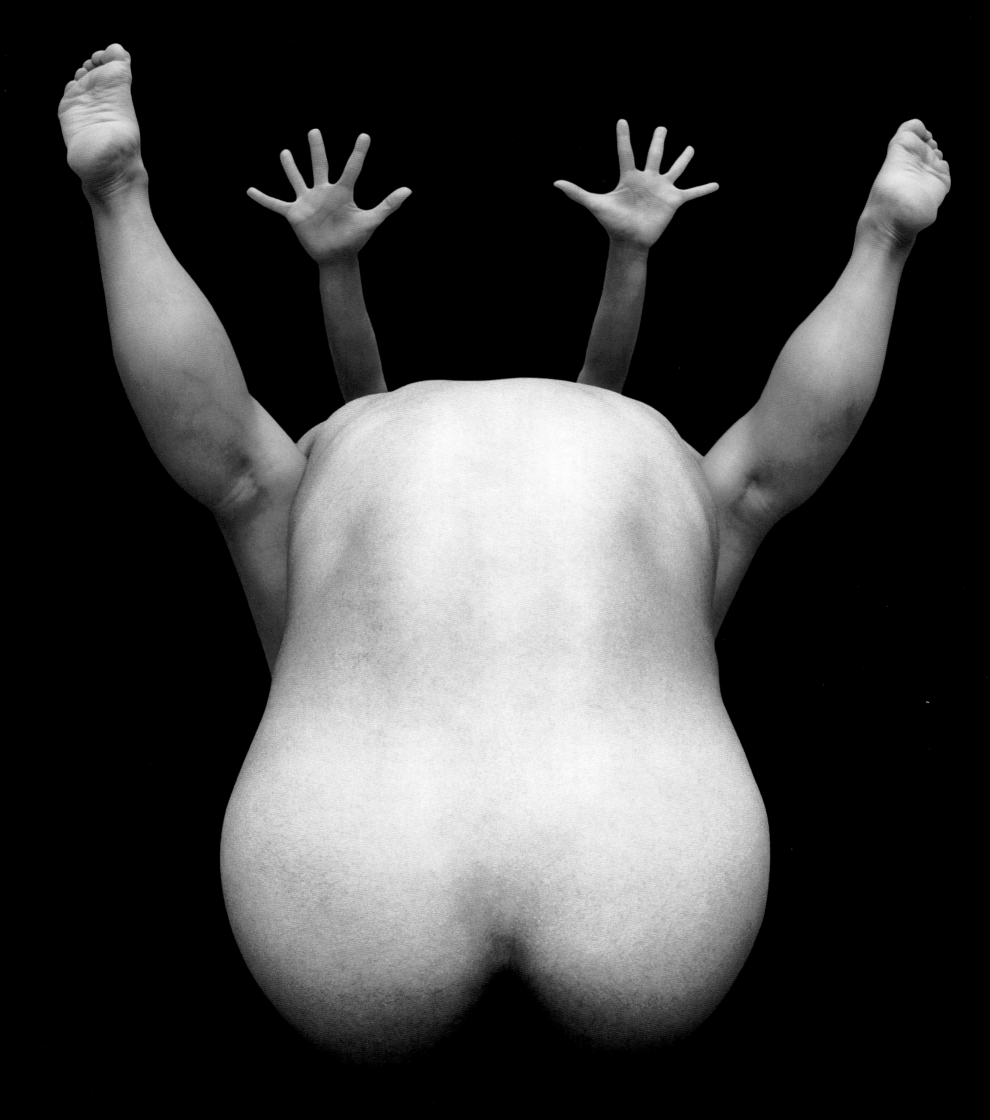

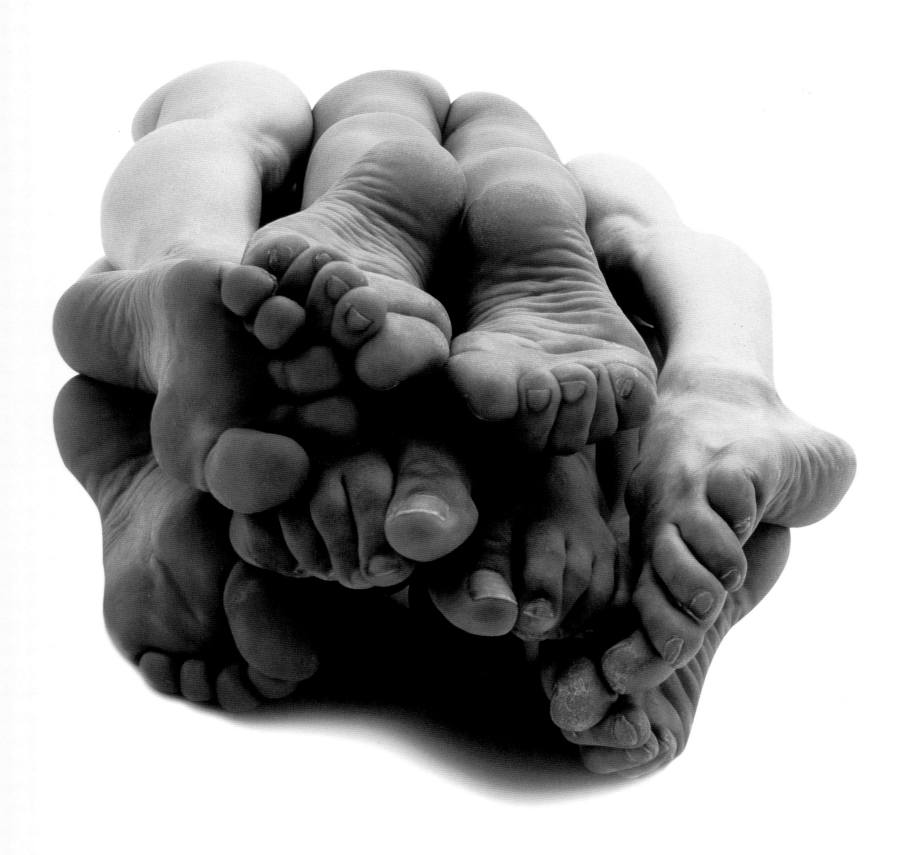

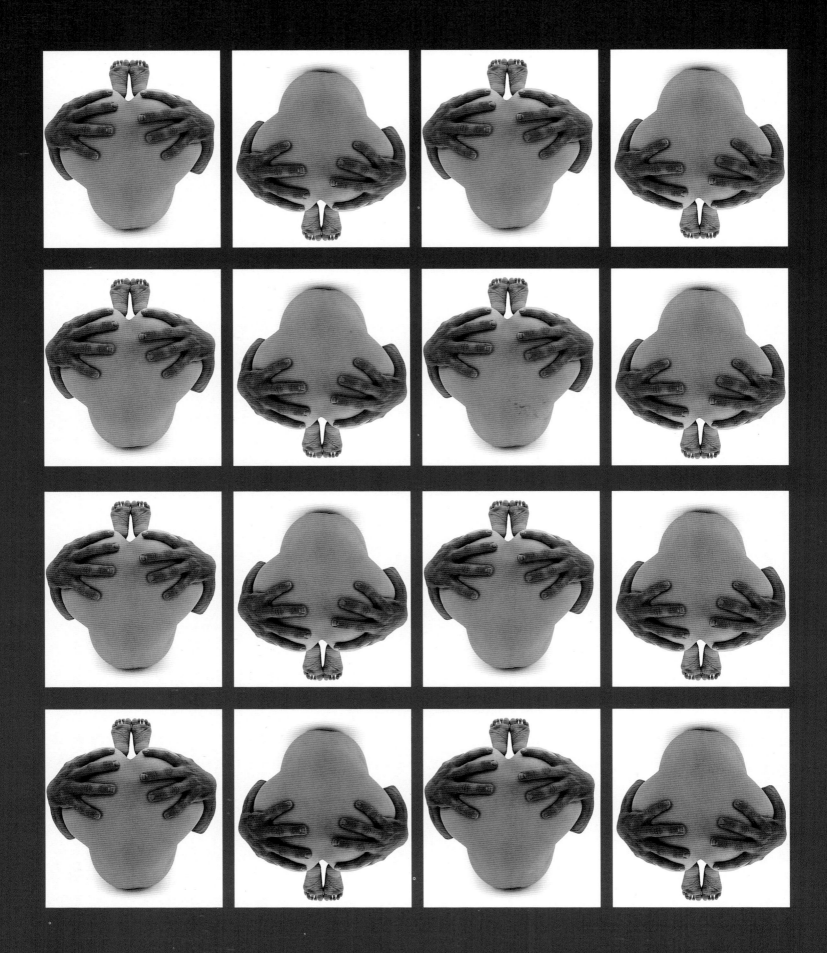

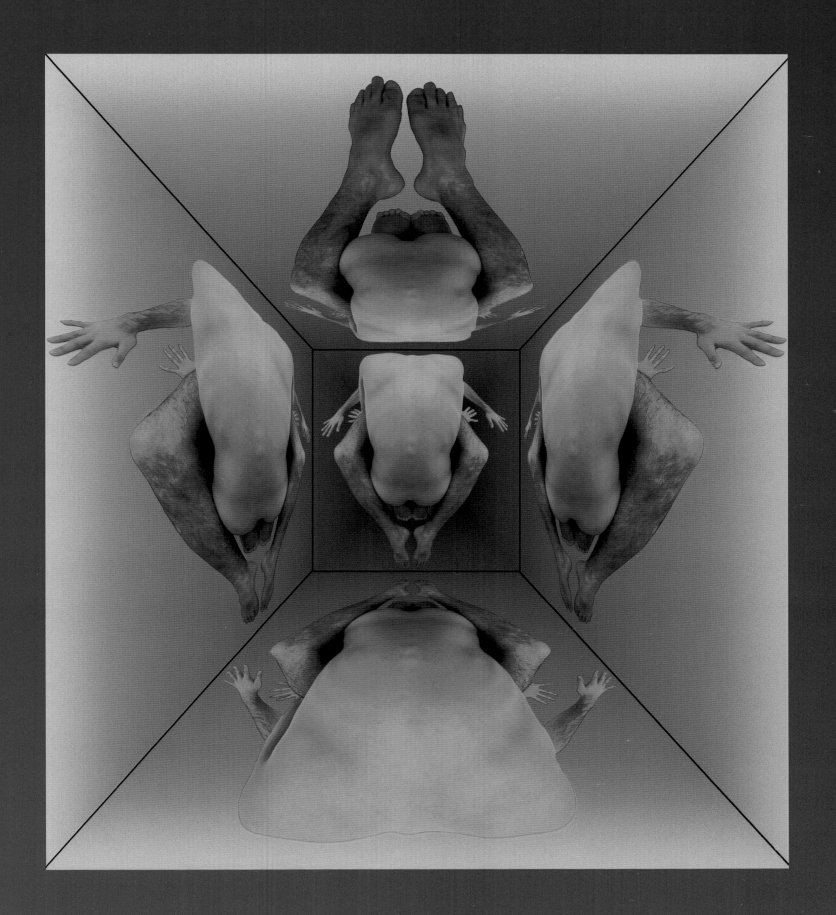

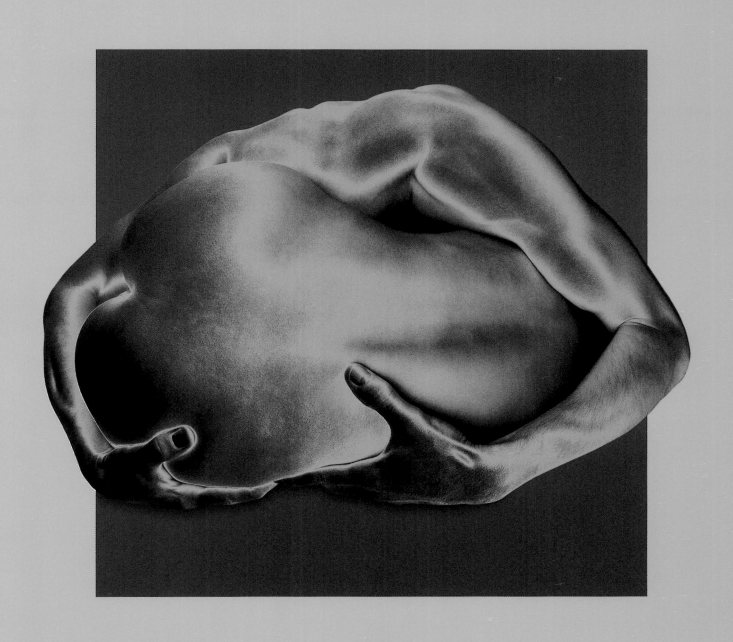

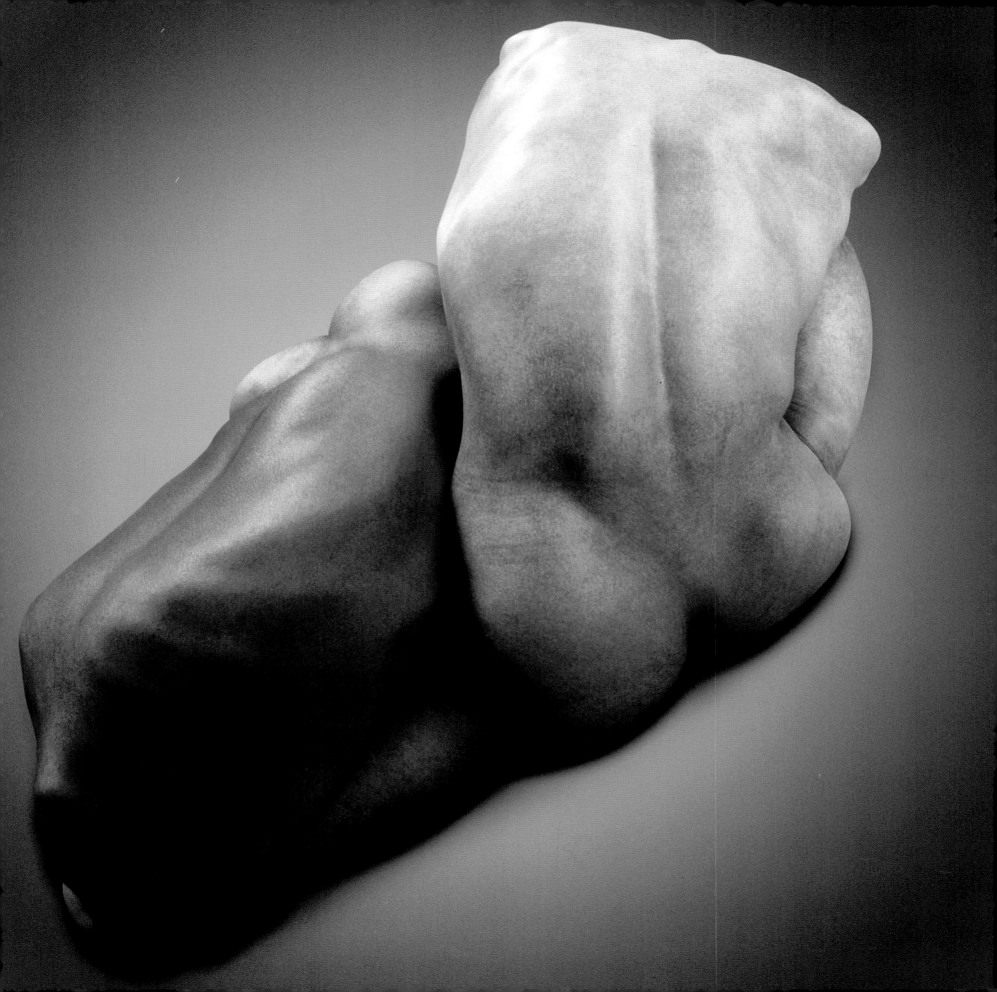

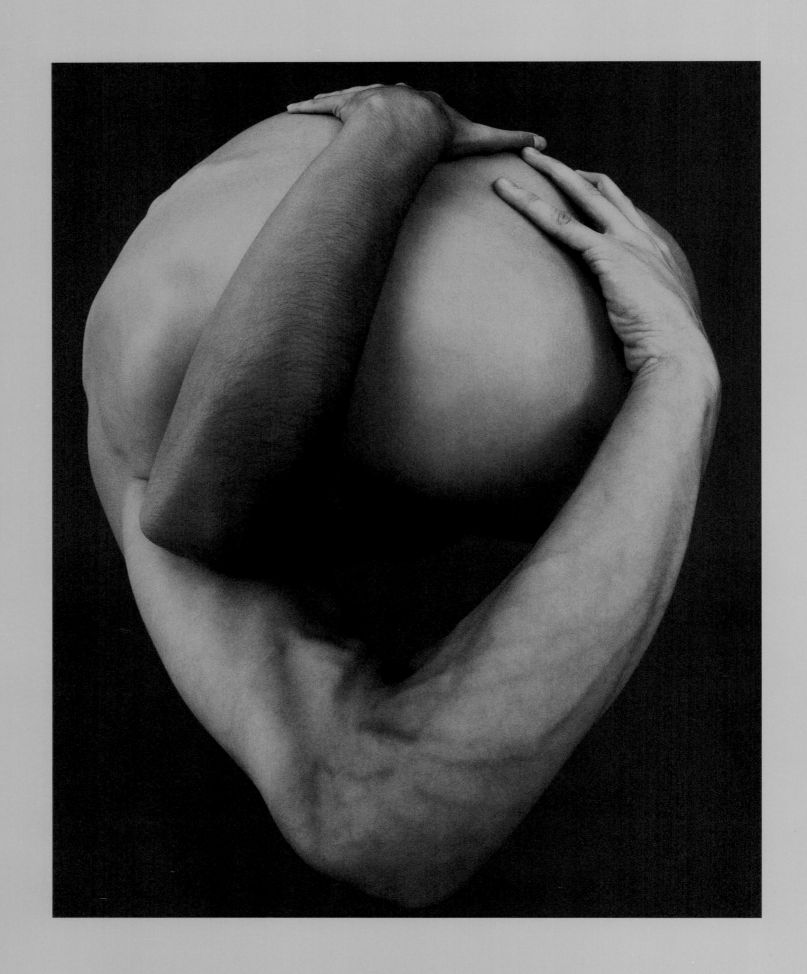

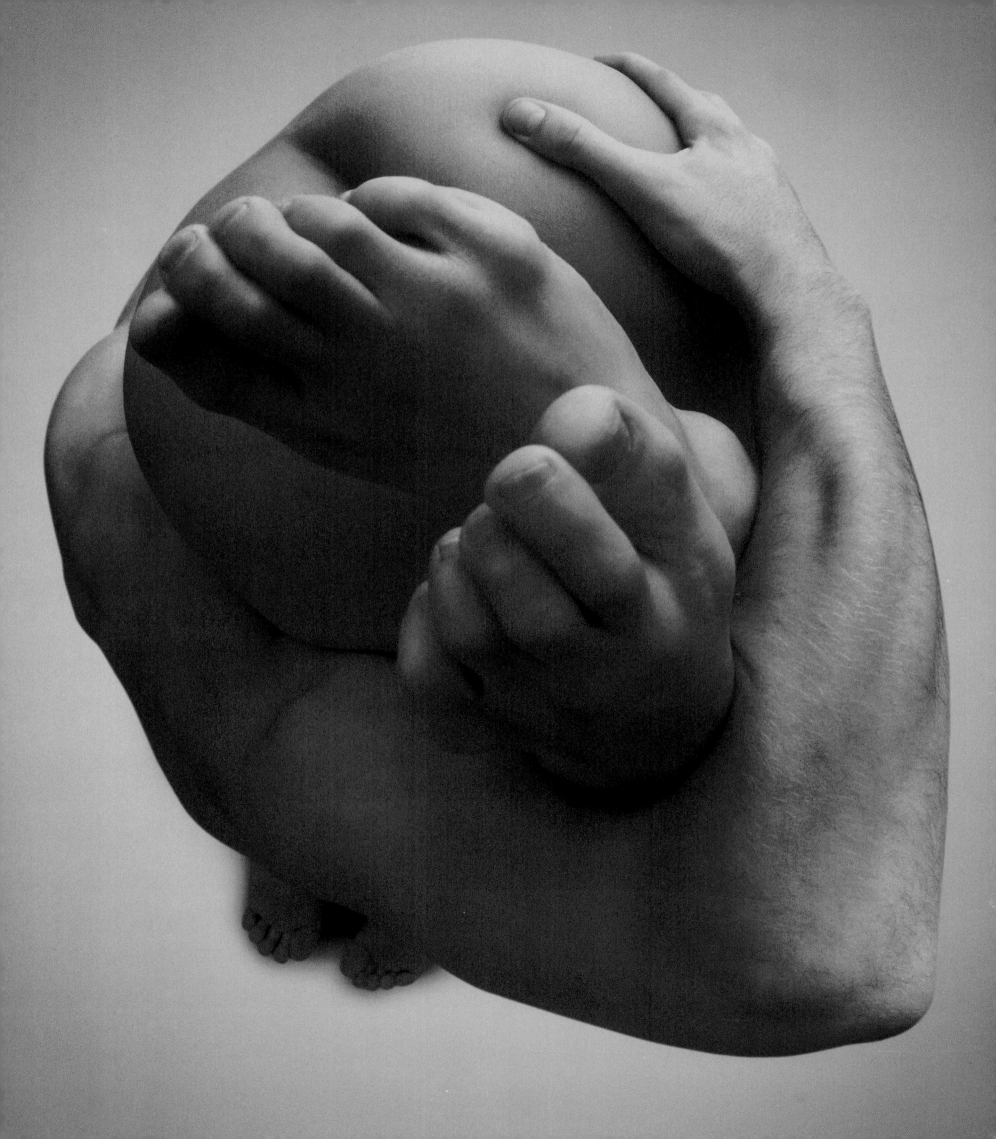

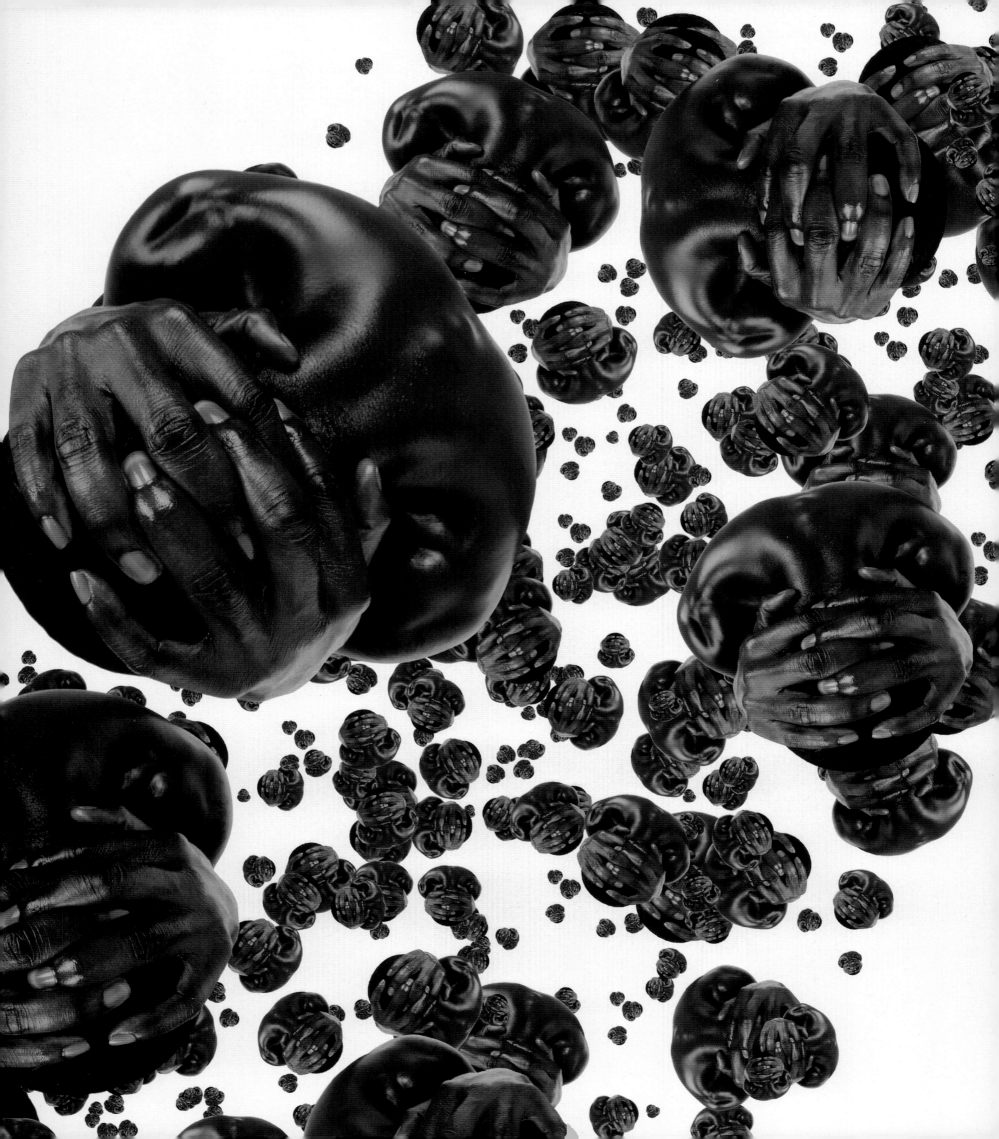

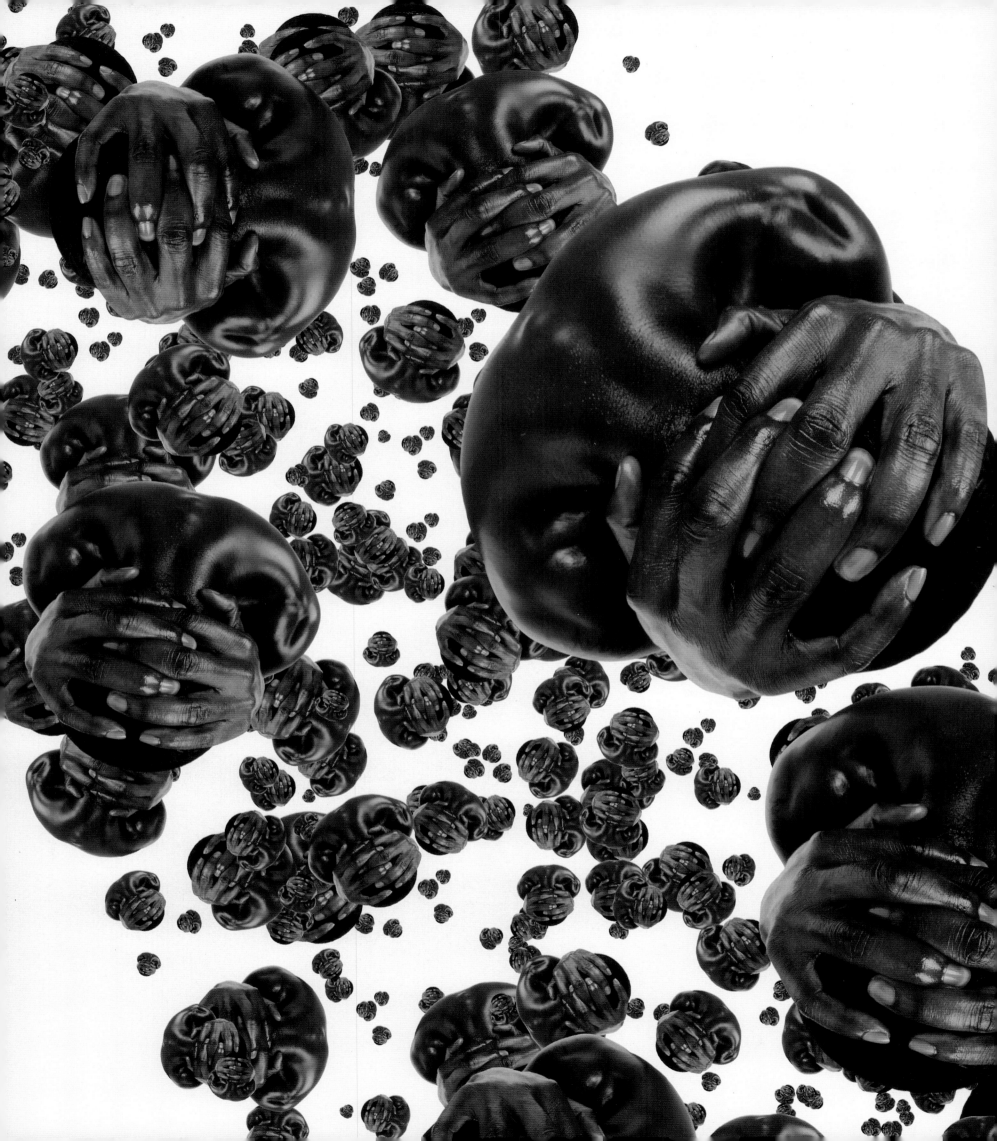

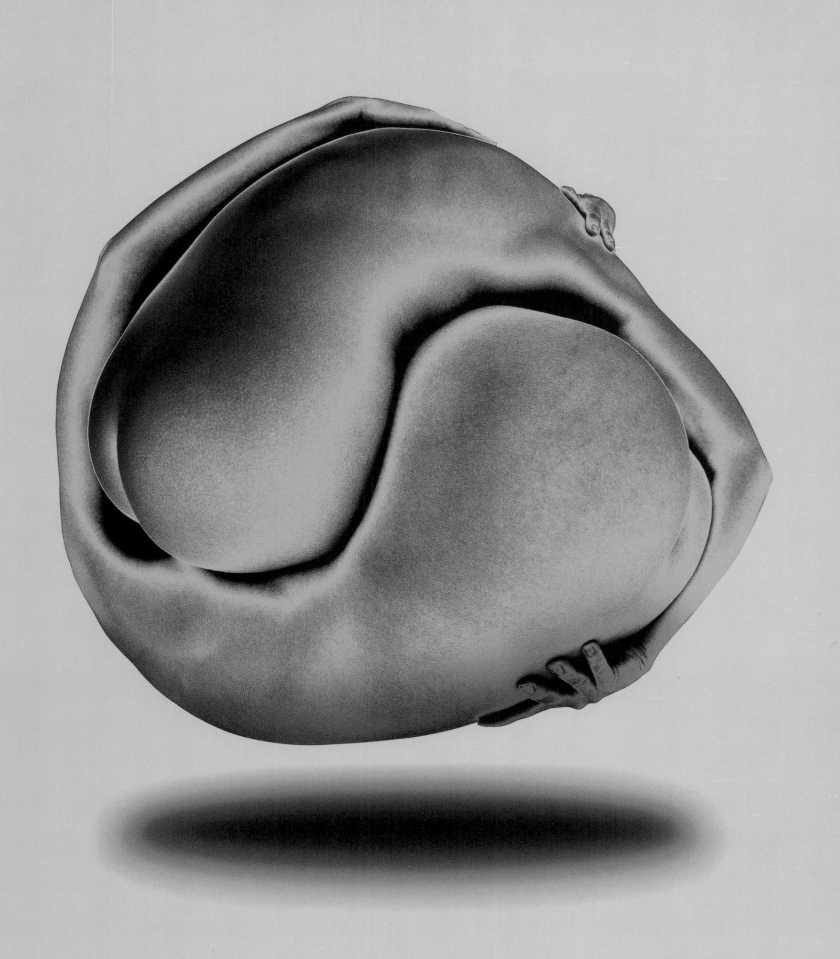

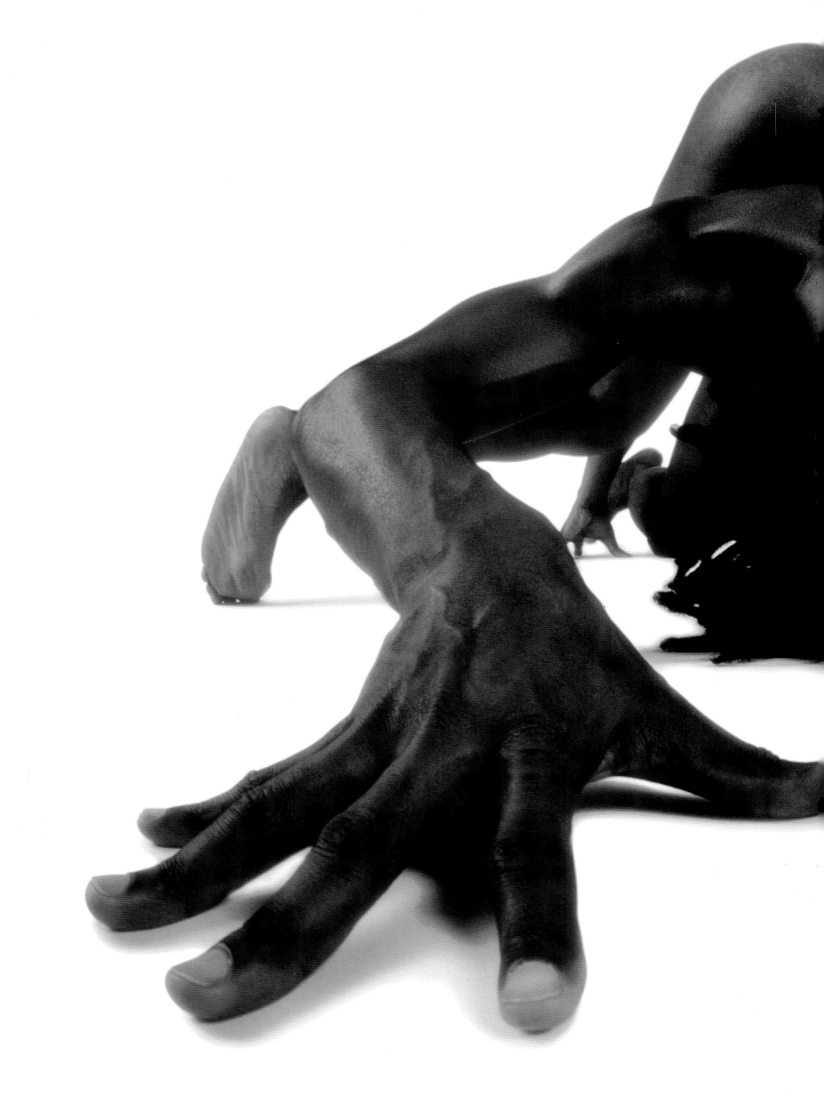

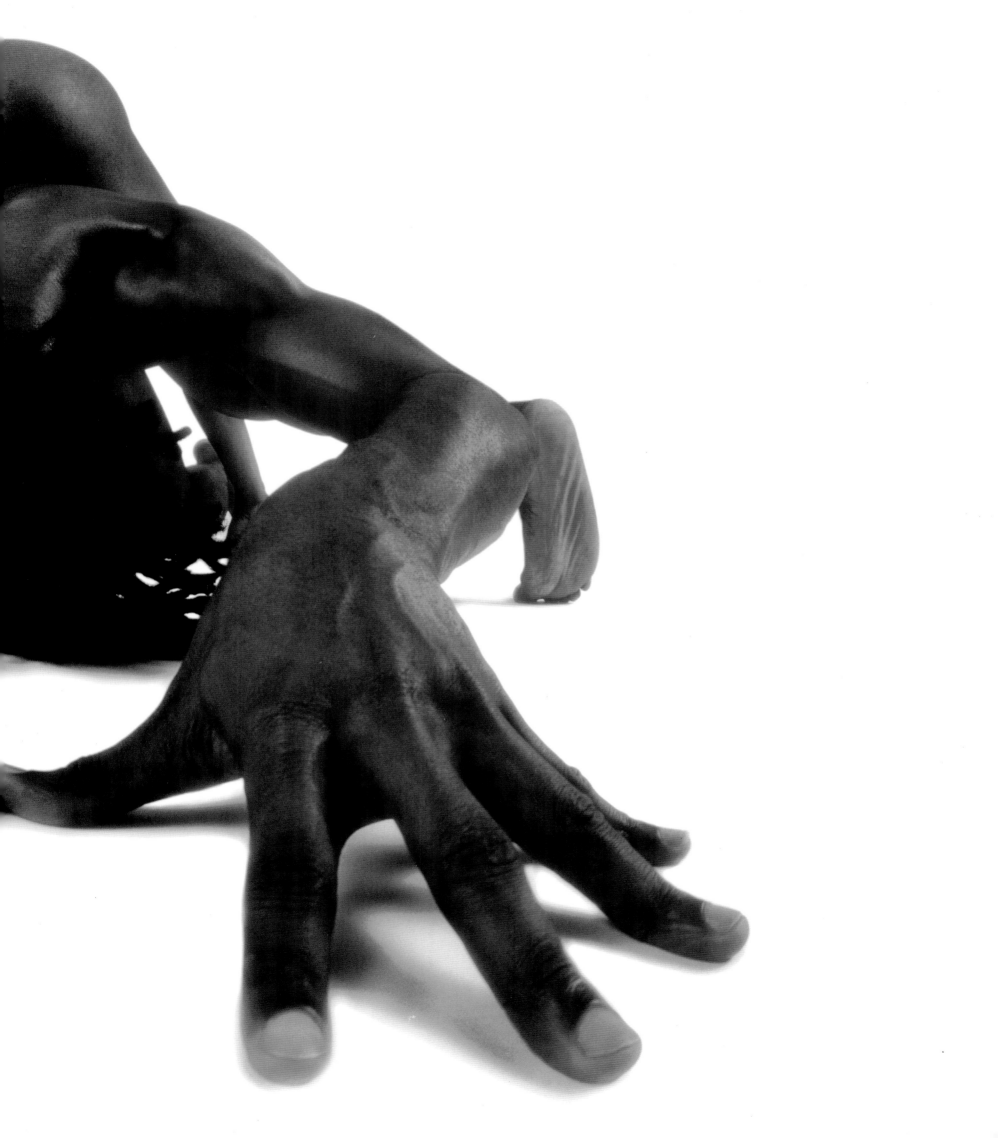

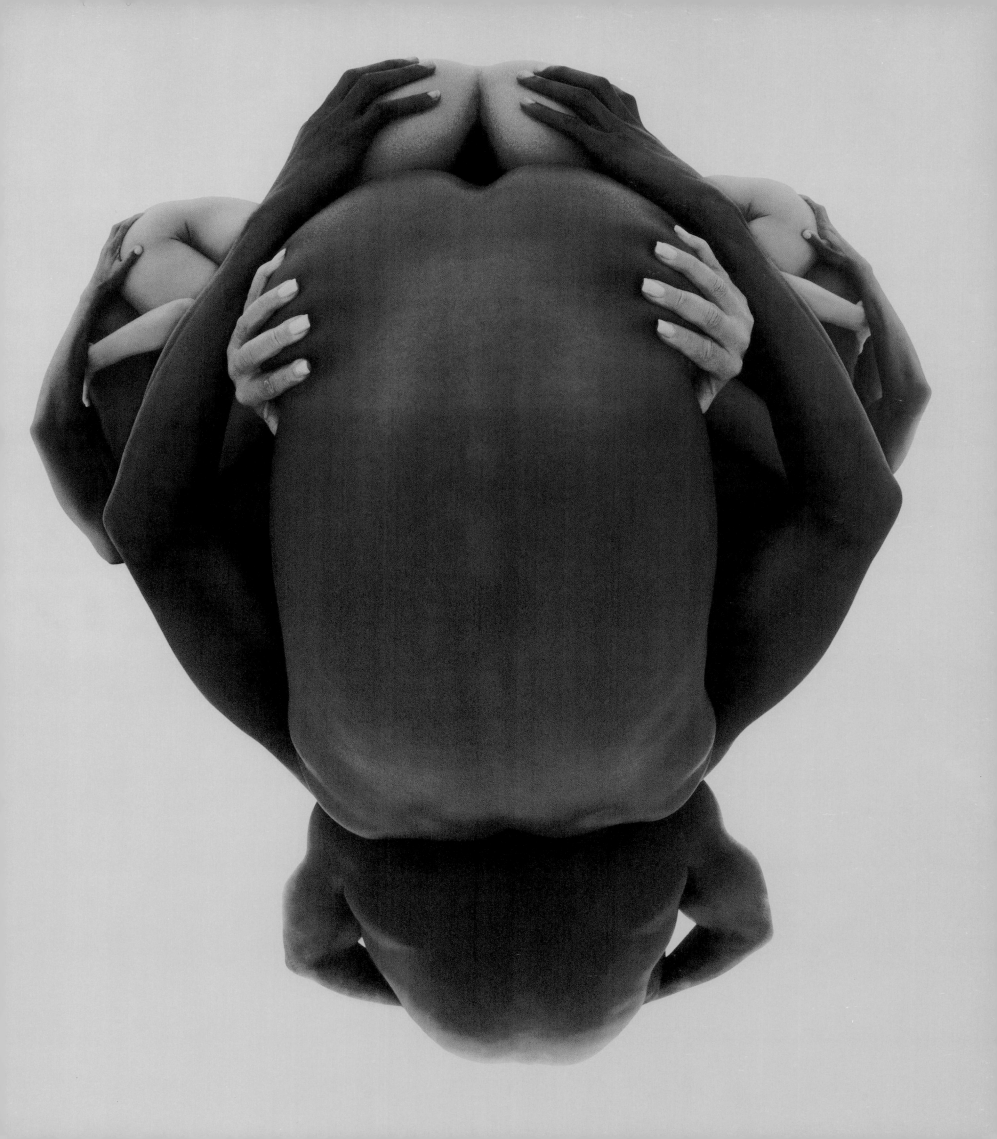

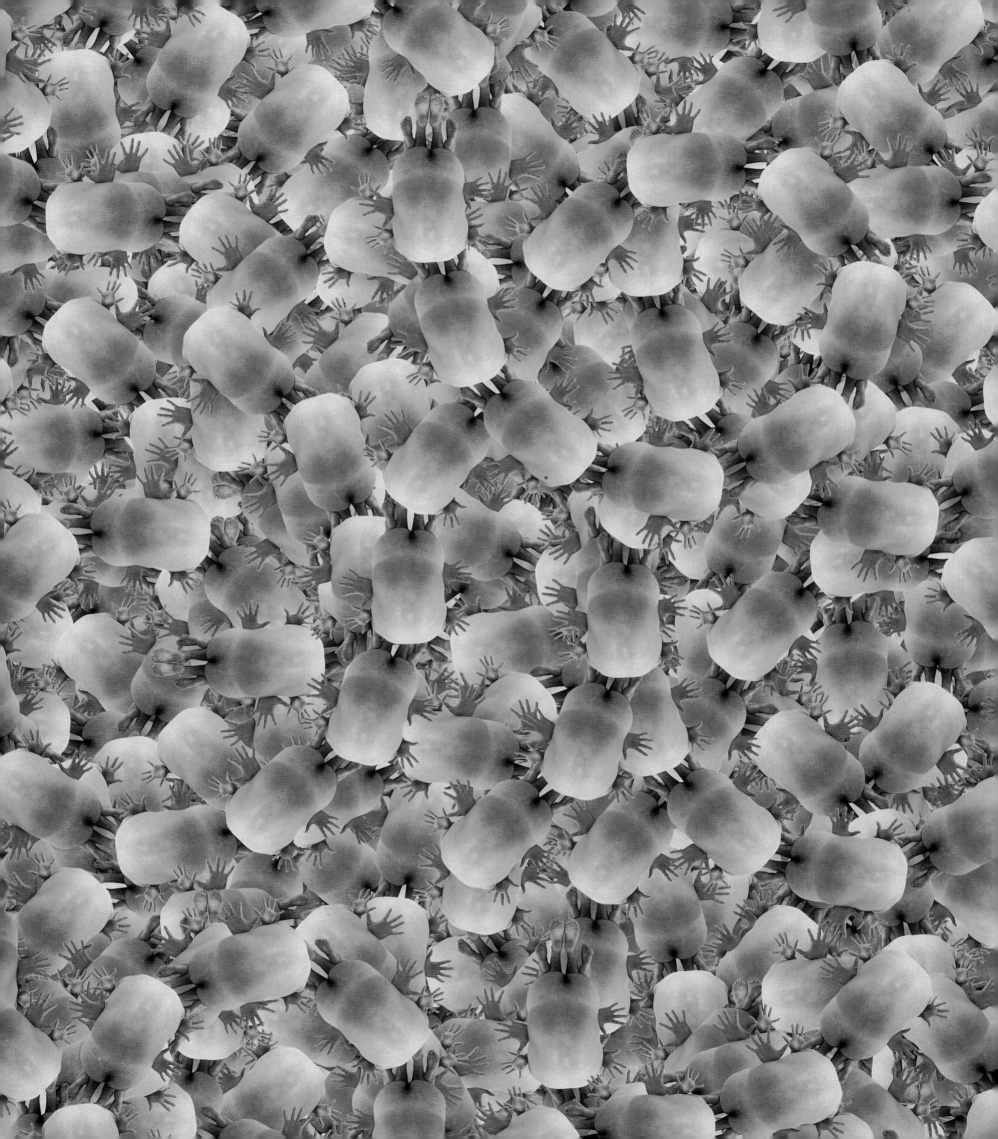

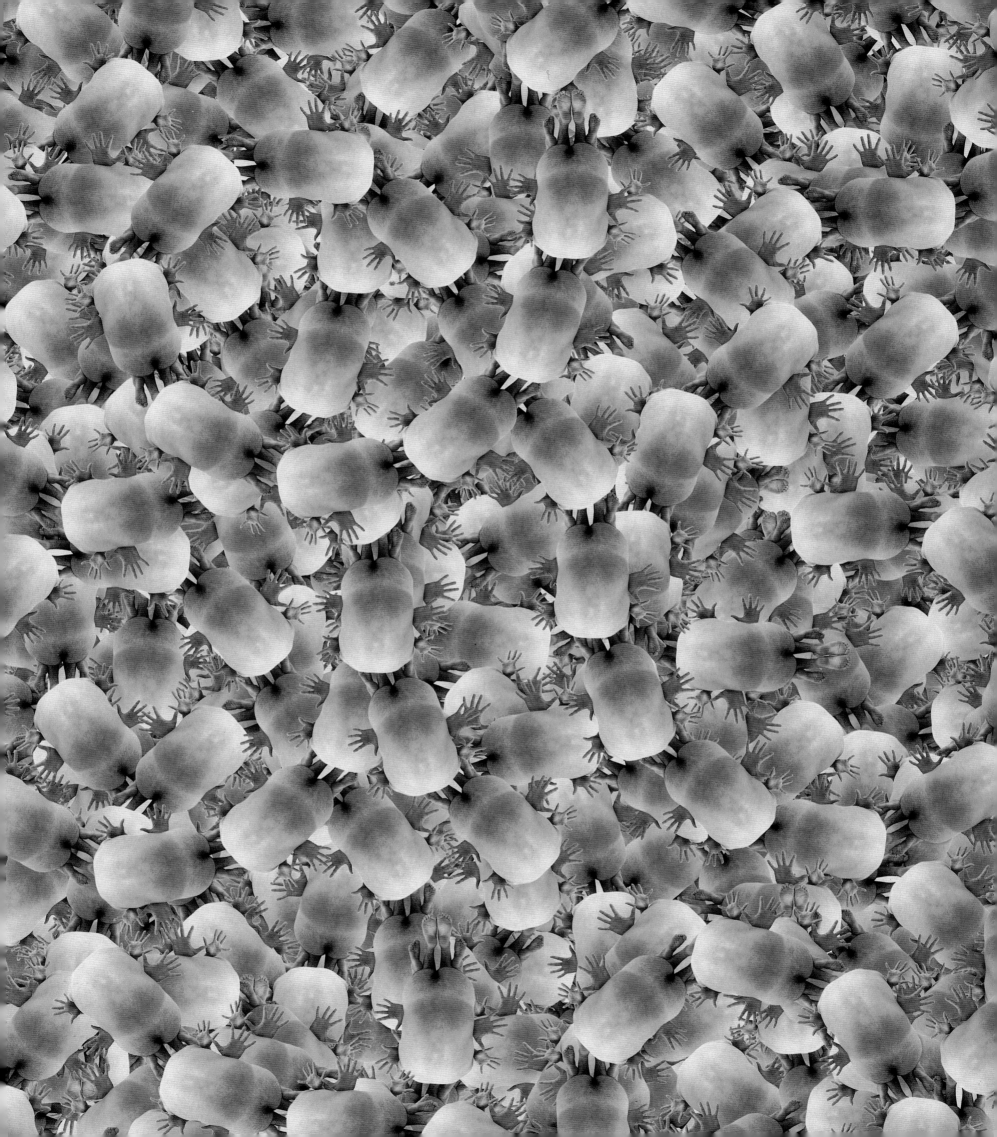

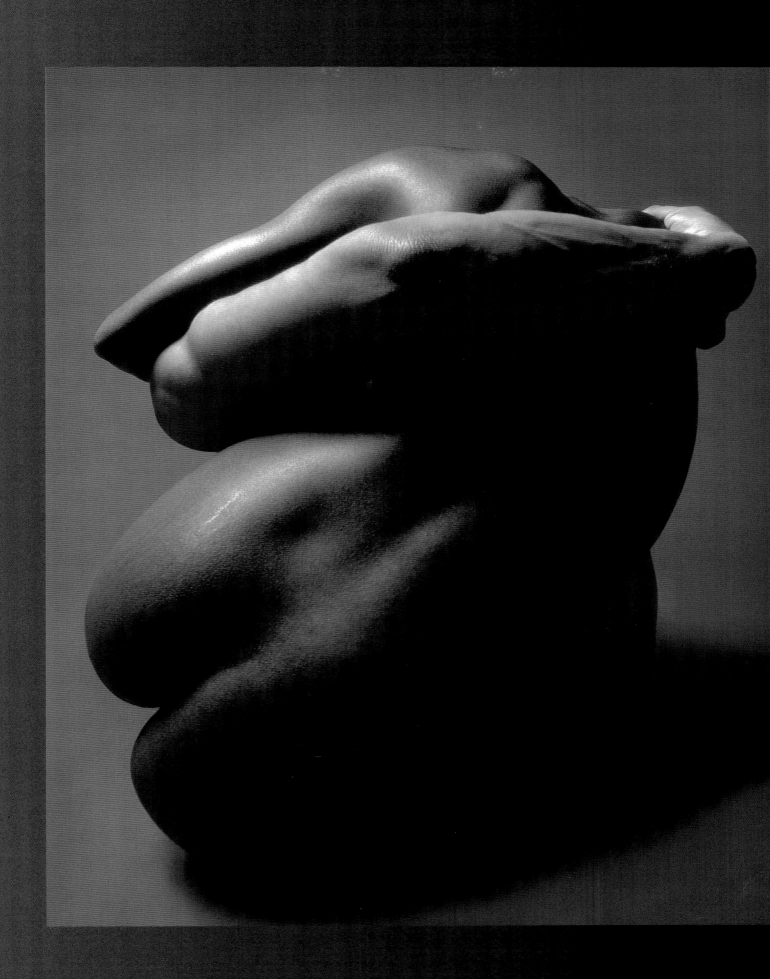

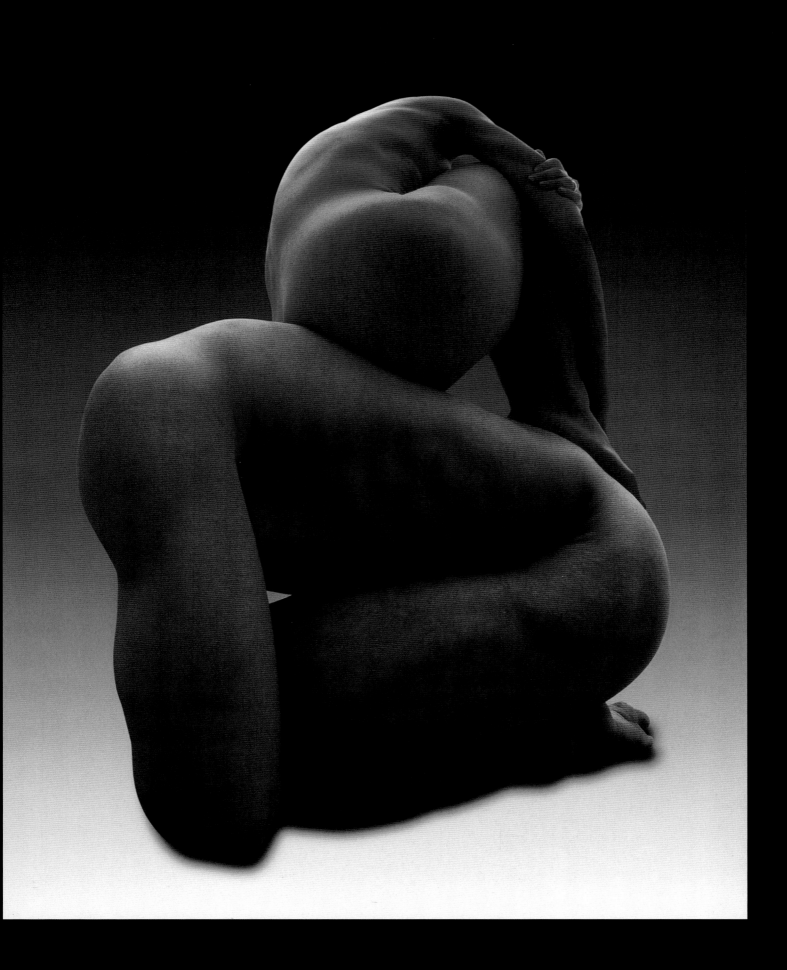

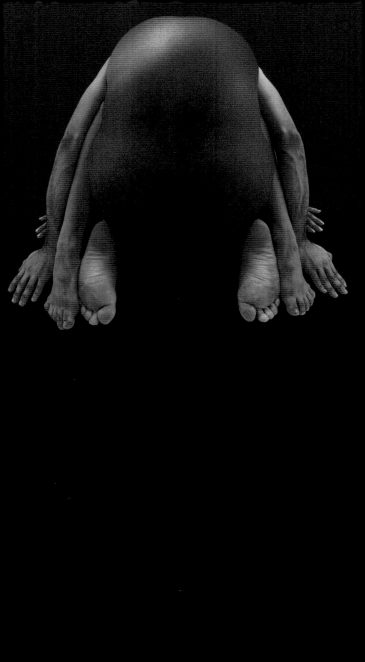

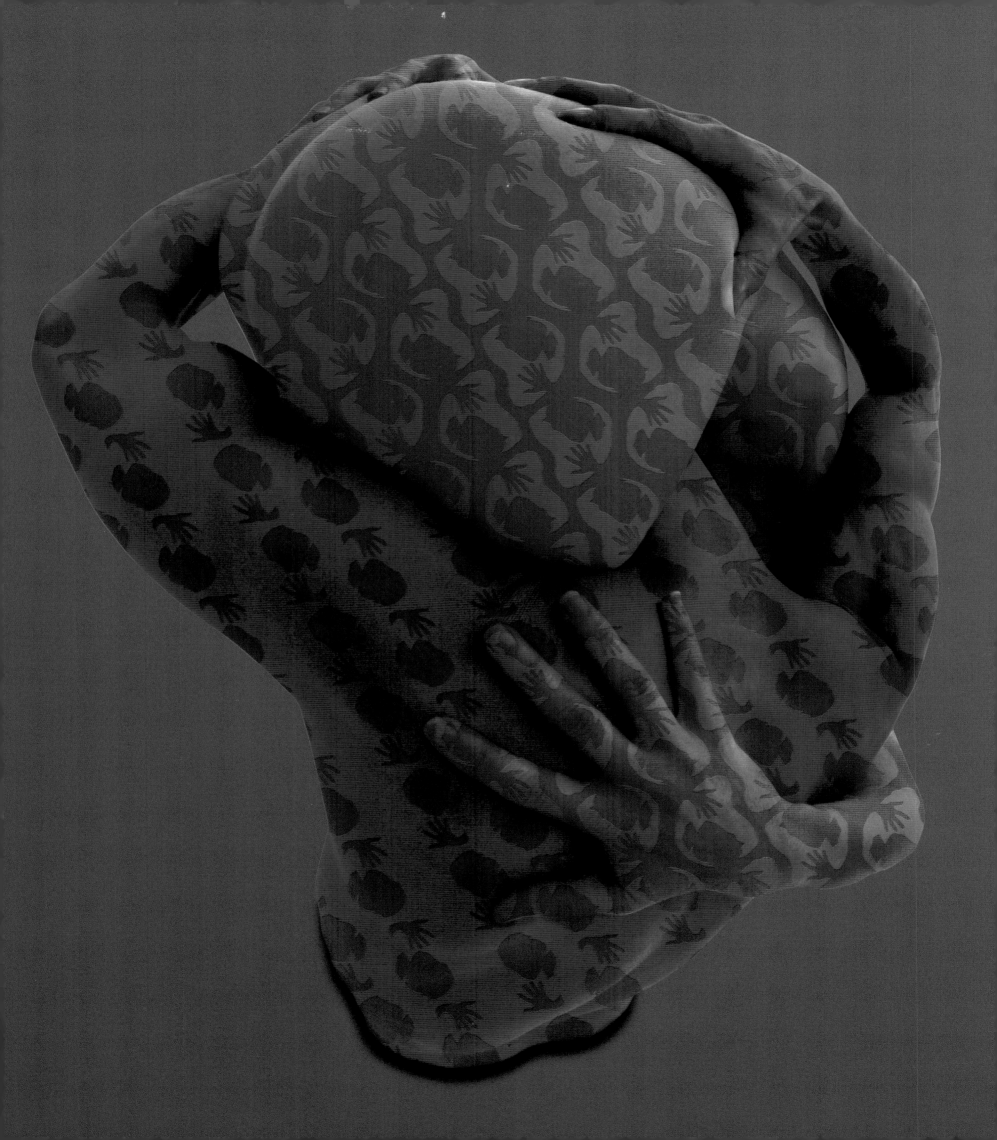

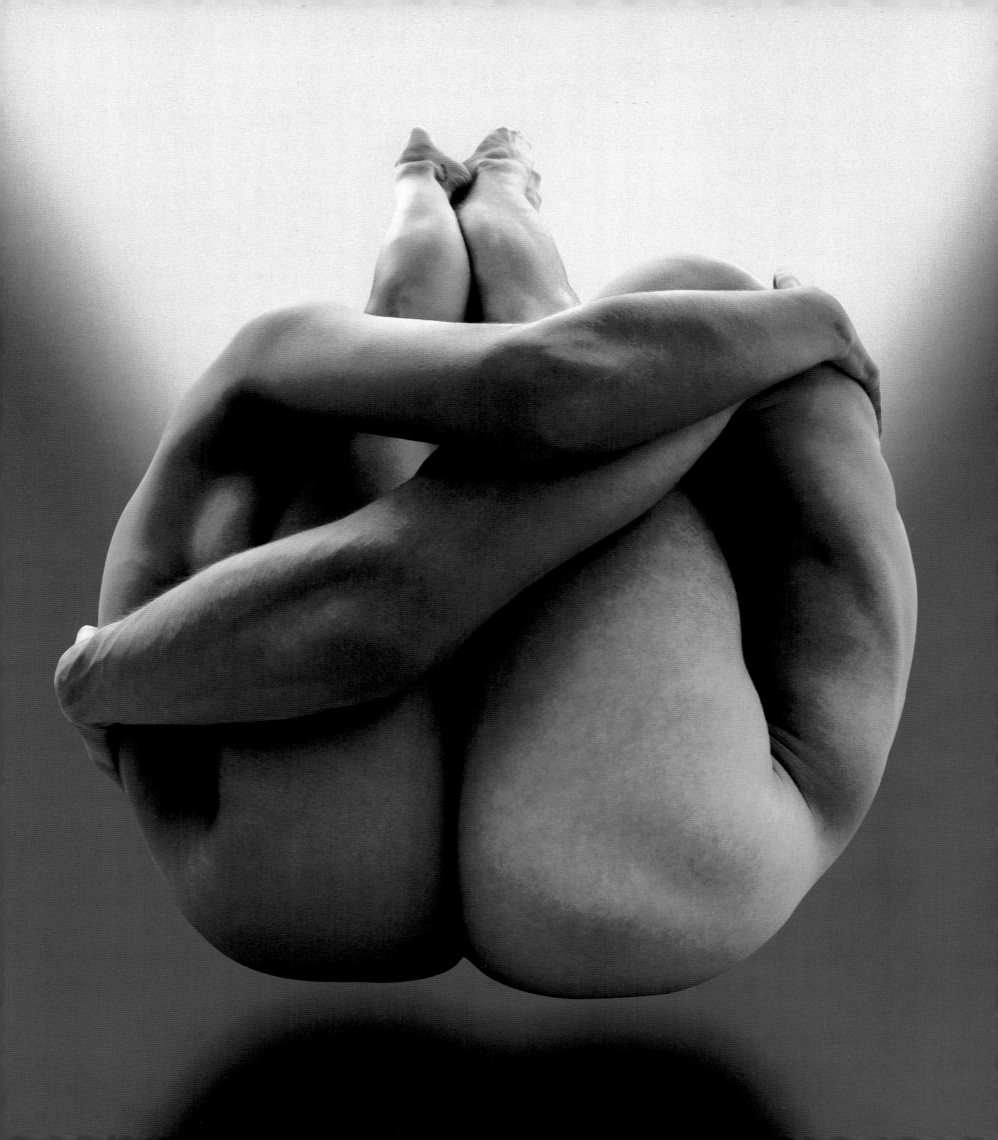

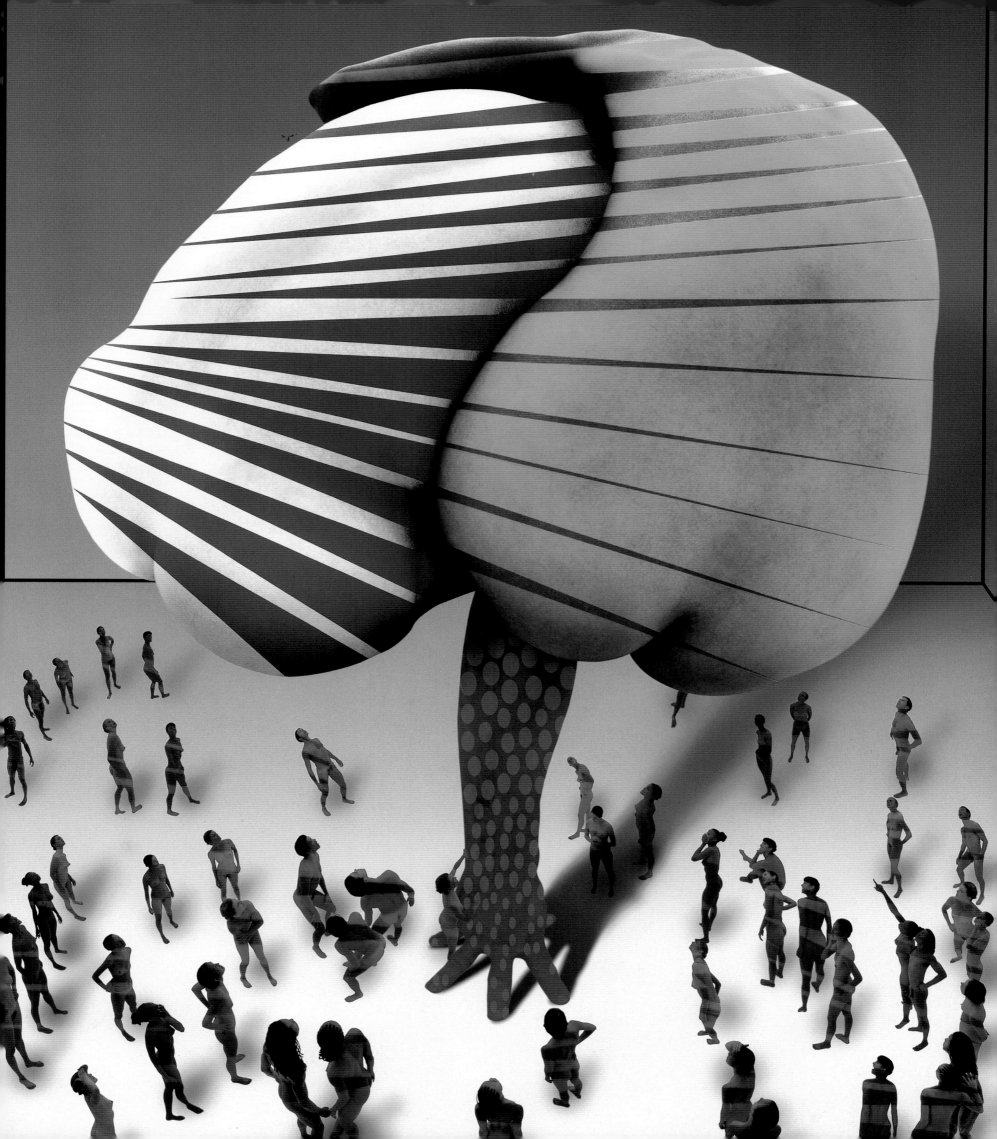

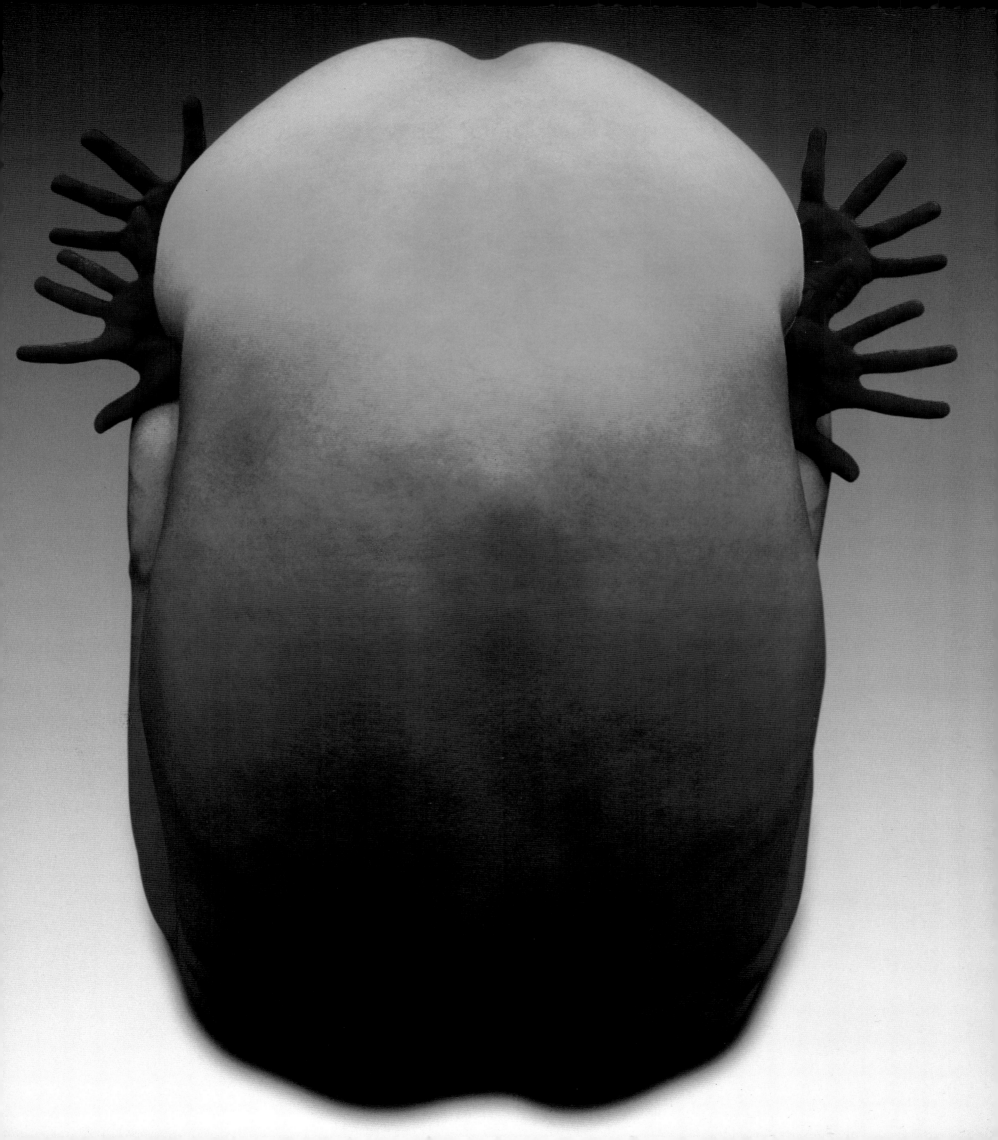

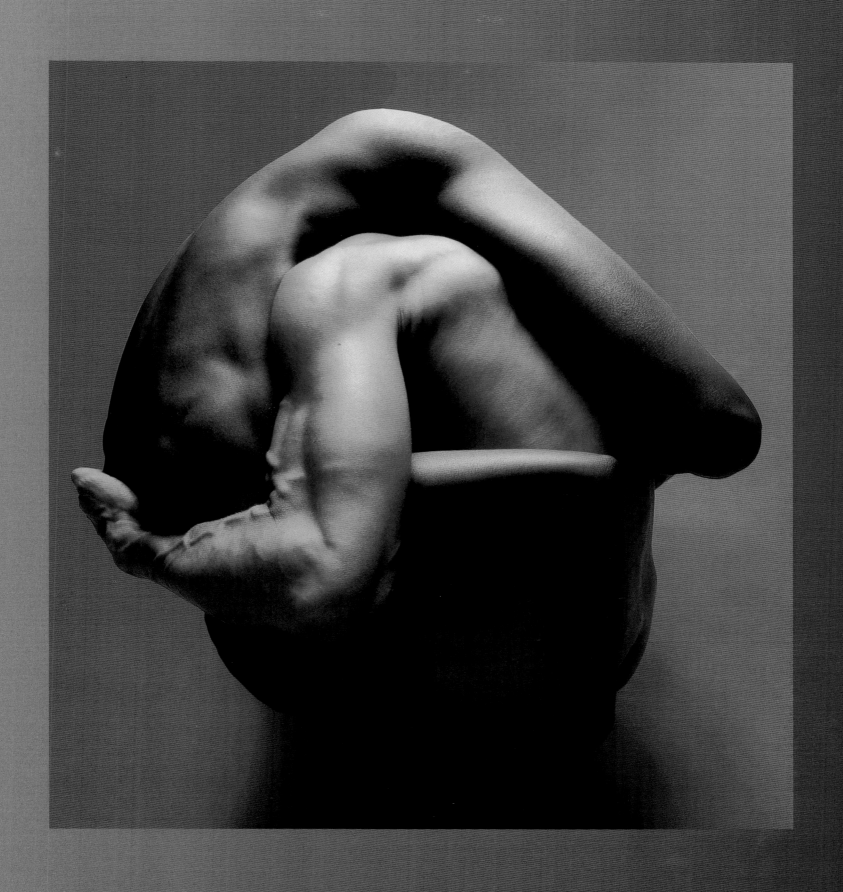

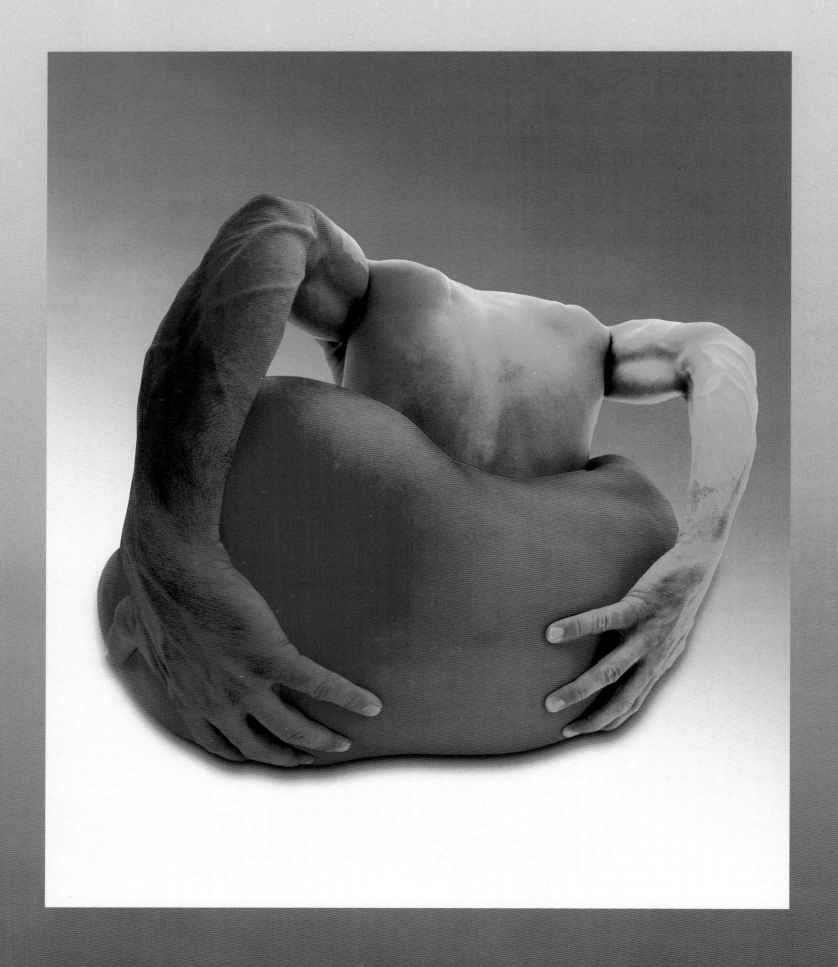

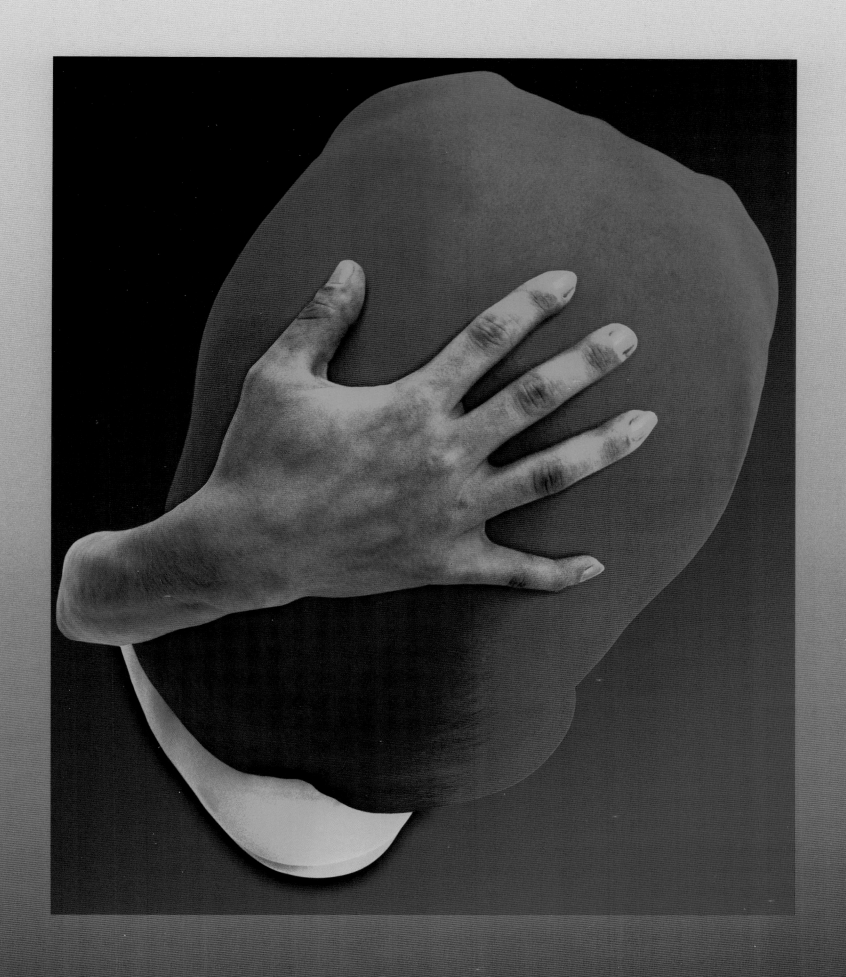

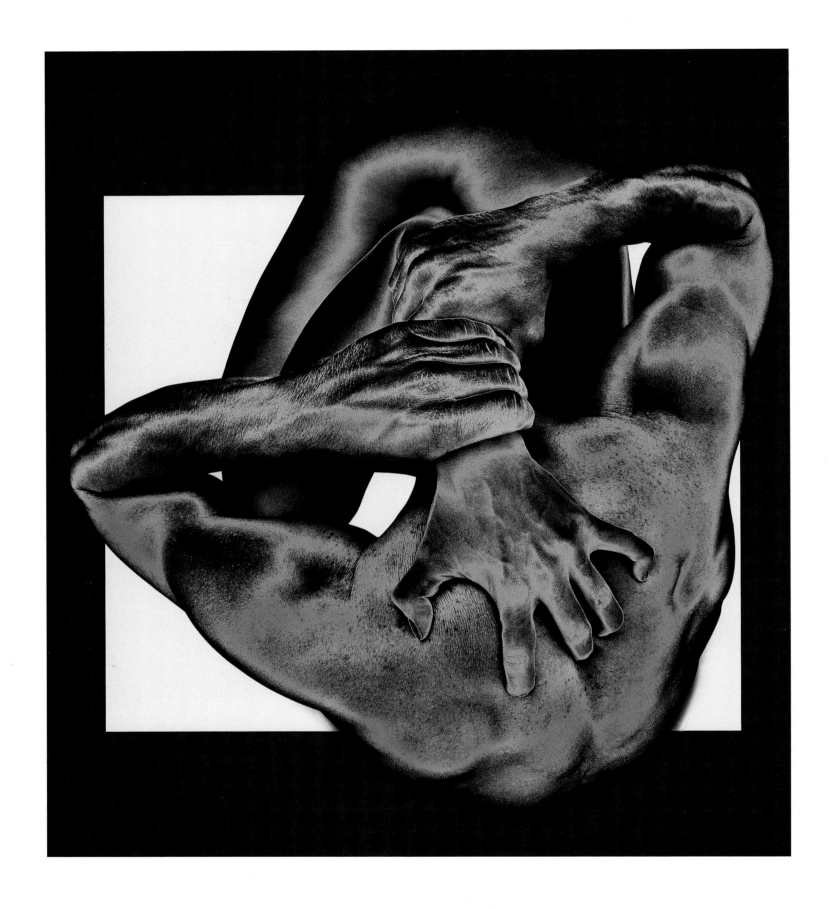

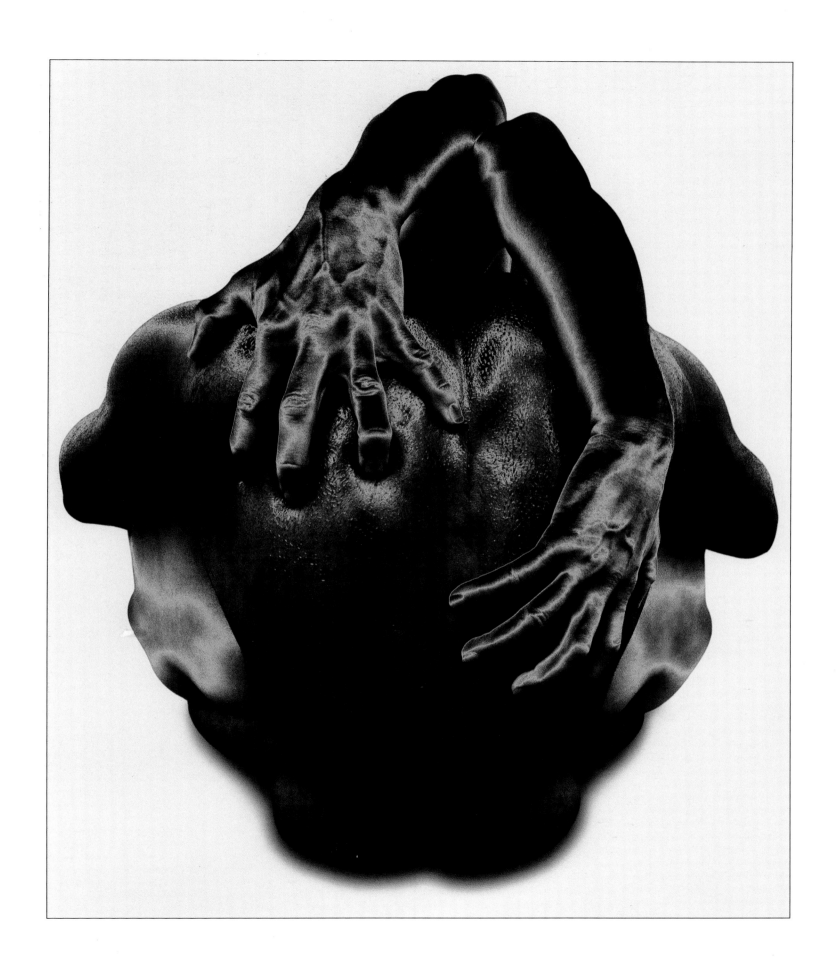

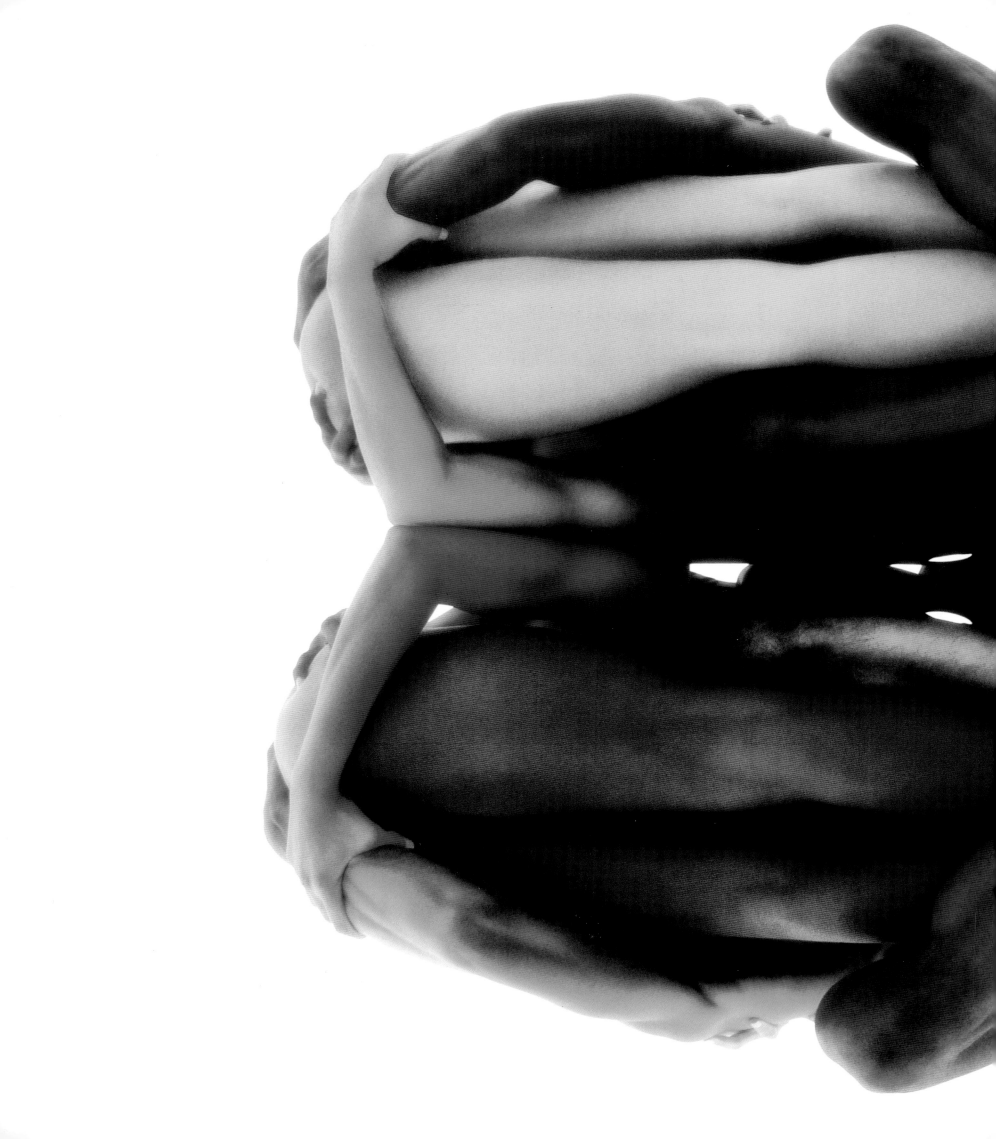

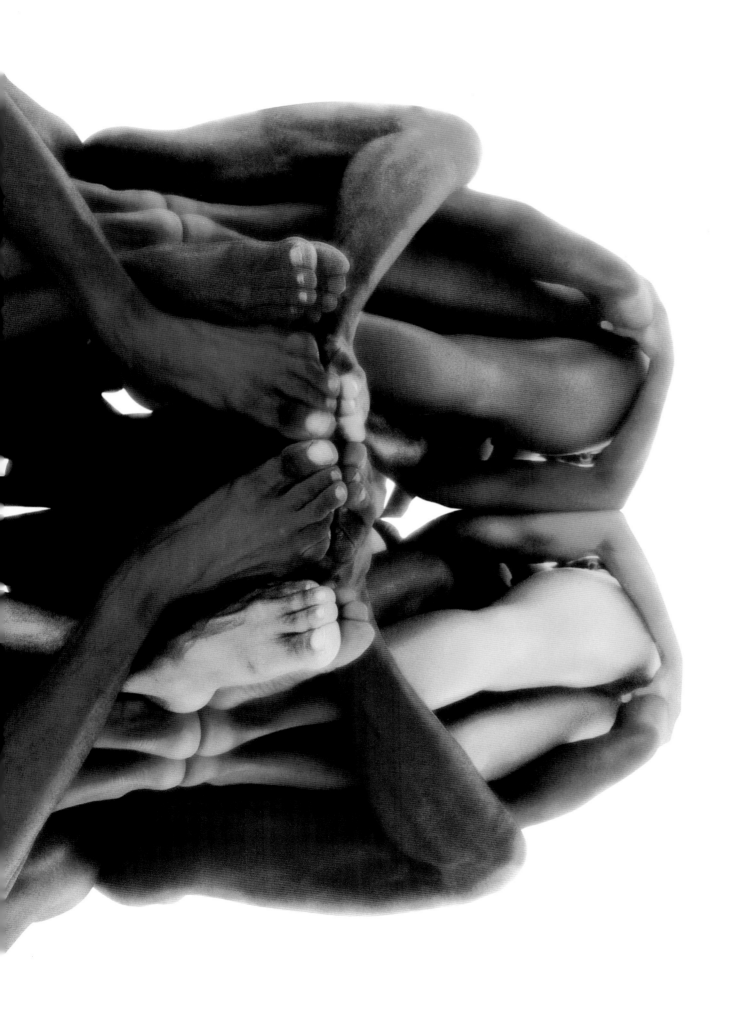

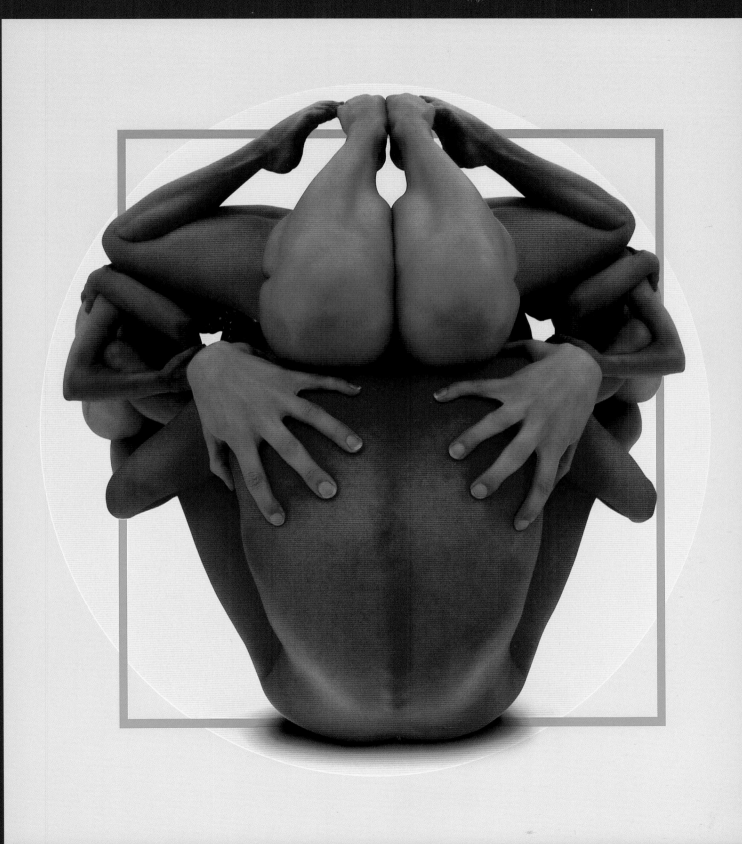

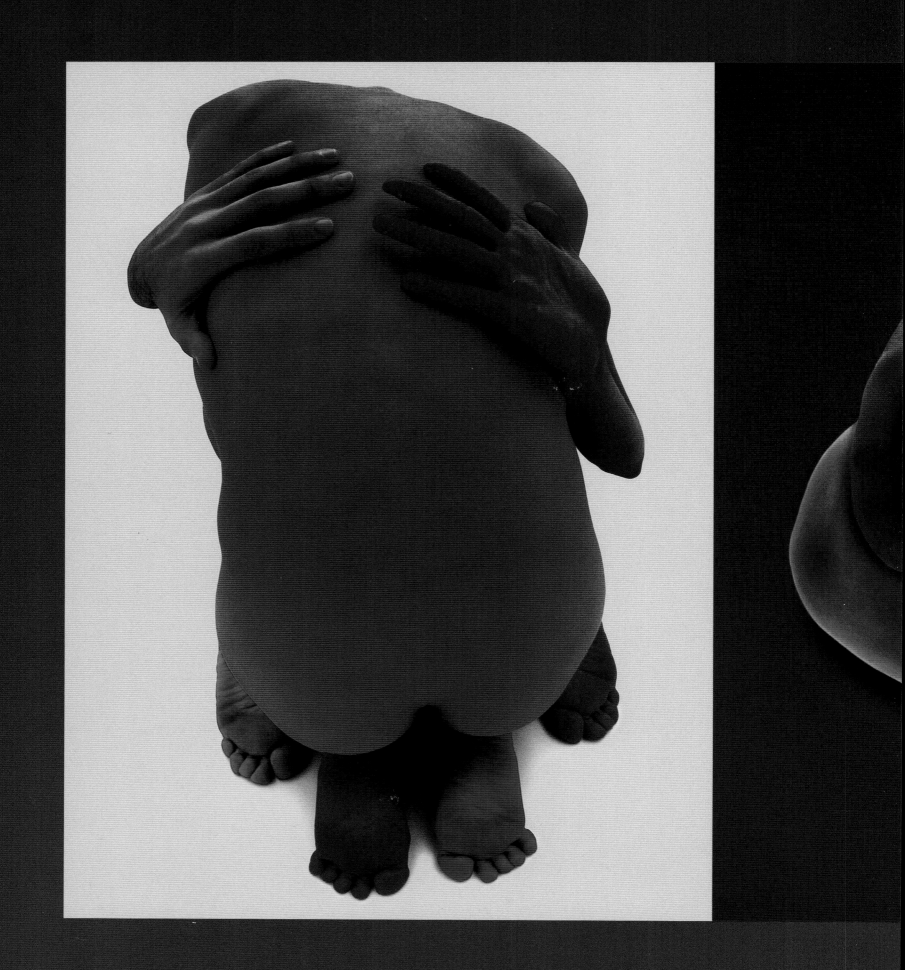

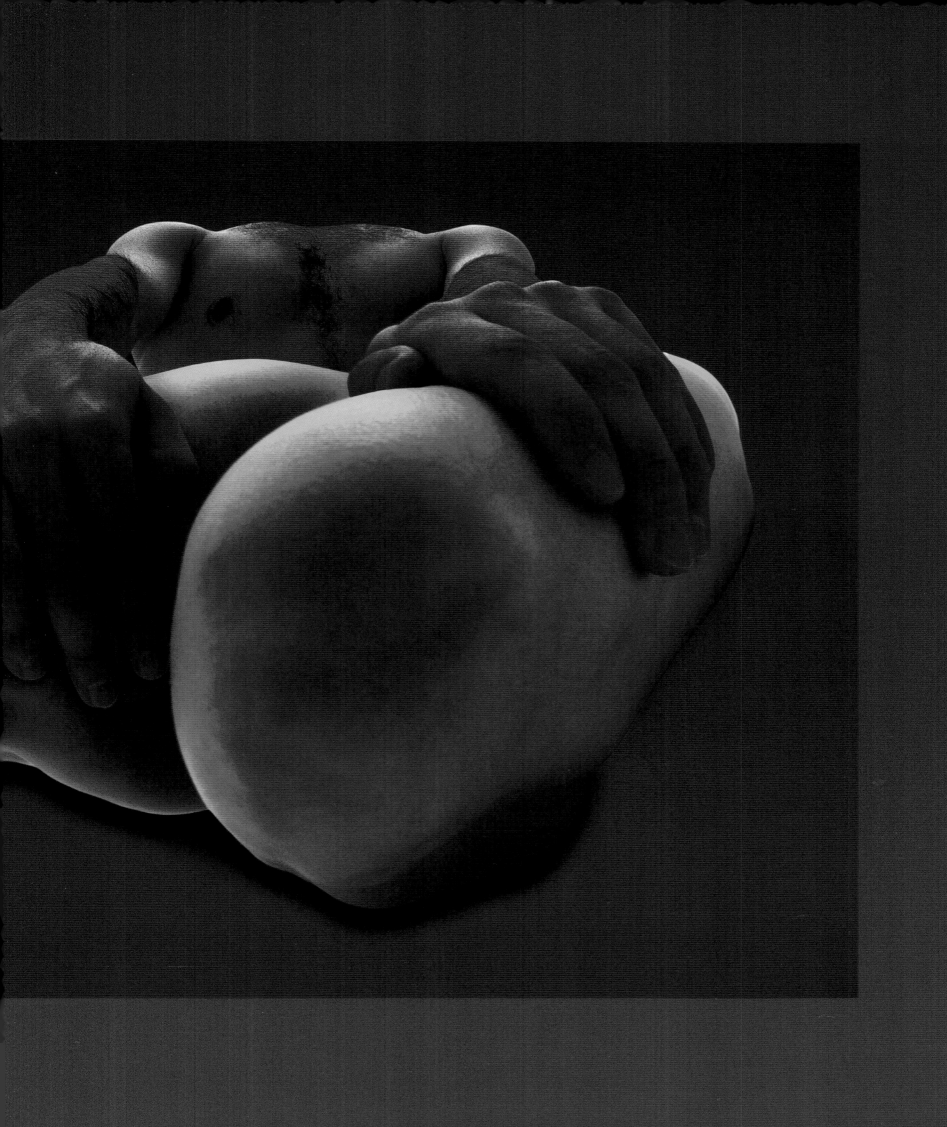

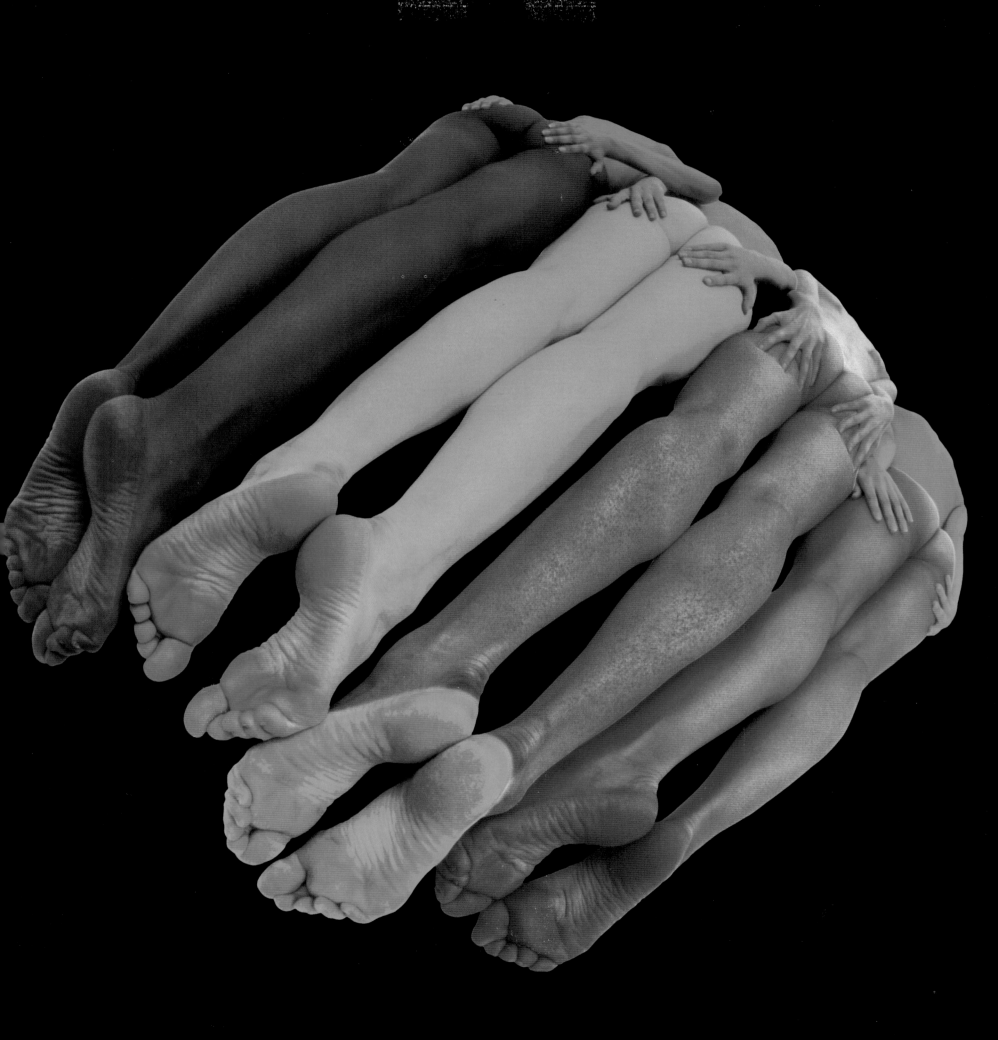

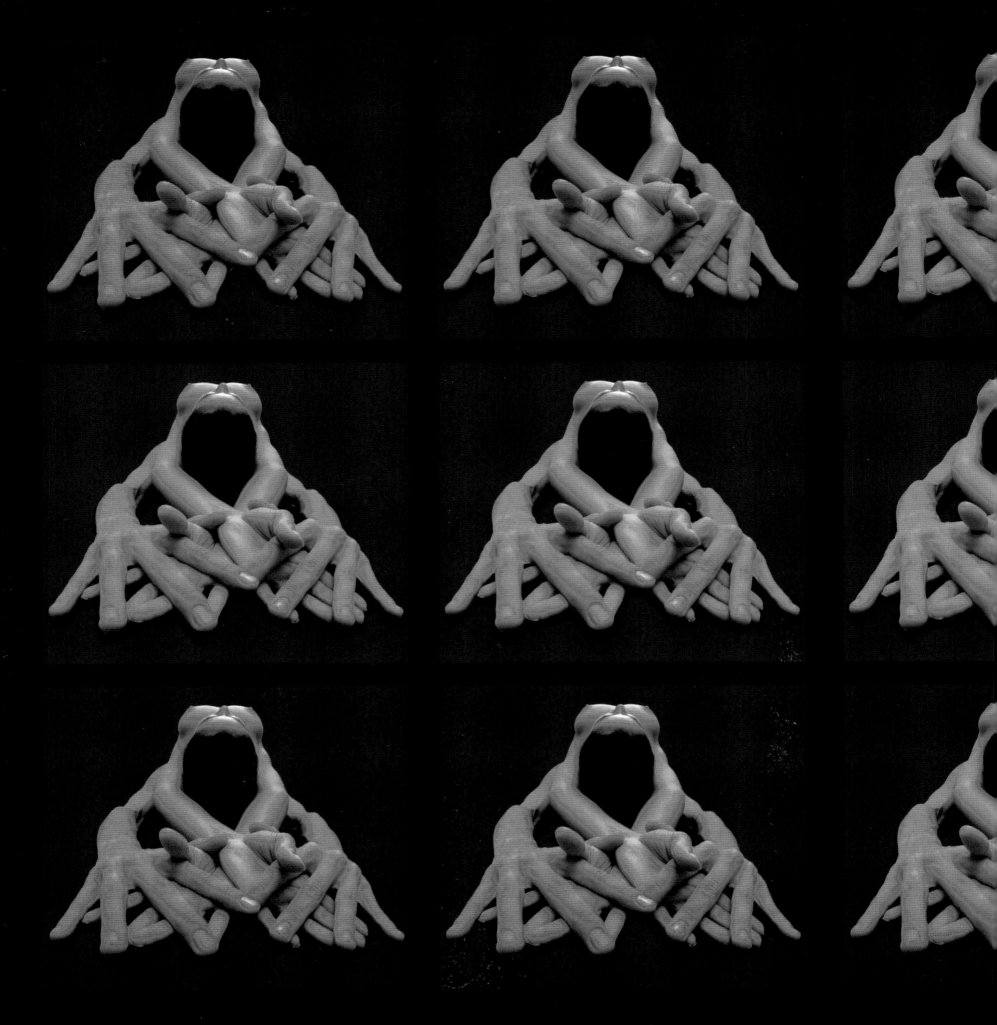

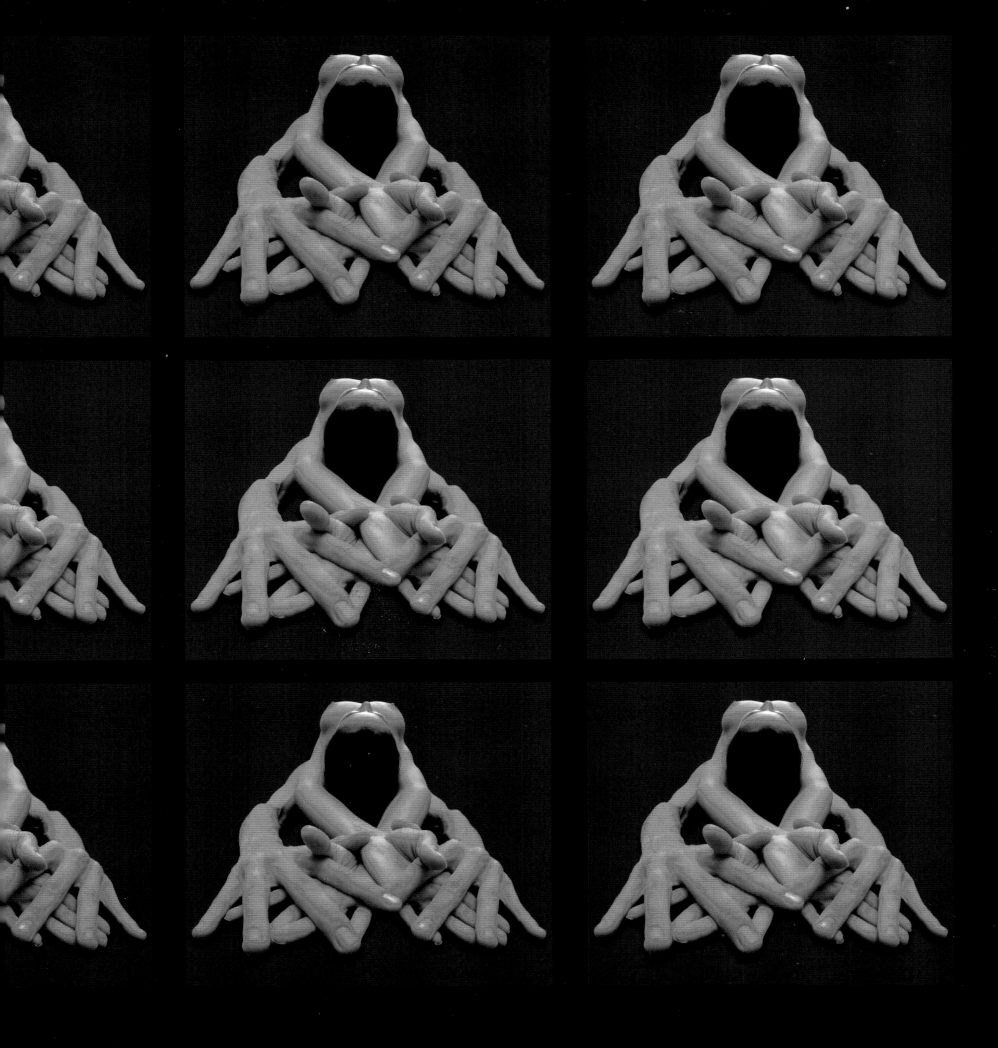

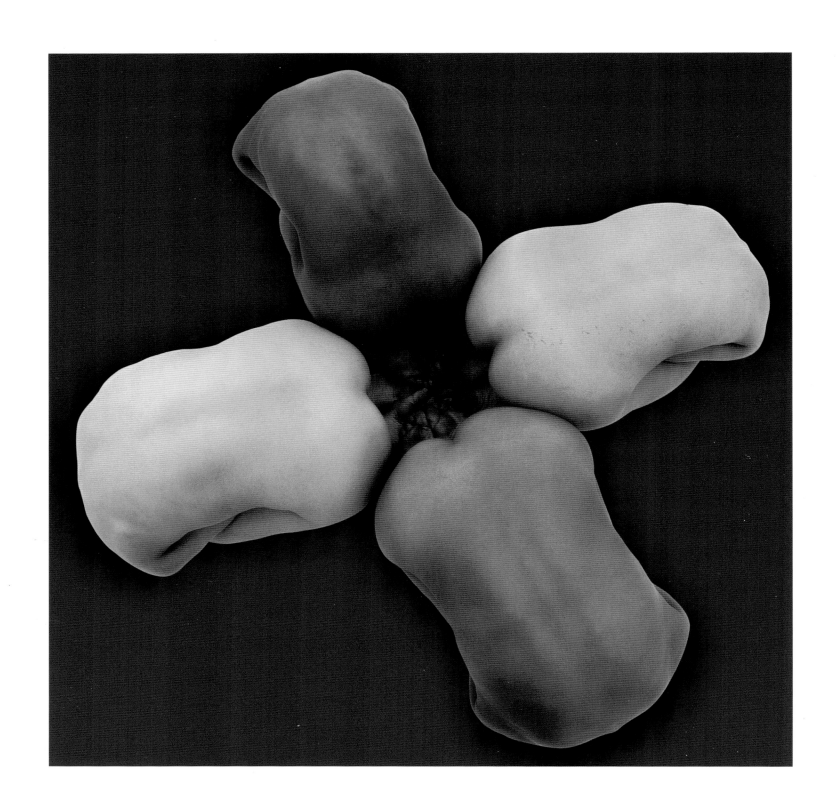

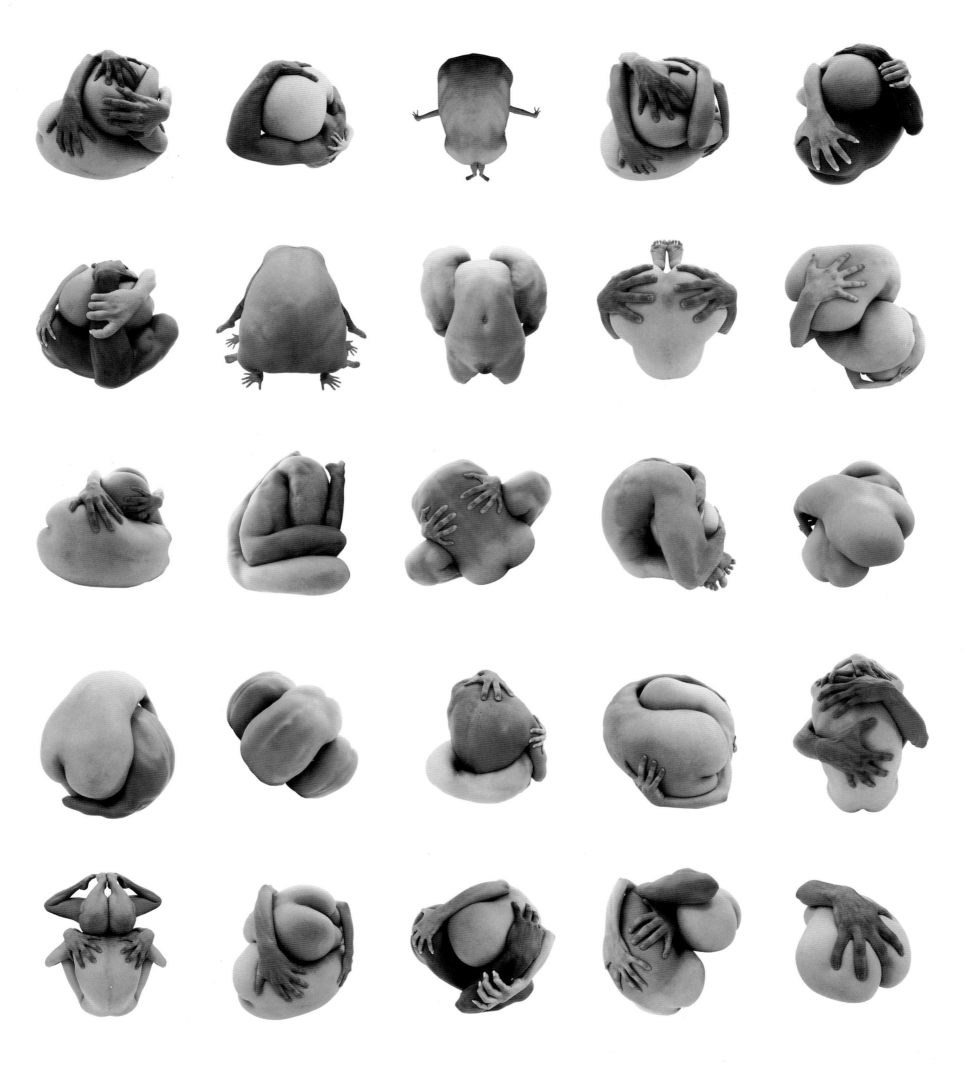

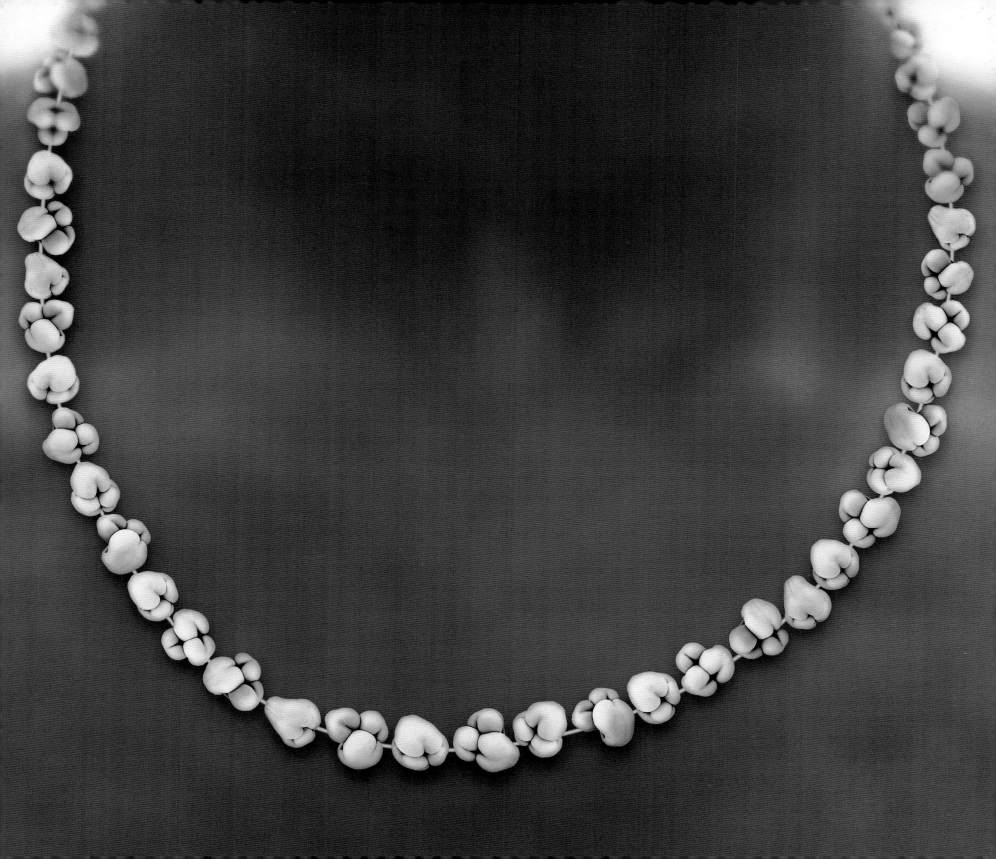

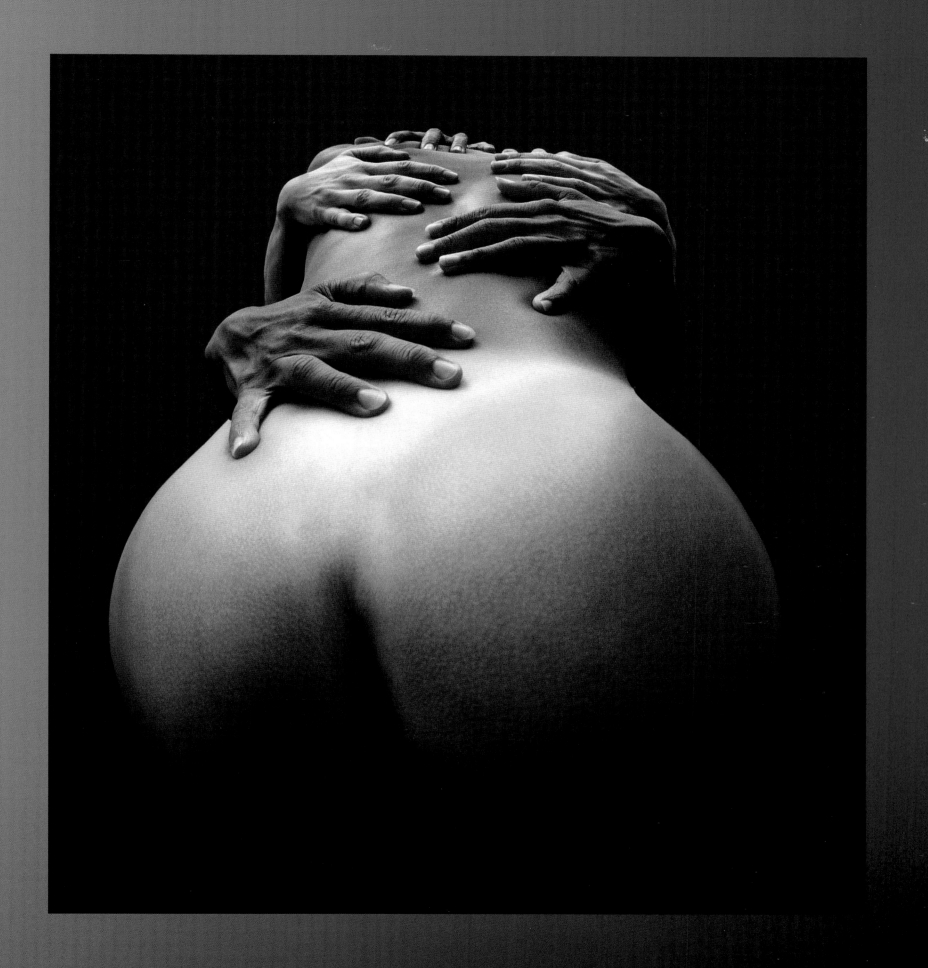

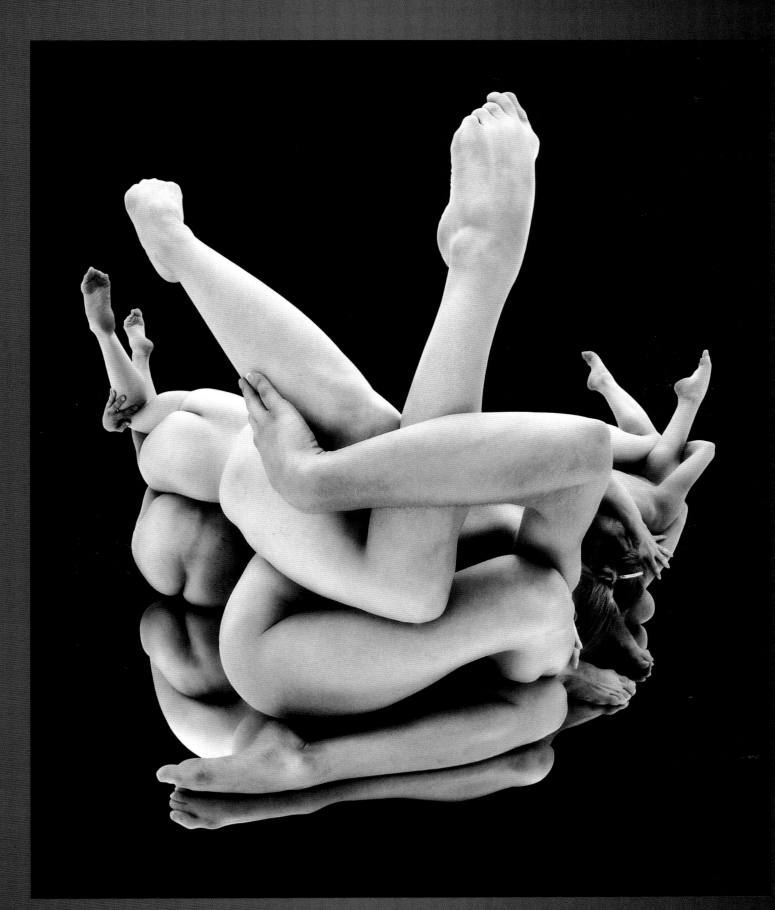

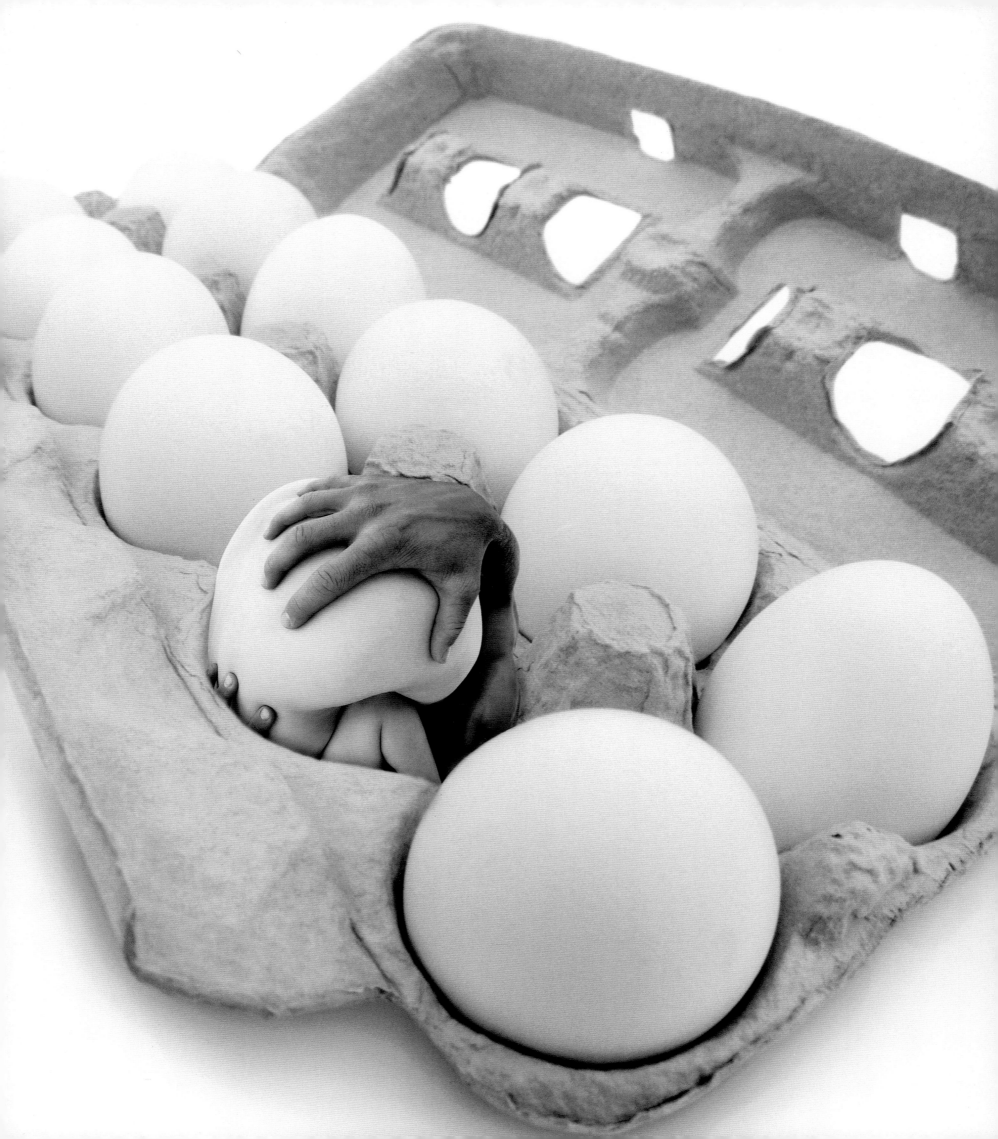

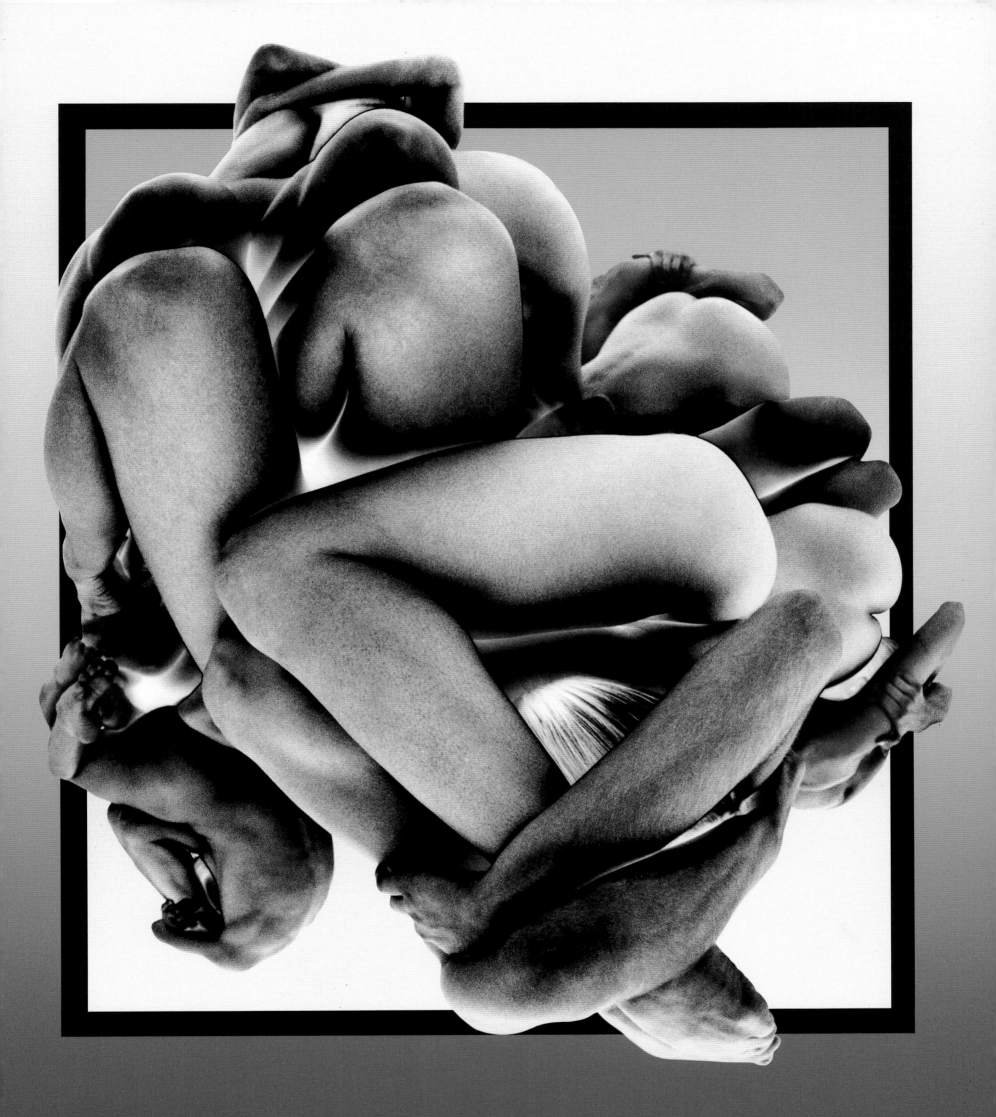

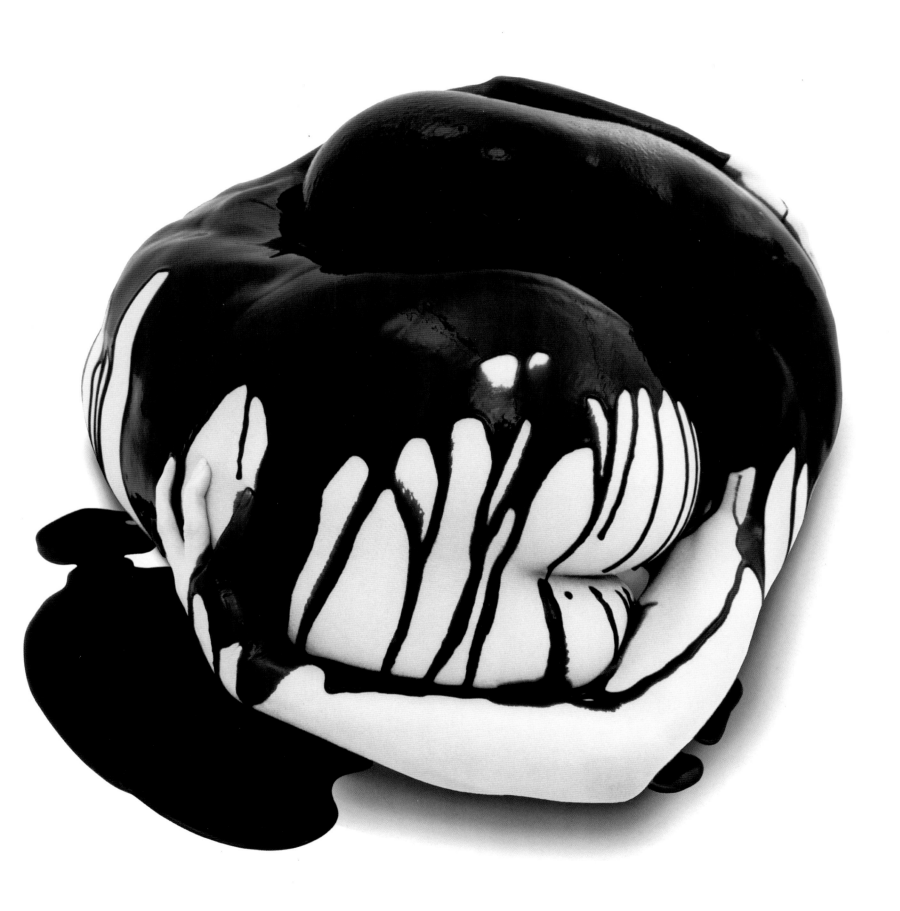

KNOTS DIRECTORY

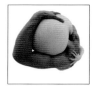
Knot #173

Knot #171

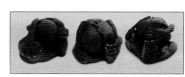
Knot #214

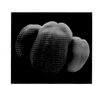
Knot #250

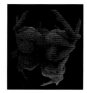
Knot #223

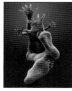
Knot #86

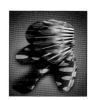
Knot #167

Knot #239

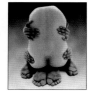
Knot #270

Knot #113

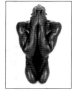
Knot #199

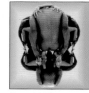
Knot #161

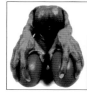
Knot #158

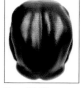
Knot #159

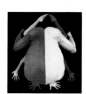
Knot #68

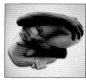
Knot #91

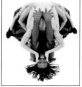
Knot #203

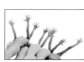
Knot #150

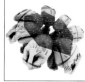
Knot #222

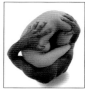
Knot #187

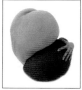
Knot #189

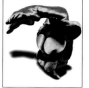
Knot #174

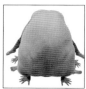
Knot #127

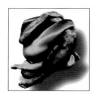
Knot #38

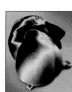
Knot #78

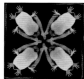
Knot #123

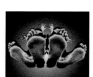
Knot #85

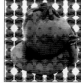
Knot #194

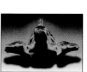
Knot #51

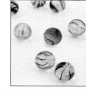
Knot #207

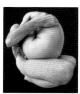
Knot #14

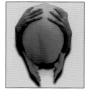
Knot #46

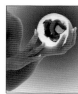
Knot #198

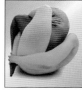
Knot #256

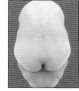
Knot #121

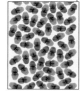
Knot #125

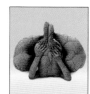
Knot #255

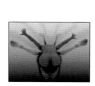
Knot #108

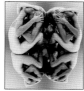
Knot #221

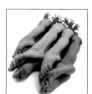
Knot #164

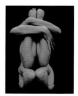
Knot #40

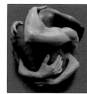
Knot #28

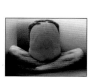
Knot #48

Knot #93

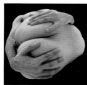
Knot #99

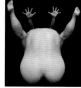
Knot #87

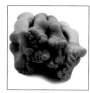
Knots #148

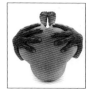
Knot #183

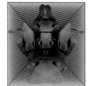
Knot #122

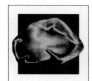
Knot #84

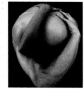
Knot #151

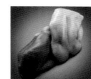
Knot #79

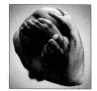
Knot #90

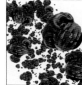
Knot #162

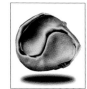
Knot #245

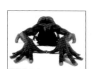
Knot #63

Knot #196

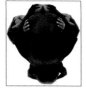
Knot #114

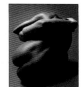
Knot #1

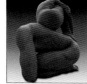
Knot #98

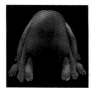
Knot #132

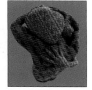
Knot #179

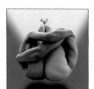
Knot #76

Knot #182

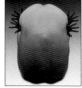
Knot #82

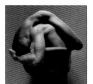
Knot #8

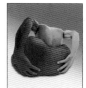
Knot #186

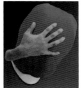
Knot #135

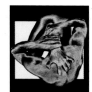
Knot #185

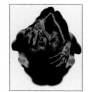
Knot #27

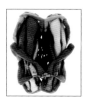
Knot #201

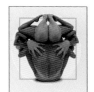
Knot #227

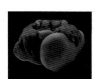
Knot #139

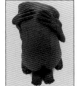
Knot #133

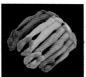
Knot #149

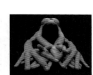
Knot #72

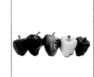
Knot #235

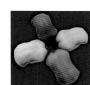
Knot #144

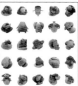
Knot #213

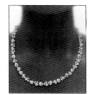
Knot #168

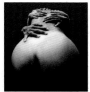
Knot #17

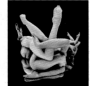
Knot #224

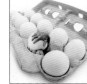
Knot #184

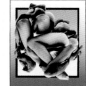
Knot #220

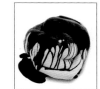
Knot #205

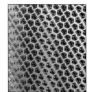
Knot #211

ACKNOWLEDGMENTS

We want to acknowledge the group of remarkable people who contorted themselves so artfully to help us create these knots: Andrew Asnes, Bryan Barkhurst, Charissa Barton, Rachel Berman, Lawrence Bishop, Lillian Rose Bitkoff, Tammy Chabowski, Kimiye Corwin, Mark DeChiazza, Andre Dokukin, Eric Dunlap, Veronica Dunlap, Jonathan Fagan, Kristina Fernandez, Erica Fischbach, Donna Scro Gentile, Silvia Goncalves, Caryn Heilman, Tia Holland, Kristen Hollingsworth, Patricia Kenny, Jessica Lang, Vladimir Malakov, Sebastian Marcovici, Amy Marshall, Laura Martin, Christopher Martin, Sara Mau, Christina May, Parrish Maynard, Tamica McCloud, Kathleen McNulty, Elizabeth Mischler, Catherine Nelson, Toshiko Oiwa, Lenna Parr, David Parsons, Tom Patrick, Trebien Pollard, Karen Reedy, Keith Roberts, Laura Shoop, Rachel Venner, and Kevin Ware.

And our special gratitude to group of people whose dedication to their work make it possible for us to do ours: Dmitris Dritsas, Alice Jordan, Phoebe Lichty, Robert Mills, Monique Reddington, and Wendy Vroom; and also, Tony Corbell at Hasselblad, USA, Darcie Eggers and Scott diSabato at Kodak, Eileen Healy at Chimera, Christopher Brown at Calument and Kevin Balli at Balcar.

We want to extend our great appreciation to the team at Rizzoli: publisher Marta Hallett, editor Ellen Hogan Elsen, and Karen Engelmann for her wonderful design.

Finally, a deep, sweeping bow to our agent extraordinaire, John Campbell of Wonderland Press, for his boundless enthusiasm and unparalleled efforts on behalf of our work.

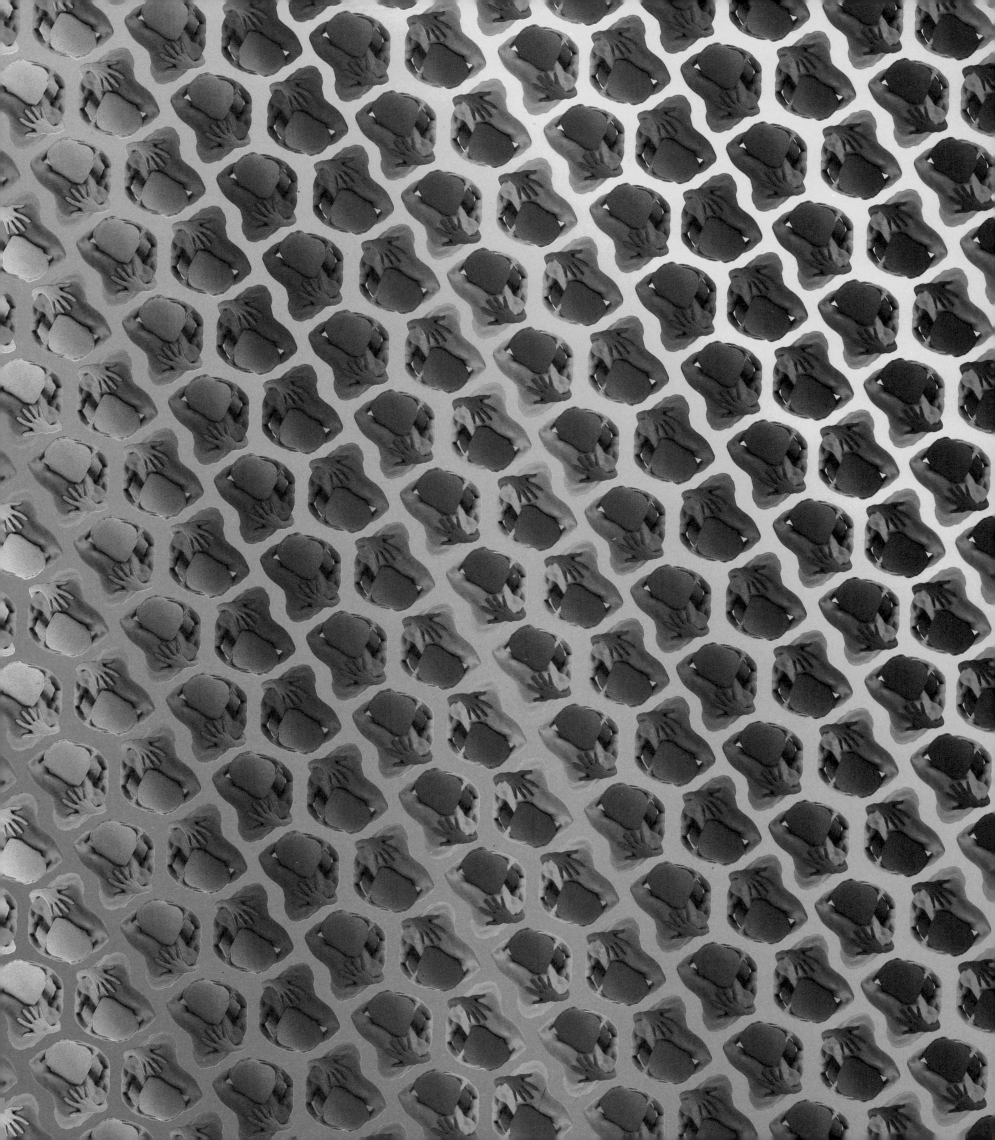